GONE TO

LACMA

BE BACK

SOON

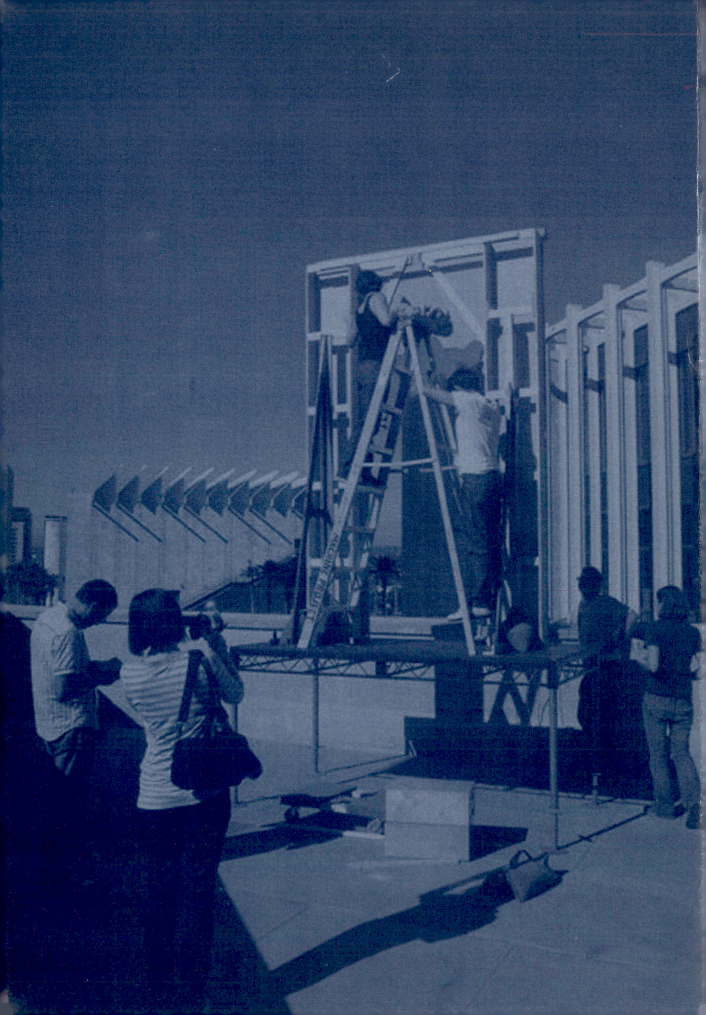

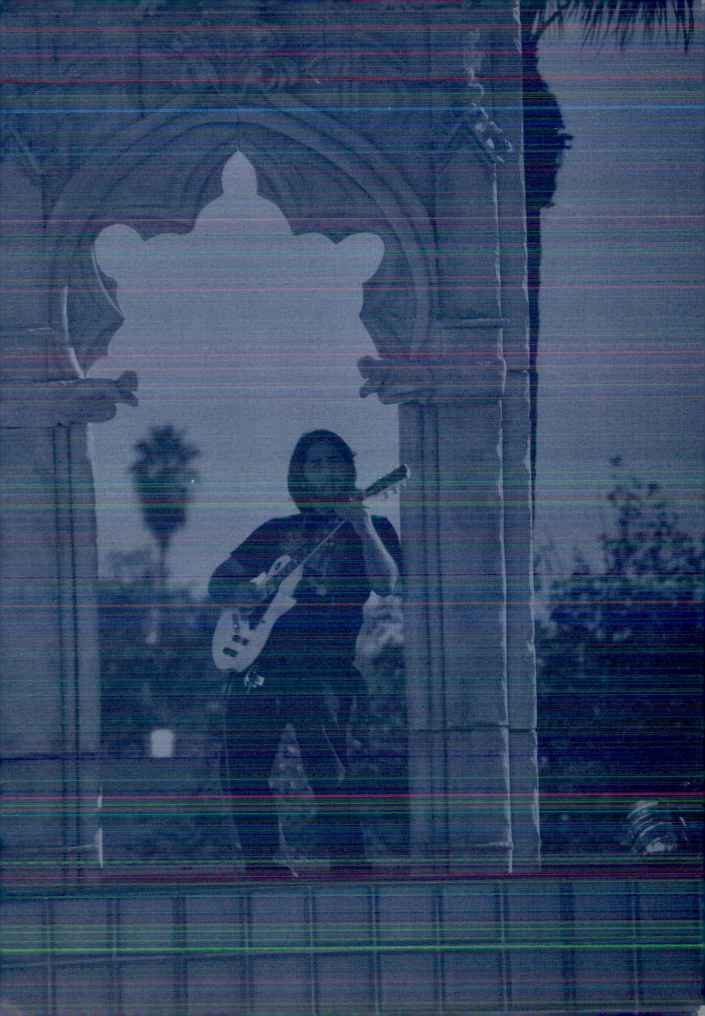

3. (p. 162)

THE ONES THAT GOT AWAY JASON BROWN
A sestina for Machine Project at
Los Angeles County Museum of Art, 15 November 2008

Garden on top of the elevator. Student driver parking valets. Child docents.
Clap-activated lighting. Boat puppets. Laser eyed statue heads—please guard
your eyes. Beware of pie toss. Saint Bernard with brandy neck-cask wandering
around the landscape paintings. Abandoned luxury items. Preparator workshop.
Can we drill into the floor? Whoopie cushions, everywhere. A voice hidden
inside a pedestal occasionally shouts out a comment or interjection.

Zombie mob. 11 a.m. blackout on the lawn, snoozing to sunburn: Bladdo!
Sunset solitaire. Escalator skiing. Knitting while drumming. Docent
lecture: a close analysis of the design of those lovely little couches hidden
amongst Greco-Roman artifacts. Synchronized fountain wading. Security guard
misinformation campaign. Cookies... with curators. Solar oven workshop
and bake-off. Business card menger sponge. Professional dog walker wandering

the halls with a pack of hounds. Giant skunk. Loud procession wandering
through the entire museum. Welcoming birdsong. Art curators: Fight!
In a dark exit, a mysterious toilet. Motorized birdhouses—a workshop.
Contemporary art pole dancer. A surprise massage from a guard or docent.
Edible plants of the Miracle Mile. "Please Don't Touch the Fogel"—guards
keep people away from him. Truth or Bronze Casting? Hot tub hidden

in a stairwell. Skunk hunter with giant net. Methane gas alarm: the hidden
story. Carnival barker. Giant kitten. An insect door for insects wandering
in and out. Op-art handball. Acoustic theremin. Please be on your guard
inside the Richard Serra sculpture, as you may be mugged... by Hamburglar!
A secret play: "Afternoon with The Silent Guard and the Grumpy Docent"
Bumper cars. Grammar rodeo. Edible weed salad for sale in the gift shop.

Machine Project hot sauce: now there's something for the gift shop.
Obligatory Wizard of Oz reference? Paranoid-critical texts describe hidden
histories of object provenance. Mime trapped in real vitrine. Docent
tour on the changing fashionability of small heads. Wandering
paths marked with arrows on floor. Poetry stairwell. Monorail!
William Shatner oil painting. Giant lawn darts. LACMA security to guard

Machine while we're away. When confronting infinity mirror, guard
yourself against the vast power of infinity. Postcards in gift shop
of an overweight photographer reflected in a shiny art object: Nude!
Art appreciation air horn. Behind a revolving bookcase, you find a hidden
wing of the museum. Remarkably poor carpentry. Helpful docent wandering
through museum, discussing the art. Wait... is this person actually a docent?

The scent of popcorn. An oil drum with burning trash and hot dogs, disregarded.
Wandering through the artifacts of modernity, a lone zombie seeks the gift shop.
Hidden grow lab. Animatronic tabla. Erotic pottery, broken. Lost nose: Found!

MACHINE PROJECT:
A FIELD GUIDE

to the Los Angeles County Museum of Art

Based on the Machine Project Field Guide to LACMA, *over ten hours of performances, installations, workshops, and events, which took place on November 15, 2008 at the Los Angeles County Museum of Art.*

CONTENTS

INTRODUCTION MARK ALLEN

Etymologically speaking, "machine" is any means of doing something. Our explorations at Machine Project reflect this by investigating everything from knitting techniques to ideological frameworks for the construction of reality. Every event we host looks at the world from a different perspective—analytic, poetic, scientific, or discursive—joined by a thread of curiosity and appreciation for other people's obscure obsessions.

Machine Project is also a loose confederacy of thirty or forty artists with whom I have been developing projects for the last five years, both at our storefront gallery and throughout Los Angeles. What I do in these projects tends to shift a fair amount depending on who I'm working with; typical roles include cheerleader, enthusiast, fan, collaborator, irritant, and organizer. These collaborations form an ongoing conversation that is at the core of Machine Project as a social organism.

The *Machine Project Field Guide to LACMA* started about a year before the show, when photography curator Charlotte Cotton invited us to think about doing some kind of event at the museum. During our initial visit, I was drawn to the dusty corners of the Ahmanson Building, and I suggested that perhaps Machine could use the whole museum as a site for a one-day event. Surprisingly, she agreed. I remember that for the first three to six months, my long-time collaborator Jason Brown and I were genuinely concerned that Charlotte was going to come to her senses any minute, but it turned out she had a much better sense of our capabilities than we did at the time.

Events that happen at Machine Project's storefront space tend to be intimate, as the room only holds about fifty or sixty people. This scale creates a temporary bubble of community enclosing both the audience and the participants. Confronted with the massive size of LACMA, we decided to think of the day as multiple Machine-sized events erupting simultaneously throughout the museum, rather than trying to blow Machine up to museum-size. This would maintain a sense of intimacy by having performers share the same public space typically reserved for visitors, so that each piece would function like a street performance, where unexpected events are encountered within a space that usually serves another function.

Our projects rarely begin with a concrete curatorial concept, and the *Field Guide* developed out of many conversations that took place while visiting the museum in the months leading up to the show. We wandered around the museum taking notes in groups of three to five people, eventually ending up with a list of about five hundred ideas. This giant list was then sorted into categories such as:

- ideas we want to do
- ideas we're hoping will magically happen but we aren't willing to work on
- ideas which are funny to talk about but not actually worth doing
- fiscally or institutionally impractical ideas
- terminally impractical or dangerous ideas that were just never going to happen

The next stage was to determine which ideas had potential to evolve, and which ideas would get worse if you actually did them—an actor dressed as the McDonald's Hamburglar mugging people inside a Richard Serra sculpture was an example of the latter. We tried our best to materialize everything that still sounded like a good idea. The remainder went into Jason Brown's sestina "The Ones That Got Away," a poem written in an elaborate and archaic form using project titles that were cut for various self-evident reasons (escalator skiing, teen driving school valet service, etc.).

We tried to think about LACMA the same way we would approach a project for a mall, a public park, a 7-11, or a dry ice factory. We looked at all available space at the museum, from the galleries to the air conditioning ducts, as possible sites to work within. The sheer volume of cultural information at LACMA made it a very easy space to work with, since there was an endless supply of content to riff off. One of the pleasures of LACMA is that it's a huge museum filled with far more information than anyone can take in during an afternoon; its scale releases you from feeling the responsibility of having to see or understand everything. For the *Field Guide*, we worked to amplify that feeling of discovery and chance encounter: as you moved around the museum, many of the performances were also in motion, and you could come across pieces by chance. No one was able to see the whole event—including myself, despite spending the entire day jogging around the premises trying to take it all in.

Given that parts of the show remain unseen to all of us, this document makes no attempt to be the *Catalogue Raisonné of the Machine Project Field Guide to the Los Angeles County Museum of Art*. Rather, just as LACMA's collections were the starting point for the *Field Guide*, we've used the *Field Guide*'s projects and ideas as a starting point for this publication—including interviews with the artists, a nineteenth-century description of the invention of the glass harmonica, crochet patterns, a fruit salad recipe based on the museum's collection, and instructions for building your own pizza oven. Should you be curious about the state of LACMA during the Pleistocene epoch, we have information on that. We have a really nice picture of Jim Fetterley, at least one flow chart, notes on flowers at the museum, a fragmentary history of LACMA's architect, lots of information on clapping, and a variety of speculations on our motives. I hope you enjoy it.

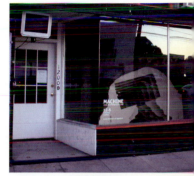

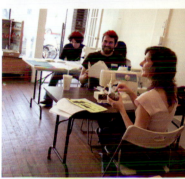

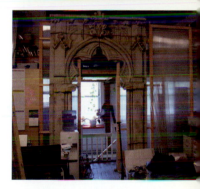

(TOP) Front window of Machine Project with *In Search of a Myopic's Leitmotif*, an installation by Ryan Taber and Cheyenne Weaver.

(MIDDLE) Sewing workshop at Machine Project.

(BOTTOM) Replica of the *Doorway of the Arms of the Count of Chazay* by Christy McCaffrey and Sara Newey, installed in the office at Machine Project.

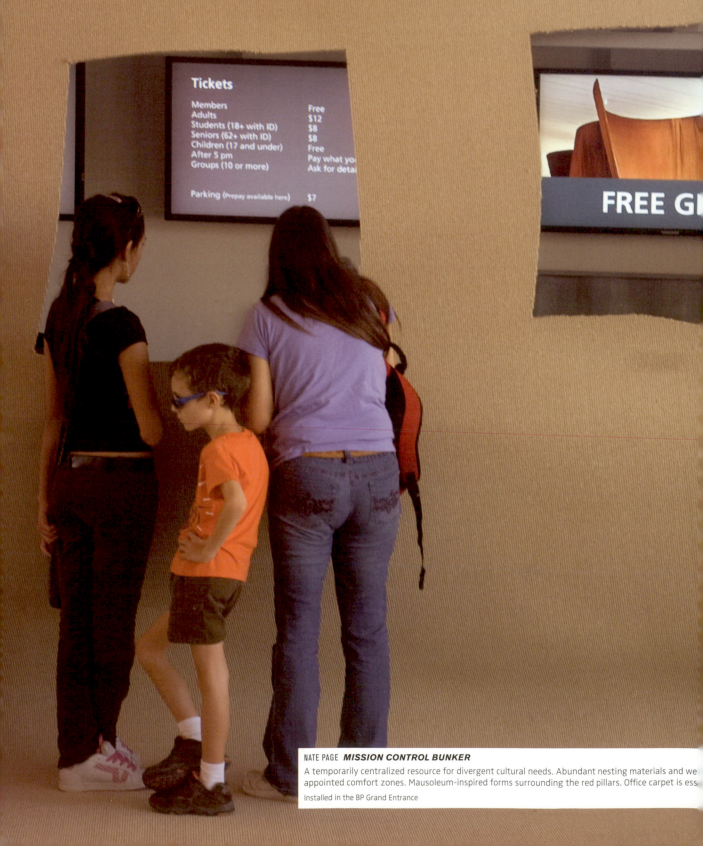

Tickets

Members	Free
Adults	$12
Students (18+ with ID)	$8
Seniors (62+ with ID)	$8
Children (17 and under)	Free
After 5 pm	Pay what yo
Groups (10 or more)	Ask for detai
Parking (Prepay available here)	$7

FREE G

NATE PAGE *MISSION CONTROL BUNKER*

A temporarily centralized resource for divergent cultural needs. Abundant nesting materials and we
appointed comfort zones. Mausoleum-inspired forms surrounding the red pillars. Office carpet is ess

Installed in the BP Grand Entrance

1.

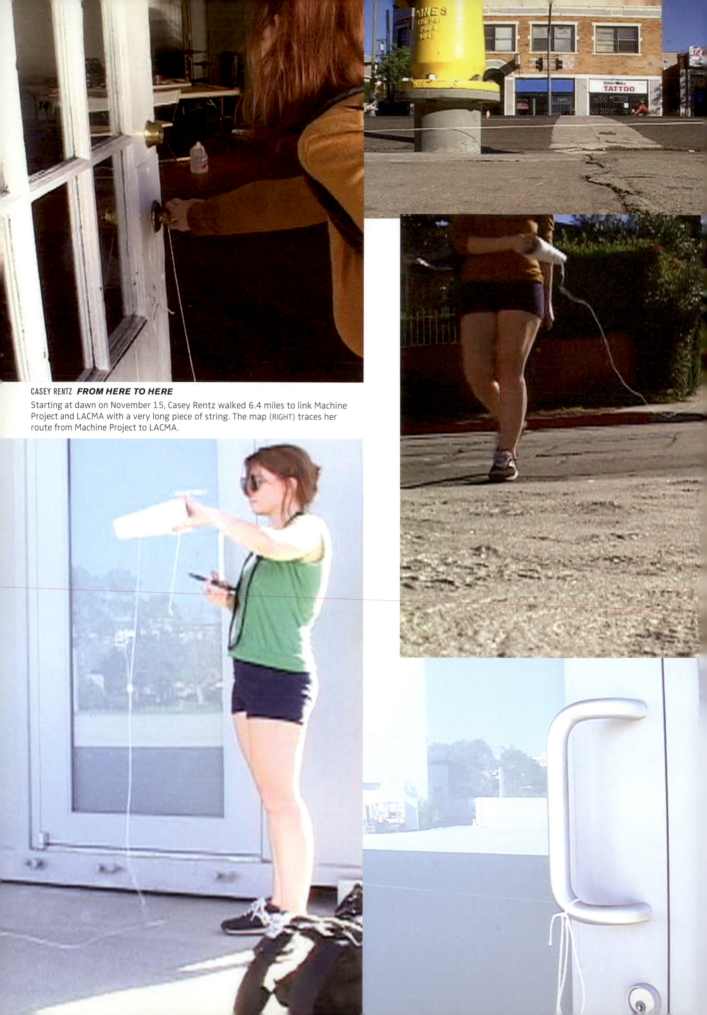

CASEY RENTZ **FROM HERE TO HERE**

Starting at dawn on November 15, Casey Rentz walked 6.4 miles to link Machine Project and LACMA with a very long piece of string. The map (RIGHT) traces her route from Machine Project to LACMA.

14

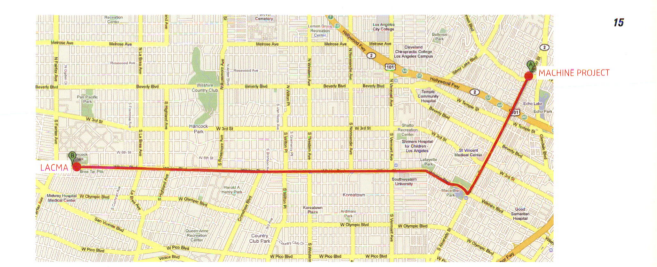

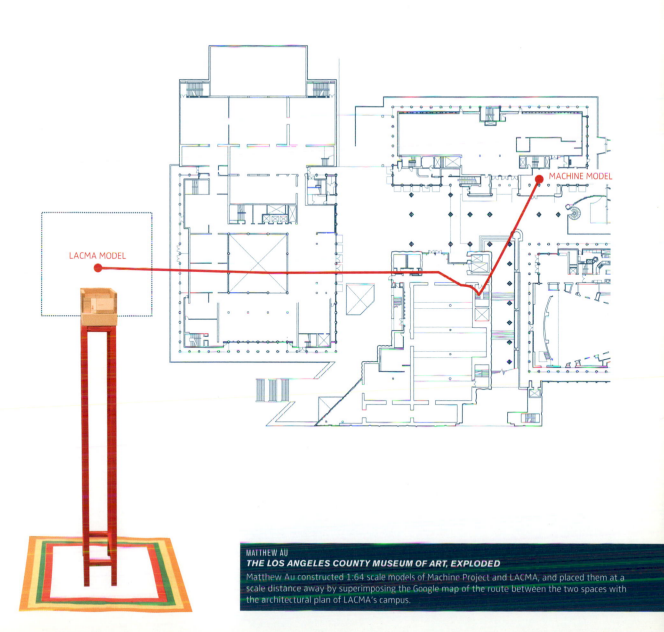

MATTHEW AU

THE LOS ANGELES COUNTY MUSEUM OF ART, EXPLODED

Matthew Au constructed 1:64 scale models of Machine Project and LACMA, and placed them at a scale distance away by superimposing the Google map of the route between the two spaces with the architectural plan of LACMA's campus.

An interview with

NATE PAGE *LIZ GLYNN*

Nate Page created the Mission Control Bunker *for LACMA's BP Grand Entrance, where the activities of the* Field Guide *were centered. The installation was constructed entirely out of excess material from LACMA's storage in the May Company Building.*

Liz Glynn LACMA is an enormous institution that has a tremendous amount of leftover stuff. How did you decide what to use?

Nate Page Usually I live with the objects and space for a while, so this was different. There was a really quick turn-around from the point of first seeing the materials to submitting the proposal, so I actually had to decide pretty quickly. I looked at physical intersections between office storage and exhibition display forms—the way they're both boxy, the way they frame or conceal information—and [thought] about their relationship to the architecture of Renzo Piano's BP [Grand Entrance] and BCAM building.

I was thinking a lot about the vacancies of objects like pedestals and filing cabinets and exploring ways that vacant feeling could develop a voice amongst the architecture. I figured since I didn't know what I wanted to do yet I should just be honest and give Mark a brainstorming sketch, which turned out to be like a sea of wonky mausoleums in the [Grand Entrance] made from old office carpet, pedestals, and supplies.

Liz What happened with the carpet?

Nate I saw tons of old office carpet in storage, about 1800 square feet on seven rolls. It registered a few days later that the carpet was key for the project to make the scale of the space work. I asked, and LACMA said I could have it. Then about two weeks before the show I got a memo that the carpet had disappeared. Each roll weighs like 350 pounds—how does that just disappear? We even started to hunt through the catacombs for them, until it got too creepy. It's a mystery.

Liz What was the strangest thing you saw in the restricted spaces (of LACMA)?

Nate The holes that were kicked through walls right next to the service elevators so the workers didn't have to walk all the way around through the service quarters to get to the main space; they could just go through the hole in the wall.

Liz The items you chose were sort of beat up and damaged, in contrast to the recently completed BCAM building adjacent to the installation. Did you feel like you were exposing the dirty underside of LACMA's polished surfaces?

Nate I wasn't thinking of it that way. It felt more like connecting into the visual language of BCAM and the [Grand Entrance], which already expose their structure and utility in their designs. For example, BCAM has the red I-beams exposed everywhere and the pavilion has gray shipping containers as a ticket booths. I was thinking more about what infrastructure was already represented in the architectural design and expand on it to include administrative forms, such as filing systems and office carpet.

Liz The *Mission Control* area had space for documentation crews, napping, workshops, haircuts, musical performances, Machine Project's information tables, and LACMA's ticket booths. How did you feel about constructing an installation that needed to include all this functionality?

Nate In the past the functionality of the space was put on hold or disrupted to make way for my installations. That negation turned the space into more of a representation to be looked at. With the LACMA project I saw what I did as a moment in the process of a temporary transformation. I moved materials from one place to another, constructed something, others inhabited and altered it through their use, and then it was disassembled and redistributed. I enjoyed conceptualizing it as a fluid process that tapped into an existing mass and created a new temporary flow for it.

Liz Does having worked on the "other side" as a museum preparator influence your approach to the museum?

Nate I do feel like I'm more tuned in to all the dimensions of the institution and I feel very aware of the things going on behind the gallery walls. Sort of like seeing through walls and an inability to just focus on the art. Which made it feel very natural to take on a project like this.

Liz I understand that your grandfather had a lot of influence on your practice. Did his approach to building have any influence on your approach to LACMA?

Nate My grandfather made a living as a sign painter. He built his house and continued to work it like a painting until he was forced to let it go when he was in his eighties. He always used representations and physical space interchangeably. I think from a young age his house fascinated me because of the fluidity of inside and outside, representation and physical space. I learned that you can work space like a drawing or painting and vice-versa.

(TOP) Rendering of office carpet spread across the BP Grand Enterance.

(MIDDLE) Leftover art shipping crates were repainted to match the ticket booth.

(BOTTOM) Nap area adjacent to the BP Grand Entrance.

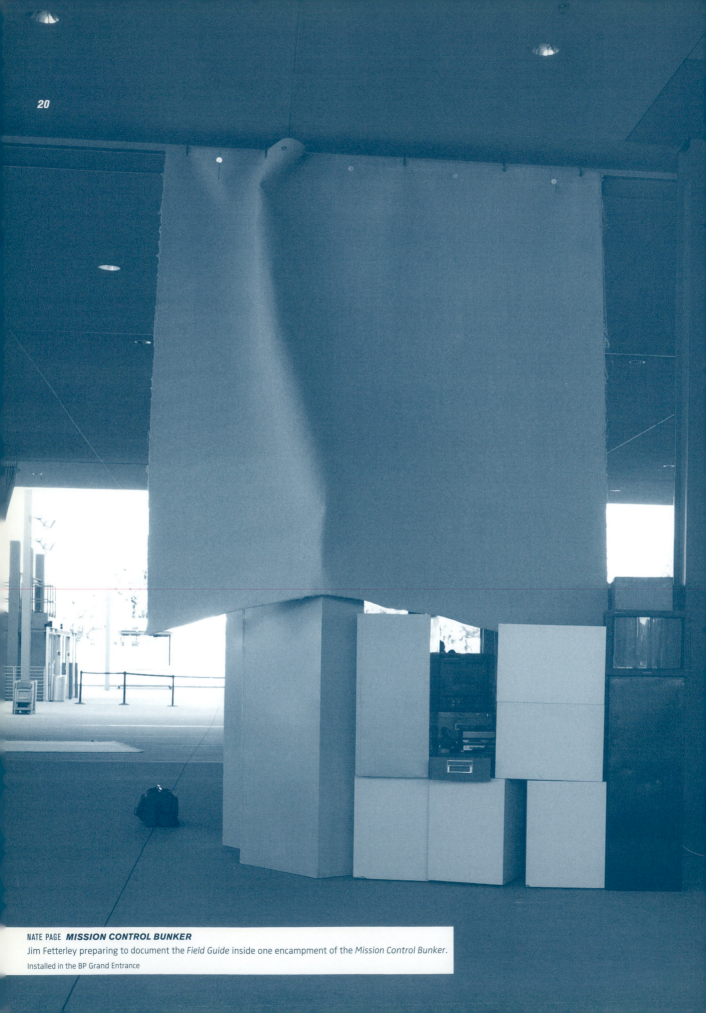

NATE PAGE **MISSION CONTROL BUNKER**

Jim Fetterley preparing to document the *Field Guide* inside one encampment of the *Mission Control Bunker*.

Installed in the BP Grand Entrance

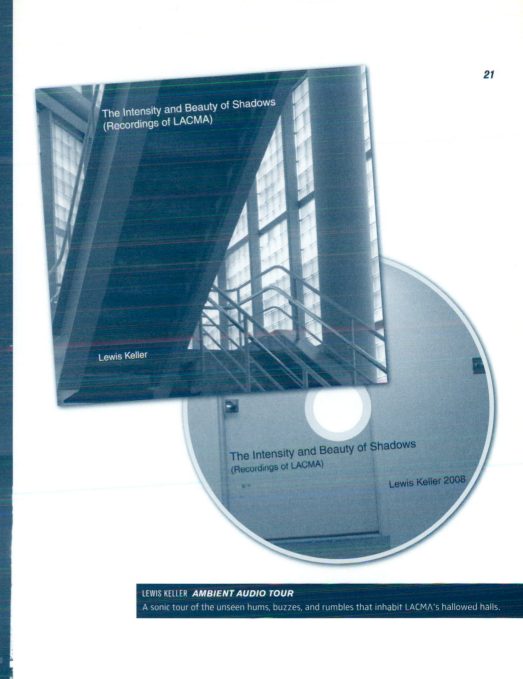

The Intensity and Beauty of Shadows
(Recordings of LACMA)

Lewis Keller

The Intensity and Beauty of Shadows
(Recordings of LACMA)

Lewis Keller 2008

LEWIS KELLER *AMBIENT AUDIO TOUR*
A sonic tour of the unseen hums, buzzes, and rumbles that inhabit LACMA's hallowed halls.

A Transcript of the Tour
LACMA DURING THE PLEISTOCENE EPOCH
ANNE K. O'MALLEY

Annie My name is Annie. I'll be leading this tour today. Thanks for coming on this tour. The title is the "LACMA during the Pleistocene." We will talk about what the Pleistocene epoch is. But presently, let's discuss where we are right this second.

We are in the largest encyclopedic museum in the western United States, like west of Chicago. That means we have a lot of different kinds of stuff here. And so, presently LACMA is undergoing a huge transformation, "transformation" meaning there is kind of a unifying trait to the new buildings being built and trying to unify the whole campus in general. So there is lots of funding being pumped into LACMA right now to dig up the ground….

All right, so let's go this way. Hello. Once upon a time, LACMA was not here. There were lots of different things here in the Pleistocene epoch, which is the period of geological time starting 1.8 million years ago and ending about ten thousand years ago.

Now, as far as geological records go, we break up time into eras and then periods and then epochs. So, when I say the Pleistocene epoch, that's within the Quaternary period, which is within the Cenozoic era. So, the Cenozoic era is where we are right now.

We're also in the Quaternary period, but the Pleistocene is over. The biggest part of the Pleistocene that we want to focus on is the ice age. Now, there have been lots of ice ages over the history of the world, about five that we can really document in the records of rocks. But there have probably been more than that.

The glacial period is an ice age, and they are actually rather brief periods of geological time. The interglacial period is what we're in right now. So, let's look over here….

Woman Can I ask you a question?

Annie Yes, please. This is a conversation.

Woman When did the Pleistocene era end?

Annie Ten thousand years ago.

Woman Okay, so we've been in the same era for ten thousand years?

Annie Yes, we're in the very recent era of the Holocene, which is just a Greek word that means new. "New era" is literally what it means. You're welcome to stand up here. So what do we see? Not a whole lot, right? Underneath where we're looking right now is actually a huge parking garage. Over there is the Broad Contemporary Art Museum, which is great because now LACMA has a lot more contemporary art than we did before.

And over yonder, there's a lot more construction occurring that looks just like some big landing pad for an airplane or something. Why this is of particular interest is that within the last two years of construction, LACMA discovered new deposits of fossils there. Why that's extraordinary is that it's actually relatively hard to come across lots of fossils. You can find marine fossils throughout California, because California used to be completely underwater, but not huge deposits of fossils the way they're found here in these big bricks. We are standing in an area that is extraordinarily rare and significant. And it just happens to be the Miracle Mile along Wilshire Boulevard, but for a long time, none of this was here. This area was part of a huge land grant from the Mexican government called Rancho La Brea. Just a big piece of land that extended about 4500 acres, north from here up to the 101 freeway.... And it was called Rancho La Brea because *la brea* means "the pitch" in Spanish.

What's pitch? Pitch is the stuff you put on your roof. It's tar. Well, it's not actually tar—it's asphalt, which is the result of a natural process of refining crude oil. So when Spaniards and Mexicans came to this area and settled this land, they decided to name this place after that stuff they kept finding [and] also found to be extraordinarily useful. They used it to mend their boats and pitch their roofs. The ownership of Rancho La Brea passed through many people's hands for generations and generations.

When this part of California passed over from the Mexican government to the U.S. government... the Rocha family had ownership. And when it was passed to the U.S., they basically had to buy their land back. In order to afford it, they broke it up into smaller pieces, and this part was bought by John and Henry Hancock. The Hancock family bought about twenty-three acres, and what we know presently as Hancock Park was a part of that exchange. So, let's walk this way....

Crude oil is what we know as fossil fuel and that's where we get our gasoline and our tar and things like that. There are huge deposits of crude oil below where we're standing right now. A million years ago, this area was the floor of an ocean. And about one hundred thousand years ago, the ocean retreated to where the Pacific coastline is today. California basically rose up out of the ocean, and all of these marine fossils that are in Southern California are from an ocean that used to be there....

So think of where we're standing right now as present day, but if we look about thirty feet below us, that's fifty thousand years ago. Geologically, that stratification is relatively easy to understand. That crude oil in the layers below us is the beginning process, the beginning part of asphalt.

Where we're standing also is at the nexus of two major fault lines which is the Newport–Englewood fault line that runs directly into the ocean. And then there is the San Andreas

fault line that runs north–south up through California. It means the ground is broken and it's rumbling and crumbling underneath us. Being broken, you have these huge fissures in the ground that are sucking the oil up like straws to the surface. These fissures tap into the oil and the pressure pulls it up to the surface, where you then have these seeps. There are also lots of gasses associated with the crude oil that eventually evaporate off. And once they evaporate off, you have the leftover byproduct, which is asphalt. The difference between asphalt and tar is that tar is the manmade by-product of refining oil and asphalt is the natural by-product of the natural process of refining oil.

So, all these fossils and all these deposits that we found over yonder are actually prehistoric animals that would get stuck in that really sticky asphalt stuff that came from the crude oil that began millions and millions and millions of years ago as an ancient sea bed…. So with that process, how did animals get stuck in an asphalt soup? We're going to go look at one right there. How do you guys feel about climbing over this? Or we can just walk over here, because there's a couple little spots right there that are magnificent. They are very small seeps, but they are really an ideal way of illustrating how this works.

Okay, this is very exciting. This is an asphalt seep…. This is actually tapping into a big crack in the ground and that crack is pulling up the oil and it comes to the surface and it starts to seep out over the surface. Then heat and evaporation refine it and give us that really sticky black material. That [one is] very small. How could an animal get stuck in that? There's a misinterpretation of these kinds of seeps, the idea that animals would get stuck in the La Brea tar pits.

But this process started about fifty thousand years ago when these asphalts steeps started to form. You have this little seep, about yea big, and it starts to spread out over the ground. You can see that this is starting to spread. One little guy gets stuck in there, maybe. Maybe he gets out. But over time, the seep will continue to spread. And you can see how it kind of forms a mound.

Animals didn't fall into a big watering hole and drown. They just walked upon a mound like this, and it's actually so sticky that the suction itself would stick them to the ground. The seep would spread and spread so eventually some animal would come around and step in it and get stuck. And that animal would be a free meal to a carnivore that came around, and then that carnivore would get stuck. It would cause this chain of entrapments. And that's why there's a huge collection of these different kinds of fossils.

This wasn't a common occurrence. This probably happened every [few] years…. So their bodies get stuck and their bodies eventually settle into the grounds, and gravity kind of takes its course and then sediments and erosion occur…. And then maybe an earthquake comes and rumbles the ground and they get mixed and then another seep just keeps forcing its way up because of the pressure, and it starts it all over again.

So in the end, these seeps that we have sort of form these conical shapes, so it starts like this, but it will eventually spread out and get really big. So we'll have these huge deposits, right? And that's why we have that sort of stratification of animals that died over time, onwards and onwards….

Man Do you know how old this is?

Annie This one?

Man Yeah, when did it start, like a few months ago?

Annie Probably a few months ago, considering that this is here. They don't really work that fast.

Here's another example…. Now we understand how the entrapment works, but how the fossilization works is that this asphalt is actually a prime and beautiful preservative. It has really special qualities that are perfect for preservation. The organic material, be it a tree, a leaf, or an animal getting stuck in there, the asphalt doesn't suck it in. It settles in and basically puts a layer around it, keeping out water and air, which would decompose the material.

We've found such intact fossils that we can tell what disease the animal died of. We can tell where they fractured a bone and if it healed back properly or not. We can tell growth rate just from the teeth of certain animals. We can tell all sorts of things. We found microfossils that have iridescent wings like a beetle. We can see bees. We can see pollen. Why this is relevant is that it actually recreates the ecosystem of the Pleistocene. We can tell what LACMA and what Los Angeles looked like at the end of an ice age…. To be honest, it probably wasn't that much different. It was probably more like San Francisco. There are actually fossils here of certain flora and fauna that you find mostly in the north. You don't really find them down south anymore.

It's really important because it recreates the ecosystem and we can have an understanding of fifty thousand years ago. So, let's go look at the stuff they found. Right now some very nice paleontologists are excavating. I wonder what they're doing….

Woman Hi Annie!

Annie Hi!

Woman How are you doing?

Annie Very well, how are you?

Woman I'm good.

Annie Meet the tour.

Woman Hi, tour.

Man Hi.

Annie So this is basically a big tree box that they've boxed all of the deposits in. When doing construction at LACMA, they came across different spots throughout the area with these fossils. They were naturally concerned that they would find deposits like this, being next to this area. The interesting thing about it is that obviously boundaries and borderlands of museums and county property do not in any way connect to where these seeps are…. There's nothing like this in the rest of the world. That's pretty amazing considering that it's such a metropolitan landscape like this. It's quite exquisite.

So when they came across these, they knew that if they started excavating, they couldn't continue construction of the new building. It would take years and years to do all of the excavation. So what they did is they basically took jack hammers and cut out these big blocks of dirt. And then they enclosed them with these pieces of wood like for tree boxes, then they sat outside for a couple of years….

Eventually, they did find their way over here. So what you see are these deposits of fossils. Now, let's go look. Every single box in there—hello—contains deposits of fossils. Some of them are [denser] than others, naturally. Some we don't know how dense they are, but to date, we've been able to find almost completely articulated skeletons of one of the largest mammoths ever found in this area.

We very rarely come across an articulated skeleton, meaning if I went and dug in the ground, I'm not going to see a saber-toothed cat sprawled out in the ground all in one piece. You would find a skull and then maybe a femur from a different animal, et cetera. It's a big stew. It all mushes together over time, because of the fault lines, because of the oil, because of the process of the tectonics itself.

So it's pretty exciting that there was a huge mammoth underneath LACMA, right? Imagine if we started digging over here and the Page museum came across like a huge deposit of paintings, or huge sculptures? That's what LACMA would feel like. That's their specialty. And that's sort of how this museum felt—it needed to take on this project….

I was talking about the Cenozoic era and the Quaternary period and the Pleistocene epoch. The beginning of the Cenozoic era is when the dinosaurs died. So before even our era stared, sixty-five million years ago, the dinosaurs died. Now because these seeps only formed fifty thousand years ago, the majority of the fossils date to about forty thousand years ago. So we don't find dinosaurs here. These are all ice age mammals.

And they're pretty crazy looking creatures too, let's be honest. There [are] fossils showing us that horses and camels were native to the United States and eventually spread out over ice masses. Columbian mammoths that migrated [north] from South America. No wooly mammoths, there was no ice here. Wooly mammoths were in Siberia and areas like that. But we had American lions. An American lion was larger than any modern-day cat. And a saber-toothed cat, whose closest relative is a modern bobcat….

Now when Rancho La Brea was broken up into Hancock Park, Henry Hancock recognized how important the asphalt was, and he realized he could sell the oil and asphalt. He sold the asphalt for about ten dollars a ton or so. He sold it to San Francisco to pave their streets, and a lot of the old sectors of San Francisco are still paved with asphalt from La Brea.

Eventually in the 1890s a professor from Boston came around, professor William Denton, and walking through this area he

recognized that these bones that they kept coming across while digging the asphalt—those bones are from prehistoric animals. At the time people didn't really understand, hadn't really gone in-depth with classifying some prehistoric animals. The workers in this area didn't really understand what exactly all these bones were. So they just threw them away or burned them. A lot of the bones were burned.

William Denton changed everything around and got a lot of attention on this area. That's when the Natural History Museum was founded in 1913, which used to be the Museum of History, Science, and Art…. In 1915, Hancock realized how valuable the land was and donated it to the county and that's why we have Hancock Park.

And so this area was originally founded to do excavations so once upon a time this whole area was completely open with big holes in the ground where they were excavating, and they found huge deposits across the way. Then in the '60s, [the Museum of History, Science, and Art] became the Natural History Museum and allocated their art collection to the new art museum. So LACMA was founded in that time and built next door to all of these deposits. And still today we find all of these deposits.

Any questions? No? Well, let's keep walking and leave the sun and then we'll walk back that direction.

These sculptures [around the park] are pretty impressive because they're silly. They were made actually in the 1910s and into the 1920s and there's a lot of them throughout the park. And that's because all of these people around the area were like, "What's going on over there? What are those paleontologists doing digging in the ground?" So they hired a sculptor to create these.

That's actually a Harlan's ground sloth. The modern ground sloth—which is not a ground sloth, but a tree sloth in South America—that's its ancestor. Over there is a short-faced bear, which is the largest bear that ever walked the planet, bigger than any other bear that is alive today. It's not taller than a polar bear, but it is big. Very, very big….

Woman I'm assuming where they built LACMA there are also deposits that would become little tiny seeps.

Annie Yes.

Woman So if you build a foundation on top of that, you can keep that from occurring?

Annie No, not really. Well, kind of, but not really. What's kind of interesting is that through this area they discovered over a hundred different sites, these deposits. The Page Museum wasn't built until around '77, so this whole area, including LACMA, used to be open. All this area used to be asphalt deposits and big holes in the ground. After excavating enough, they would try to take out the seep to where it formed originally. That blocks it off and they can take all the fossils out, but that doesn't stop the oil from coming back up….

And this is Pit 91, which is an ongoing excavation which they have been doing since about 1969. But it was started in 1915 and they found something ungodly like eighty thousand fossils in that site alone, so yeah, it's not really stopping and it's going to continue to happen. But you can put something over it.

Woman But it won't like eventually push through the floor of—

Annie No, it's not that strong. I mean, people have complained in the La Brea area, over there where all those little condos and things are. It used to come out through the faucets.

They have better plumbing now, but… oil used to come out through people's front yards and into their plumbing and things like that. You can walk all around Wilshire and you can come across these little seeps.

Man Well, they have to repave Wilshire every two or three years because it comes up right through the ground.

Annie Exactly. It's true. It's not necessarily due to the infrastructure…. It's bizarre that such a metropolitan part of the city was built up around this and that it's next door to an art museum. Just walking along Wilshire you wouldn't expect it. You wouldn't think that this is one of the largest ongoing excavations in the world. But paleontology doesn't get a lot of funding, so they can't really go that far with it. The guys that we saw over there doing the digging, they dig for twelve weeks out of the year because that's what their budget allows for. And every year they come across thousands of fossils. It's just so dense.

And again, why that's extraordinary is that you don't have that landscape anywhere else, and it really gives us an understanding of what drastic changes in climates do. Like with these vicissitudes of the climate, we need to understand why the planet goes through the cycles the way is does. So, it's interesting that LACMA has also provided more insight into that.

All right, well, I would like to thank you for joining me today.

Woman Thanks, Annie.

[Applause]

Annie You're welcome. Let's go back and see some art.

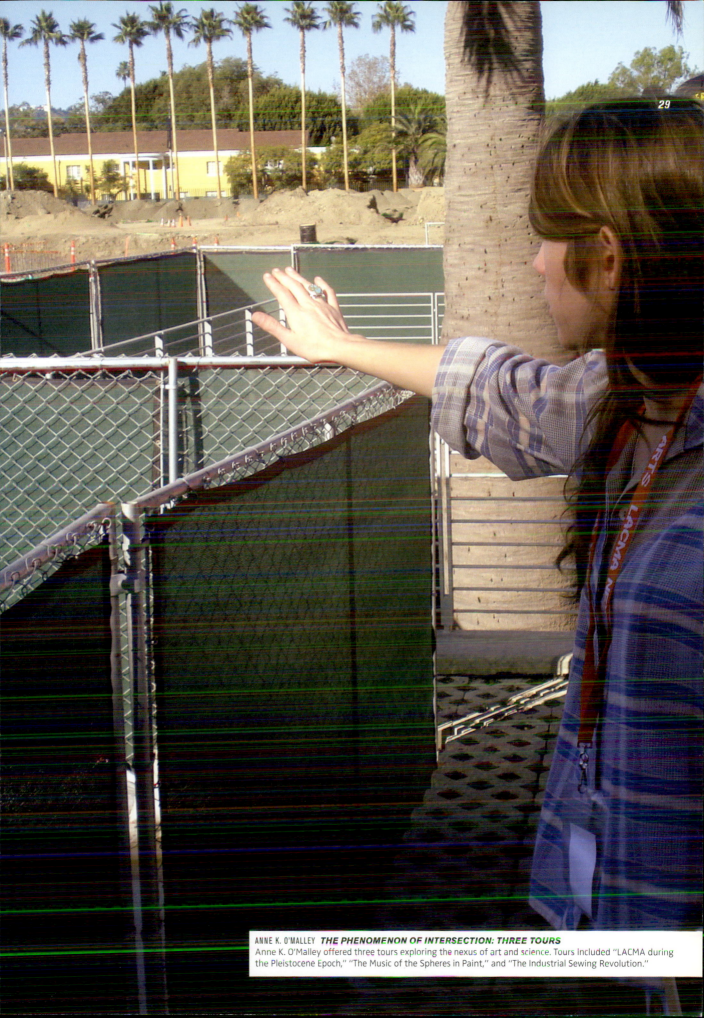

ANNE K. O'MALLEY *THE PHENOMENON OF INTERSECTION: THREE TOURS*
Anne K. O'Malley offered three tours exploring the nexus of art and science. Tours included "LACMA during the Pleistocene Epoch," "The Music of the Spheres in Paint," and "The Industrial Sewing Revolution."

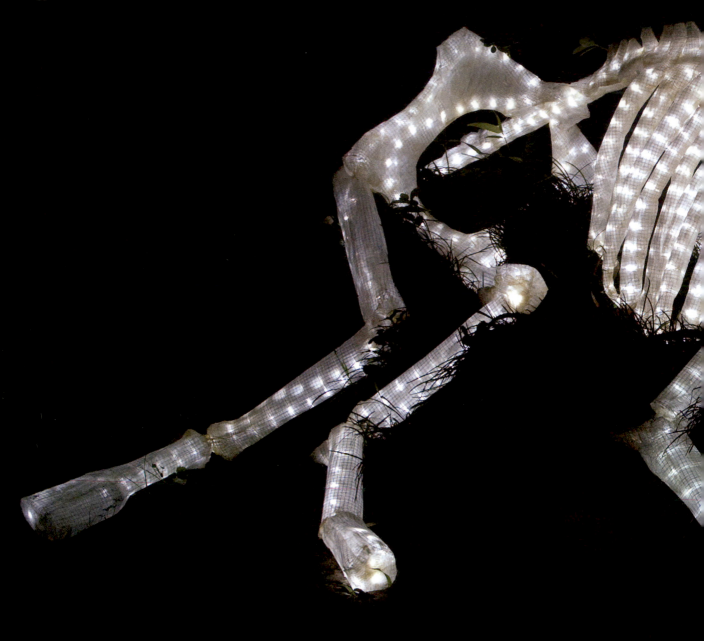

KAREN LOFGREN **BELIEVER**

Installed in the Pavilion for Japanese Art Gardens

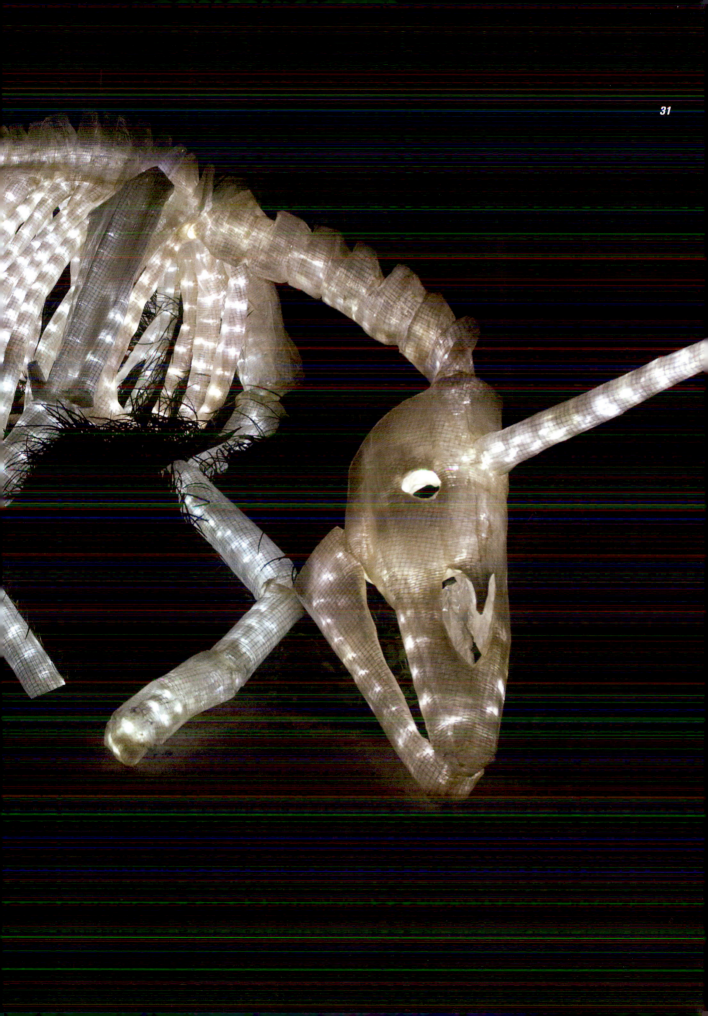

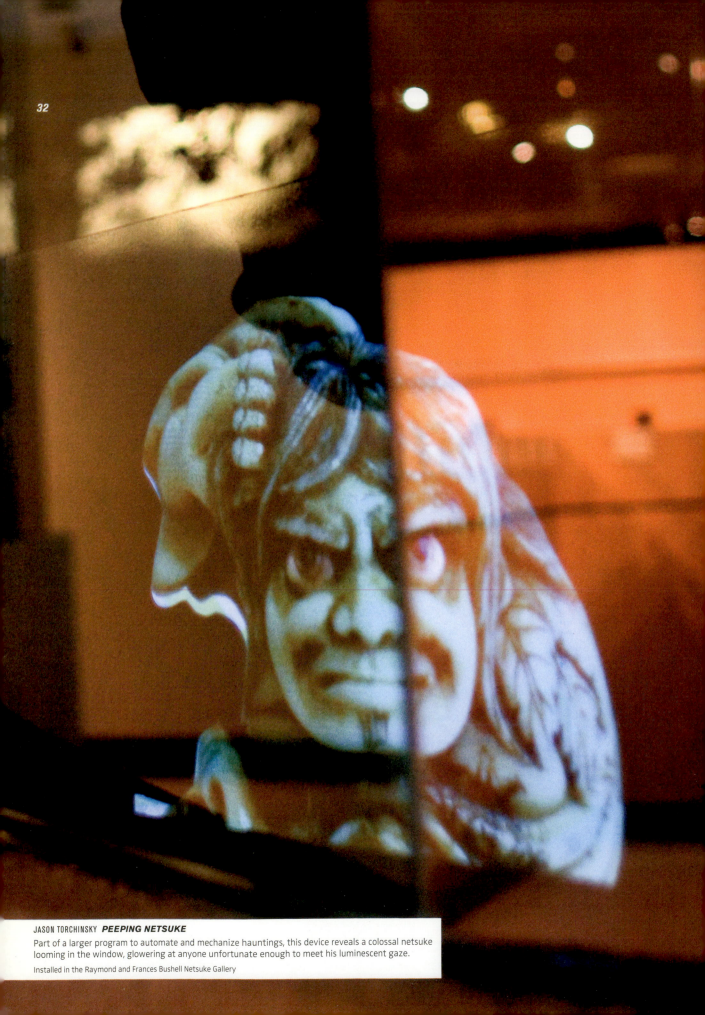

32

JASON TORCHINSKY *PEEPING NETSUKE*

Part of a larger program to automate and mechanize hauntings, this device reveals a colossal netsuke looming in the window, glowering at anyone unfortunate enough to meet his luminescent gaze.

Installed in the Raymond and Frances Bushell Netsuke Gallery

2.

SUNFLOWERS *WALTER KITUNDU*
Mechanical-light-time-lapse-plant-growth-illusion

MATERIALS: Wood, wire, slow-moving motor, elastic, mylar, fishing line, and hot glue.

1.

MAKE NINE CAMS— PULLEY-LIKE CIRCLES

Drill off-center holes in cams.

Pass dowel through cams.

Attach motor to dowel.

Secure the free end of the dowel.

2.

MAKE FRAME

Cut mylar squares.

Use a soldering iron to melt tiny holes in the center of each mylar square.

Span the frame with elastic.

Stick the mylar to the elastic with hot glue.

3.

MAKE LOOPS OF METAL WIRE— ONE FOR EACH CAM

Loop them around each cam—tight enough so they don't fall off, loose enough so they slide.

Add a mini loop to the end of each wire loop.

Tie fishing line to it and pass the other end through the center of a corresponding mylar square.

Tie the fishing line to something like a washer or a toothpick—so it can't pass through the mylar and come loose. Make sure there is enough tension— the elastic will see to that.

4.

FACE IT INTO THE SUN AND TURN ON THE MOTOR

The mylar will be pulled back a distance. The sunlight wil turn into flowers. The timelapse will happen in nearby shade.

WALTER KITUNDU **SUNFLOWERS**
These hand-cranked devices reflect radiant light into curious airborne patterning.
Installed in the BP Grand Entrance

4. (p. 162)

Cursory Notices on the Origin and History of the
GLASS HARMONICA

Excerpt from Charles Ferdinand Pohl,
Cursory Notices of the Origin and History of the Glass Harmonica, 1862

The Press of that time having reported favourably of a new musical instrument composed of glasses, the grandfather of the author of this work was encouraged by his friends to essay his skill in constructing a like instrument. This same Ferdinand Pohl, a simple joiner in Kreibitz, a small town in Bohemia, was ever disposed to fill up his leisure hours with useful and agreeable occupations. Although he had only heard that the instrument in question was of glass, he, by regarding a glass bell similar in form to those placed over clocks to preserve them from dust, was instantly struck with the idea that this would enable him to accomplish his object. He worked now so zealously at his undertaking that he began to neglect his regular business, but at length had the satisfaction to see the first instrument finished by his hands. With great joy he opened the door of the working-room to call for his wife to be witness of his success, when a draught of air closing violently the door, the portrait of St. John, hanging over the instrument, fell and broke it in pieces.

In his despair the unhappy man, in his first excitement, stamped violently on the poor saint, but, blessed by nature with a great deal of perseverance, soon resolved to construct a new instrument, the precursor of a very great number, with which he subsequently visited the Leipsic fair, and which are now dispersed nearly throughout the world.

Notwithstanding the objections made against the instrument, as having a tendency to affect the nerves—indeed, so much so as to cause it to be forbidden in several countries by the police (in the Museum at Salzburg it is still shown to the visitors as such)—its introduction to the public, and its consequent favour could not be prevented; and even the poets of that period sang its praise for its sweet and melting tone, and thus tended to render it popular.

. . . .

The esteemed Fr. Rochlitz, well known by his works on musical theory and criticism, writes, in the musical journal established by him,[1] against the generally adopted opinion of the injurious effect of the Harmonica: "I maintain, from experience, that the effect of its play is as little injurious as that of any other expressive instrument. In the choice of the compositions best adapted for it, one can easily select such pieces as touch the heart and softly animate its feelings. But, be it observed, the Harmonica, like all soft and delicate instruments, should not be too continuously played; like every pleasure of a refined nature that leads the mind to contemplation, if too much enjoyed, it abstracts us from the ordinary enjoyments of social life, and thus may become an evil. Also, we should not indulge in its soft and pleasing tones too much at night. These are the only precautions I deem it necessary to recommend in playing the Harmonica—a precaution which we must exercise in all that excites the feelings in a higher degree, however it may raise, elevate, and refine the taste and sentiment."

1. Leipsic, 1798. Vol. i., page 97.

CITATION: Charles Ferdinand Pohl, *Cursory Notices of the Origin and History of the Glass Harmonica* (London: Petter and Galpin, 1862), pp. 7–9.

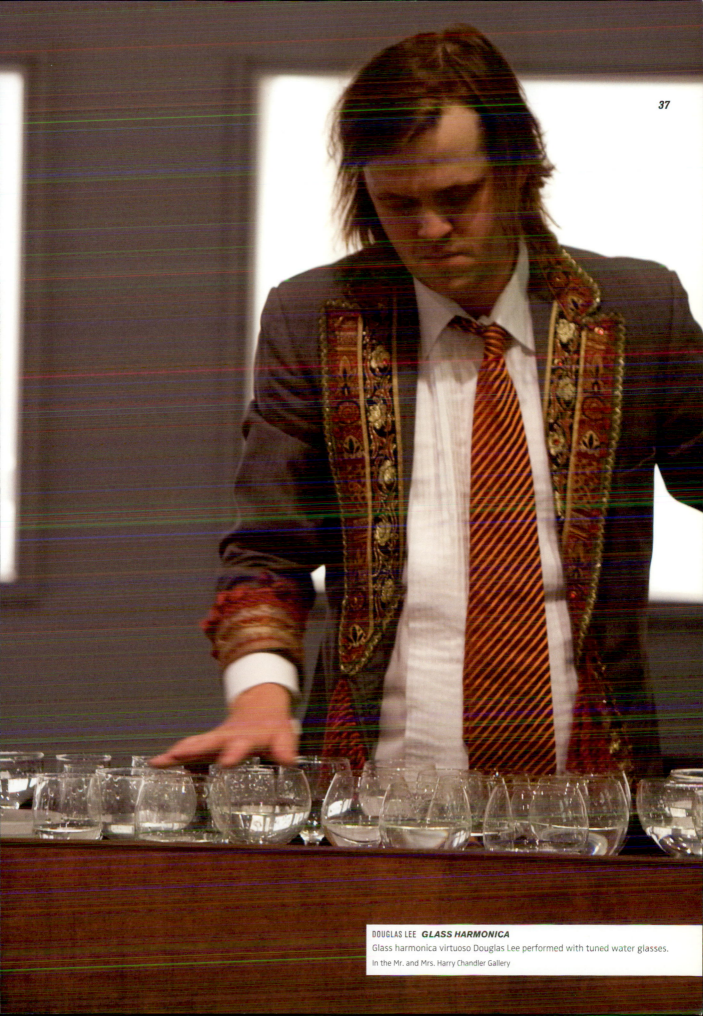

DOUGLAS LEE *GLASS HARMONICA*
Glass harmonica virtuoso Douglas Lee performed with tuned water glasses.
In the Mr. and Mrs. Harry Chandler Gallery

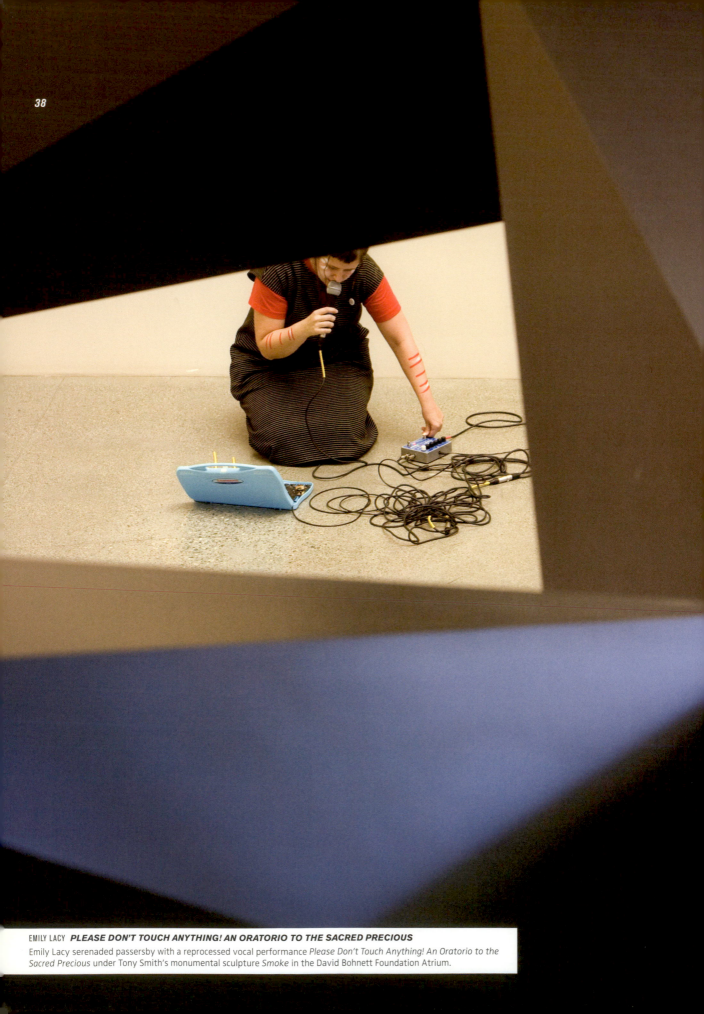

38

EMILY LACY *PLEASE DON'T TOUCH ANYTHING! AN ORATORIO TO THE SACRED PRECIOUS*
Emily Lacy serenaded passersby with a reprocessed vocal performance *Please Don't Touch Anything! An Oratorio to the Sacred Precious* under Tony Smith's monumental sculpture *Smoke* in the David Bohnett Foundation Atrium.

PLEASE DON'T TOUCH ANYTHING!
An Oratorio to the Sacred Precious EMILY LACY

In researching the piece I studied several forms of religious or sacred music. I was exploring the art in the museum as a deified and sacred thing, and the belief that this sanctity barred humans from touching the objects. In exploring the forms of religious music, I became interested in having a fast-paced baroque era chorus gleefully inform visitors that they may not touch the art. I thought this would be humorous and confusing to the passerby. So I started researching the form of things like Handel's *Messiah* and found that oratorio held much credit in its form to opera, but that what differed was the content. Where opera was intended for narratives of history and mythology, with plots depicting human folly, oratorio was distinctly designated by the Church as having only to do with sacred subject matter, in stories from the Bible and the lives of Saints. I found an intense pain in this music when I listened to it in the recorded form. That pain felt like it originated in some great long-lasting repression, of desire perhaps, and I chose to expand my own piece of music for the performance to include a dark sounding beginning section, in a commemoration of this pain. Soon in my development of the piece, "knowledge" came to stand in for what was being testified as sacred—I began to write sections of verse that in order to explain and support "Please don't touch anything" said things like:

> All here is Sacred
> All here is Bound
> All here is Proud
> All here is Found
>
> And it gives you everything
> So don't take it away
>
> It's ours
>
> This tension is ours
> This pride is divine

I tried to fuse the object of the art in the museum, with religious "knowledge" or privilege. I will attach my notes for composing the piece, with full lyrics.

As I studied more sacred music, especially African and Bulgarian choral folk music, I began to like the contrast of the openness and freedom of those forms, their folksy voices, and the greater emphasis on hope that I felt in their recordings. Really what I was attracted to in these other forms, was an emphasis on faith, as opposed to fear, repression, confinement, and pain. So in looking at the whole performance as a cycle, that I would be using the looper pedal for a full hour, I developed the piece into two distinct cycles that challenged each other. Although both would attempt to deify the artwork in a sense I was interested in employing two different styles of sanctity. The second section came to deal with innate knowledge, faith in something being precious because it was here, a part of the universe as opposed to somehow separate, divined from it. So the second section says things like:

> Nobody knows, nobody knows!
> But you have dreamed it!
> You have dreamed all this before!
> YOU DON'T KNOW WHERE YOU ARE,
> BUT YOU ARE HERE.
> You dream and it's here
> Stamp out the fears, the devils, you are strong
> You will rise with your family
> You are free
> You will return to the Earth as you have come.

I became interested in the tension of these two forms and how I could exhibit the different styles through performance and approach/address the Smith sculpture within them.

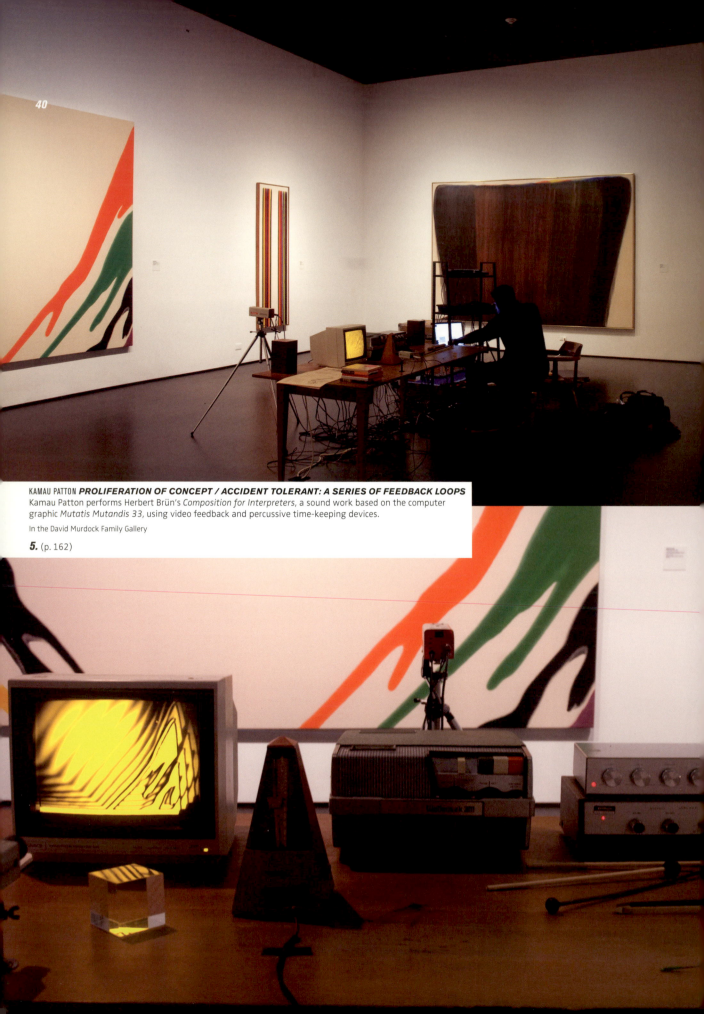

KAMAU PATTON *PROLIFERATION OF CONCEPT / ACCIDENT TOLERANT: A SERIES OF FEEDBACK LOOPS*
Kamau Patton performs Herbert Brün's *Composition for Interpreters*, a sound work based on the computer graphic *Mutatis Mutandis 33*, using video feedback and percussive time-keeping devices.

In the David Murdock Family Gallery

5. (p. 162)

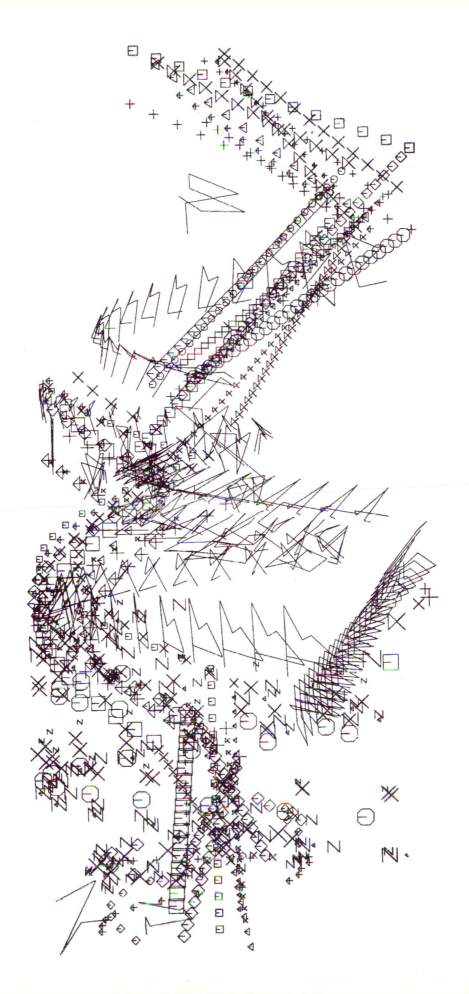

HERBERT BRÜN **COMPOSITION FOR INTERPRETERS, 1968/75**
Mutatis Mutandis 3½, composed by Herbert Brün, 1968. Ink graphic drawn by plotter under control of computer program. Proliferation of Concept/Accident Tolerent is a Sculptural/ Musical analogy to the composed process of Brün's graphic.

Proliferation of Concept / Accident Tolerant:
A SERIES OF FEEDBACK LOOPS *KAMAU PATTON*

In *Proliferation of Concept / Accident Tolerant: A Series of Feedback Loops*, Kamau Patton interpreted Herbert Brün's 1968/75 composition *Composition for Interpreters*, a sound work based on the computer graphic *Mutatis Mutandis 33* (pictured on previous page). Patton's performance employed video feedback and percussive time-keeping devices. What follows is Herbert Brün's description of the conditions for interpretation excerpted from the liner notes of a recording made by Allan Otte and Garry Kvistad.

COMPOSITION FOR INTERPRETERS

Mutatis Mutandis, compositions for interpreters, are ink graphics drawn by a plotter under control of a computer programmed by the composer. *Mutatis Mutandis* are not to be treated as scores, (i.e.) as sets of instructions which, if obeyed, would lead a performer to "execute" their shapes, symbols, and configurations at they follow one another, according to his reading habit, on the page. The interpreter is not asked to reconstruct my computer program, the structured process that actually generated the graphics. Rather, he is asked to construct the structured process by which he would have liked to have generated the graphics. Finally, he should compose a working model (a score?) of this structure in and for the medium of his choice, be it sound, movement, language, film, etc., and then perform it.

The Interpreter is not asked to improvise.
The Interpreter is asked not to improvise.
He is asked to compose.

–*Herbert Brün, (1968/75)*

"One of Brün's major concerns with his computer graphic compositions is collective input: his, plus that of an interpreter. A collaborative realization seemed a positive extension of that concept." —Allen Otte

From *Mutatis Mutandis*, by Herbert Brün. © Smith Publications, 2617 Gwynndale Ave., Baltimore, MD 21207. Used by permission.

FOL CHEN *LIZ GLYNN*

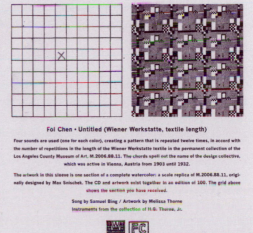

Fol Chen • Untitled (Wiener Werkstatte, textile length)

Four sounds are used (one for each color), creating a pattern that is repeated twelve times, in accord with the number of repetitions in the length of the Wiener Werkstatte textile in the permanent collection of the Los Angeles County Museum of Art, M.2006.88.11. The chords spell out the name of the design collective, which was active in Vienna, Austria from 1903 until 1932.

The artwork in this sleeve is one section of a complete watercolor: a scale replica of M.2006.88.11, originally designed by Max Snischek. The CD and artwork exist together in an edition of 100. The grid above shows the section you have received.

Song by Samuel Bing / Artwork by Melissa Thorne
Instruments from the collection of H.G. Thorne, Jr.

FOL CHEN *UNTITLED (WIENER WERKSTÄTTE, TEXTILE LENGTH) CD*
The band Fol Chen makes the connection between pattern and song explicit in this aural interpretation of a Wiener Werkstätte textile.

Liz Glynn Could you tell me about the bridging between high and low cultures embodied by the Wiener Werkstätte?

Melissa Thorne The Wiener Werkstätte ethos was more high culture than low. The idea was to make high-quality decorative objects/materials, with an emphasis on the handmade. So, Wiener Werkstätte furniture and textiles were of extremely high quality, with great attention paid to craftsmanship. In fact, this level of craftsmanship led to their designs being extremely costly—as a collective, they were more concerned with maintaining that level of quality, so their work was really only available for elite collectors.

However, in a museum context, decorative arts and crafts are on the "low" end of the art spectrum, in comparison to non-applied arts like painting or sculpture. As a painter, I'm always interested in the ways that different sectors of culture borrow and steal from each other. For us, it was interesting to take a design resource (which was probably initially produced as a painted mock-up), turn it into a painting, and then cut up the painting to make a new design object (the CD). It was like going full-circle.

Liz How do the handmade instruments fit in to those ideas?

Melissa We wanted to mimic the Wiener Werkstätte devotion to handcraft as much as possible. The instruments are handmade, mostly from wood, and use the same types of joinery and construction as furniture—we thought this was a good parallel with the handmade construction of WW designs.

Liz Melissa, you mentioned using instruments that your grandfather had made. What were they? Did he make them as a hobby, or a trade?

Melissa My grandfather is a lifelong woodworker. Although he no longer practices, he built fine furniture, cabinetry, and even his house. His craftsmanship was influenced by the Arts and

Crafts ethos, and his design sense matured during the period most people now refer to as mid-century modern. Technically, this work was a hobby, since he didn't pursue it commercially, but it is probably more accurate to call his woodwork a serious artistic practice, since he approached it with critical intention, a developed technical background, and original designs. The handmade instruments in his collection were either made by him, or purchased by him during travel.

Liz Could you explain the process of using a textile pattern as a musical score?

Samuel Bing We were working from the premise that music and textiles both utilize pattern, texture and repetition. A basic example of translating a textile pattern into music would be interpreting a black-and-white checkerboard pattern as a "four on the floor" House beat, assuming you assigned a kick drum sound to the black squares and silence to the white squares. Since the WW piece we chose was more complex than a checkerboard, we took into account color and surface area in assigning sounds and determining the length of each sound.

Liz Was there anything significant about the recording technique: digital versus analog, for example?

Samuel We recorded digitally, but since the pattern has an imperfect, handmade quality, we re-recorded the sounds onto a handheld tape recorder. When played back, it drifts out of sync with the digital recording. We thought that was analogous to the way the printing techniques used by the Wiener Werkstätte were slightly off-register.

Liz This one might be a reach, but are there any parallels between some of the do-it-yourself workshops Machine offers and the ethics of the Wiener Werkstätte? If it's an obvious no, forgive me for being daft here.

Melissa I think the WW ethos and the Machine ethos may be opposed. For instance, Machine makes technology available and accessible to artists, because it's assumed that there's a scarcity of knowledge. During the Wiener Werkstätte era, manufacturing technology was becoming widespread for use in furniture. The WW designers were really working against technology, trying to preserve building and finishing techniques that were becoming either obsolete or prohibitively expensive.

However, this is parallel to certain types of activities that Machine promotes, for instance, jam-making, pie-baking, sewing. These are activities that emphasize skills that are becoming lost in contemporary lifestyles. Additionally, our own production of the CD edition is related to a DIY aesthetic, since we literally did all aspects of the production ourselves. And, obviously, we were able to do so because of technology: digital recording makes it possible for anyone to produce their own music, and Machine teaches courses that facilitate different aspects of digital sound manipulation. In this regard I think our edition is a conceptual bridge between WW and Machine.

Liz You decided to cut up the copy painting of the textile to cover the CDs. Any thoughts on mass distribution of the handmade?

Samuel To me, it seems like something that's far more common in music than art right now, where anything, cough, handmade, is hundreds if not thousands of dollars.

Melissa We tried to make something that could hover between being "mass-distributed" and fine art. There are one hundred in the edition, but they're each unique, and the level of craftsmanship in both the recording and the packaging is extremely high. Often limited edition music posters are hand-screenprinted, but that's still reproducible.

Liz Do you have any thoughts about how music functioned in the museum during the show?

Melissa It was much more central to the experience than we expected: we actually thought the live musical performances in LACMA were the most powerful component of the day, since they transformed individual spaces so immediately.

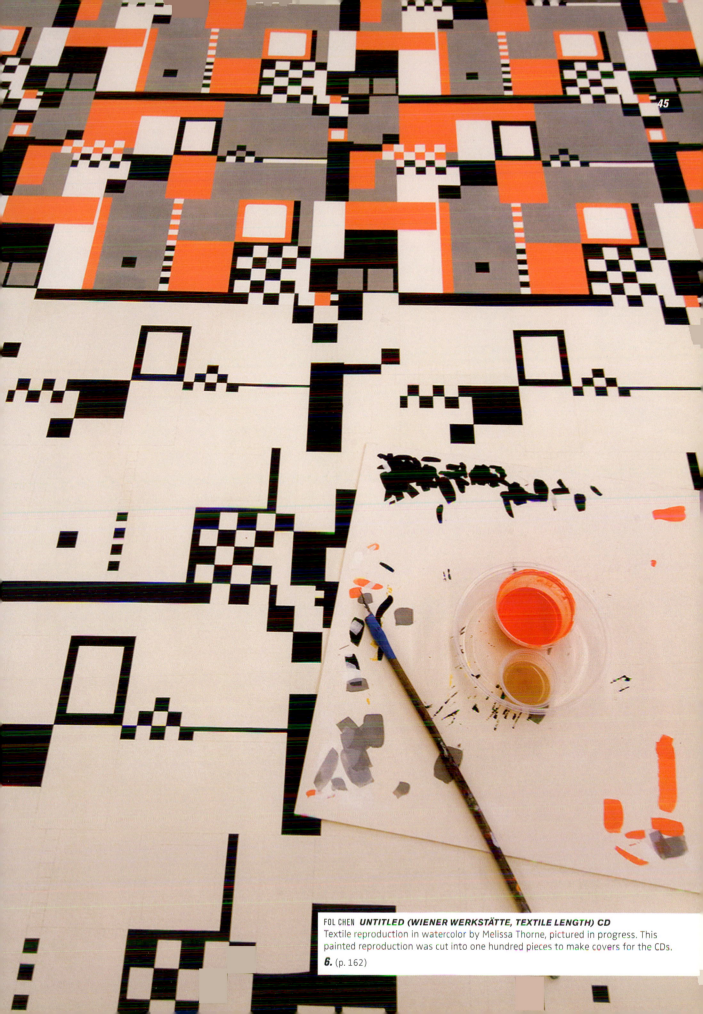

FOL CHEN *UNTITLED (WIENER WERKSTÄTTE, TEXTILE LENGTH) CD*
Textile reproduction in watercolor by Melissa Thorne, pictured in progress. This
painted reproduction was cut into one hundred pieces to make covers for the CDs.
6. (p. 162)

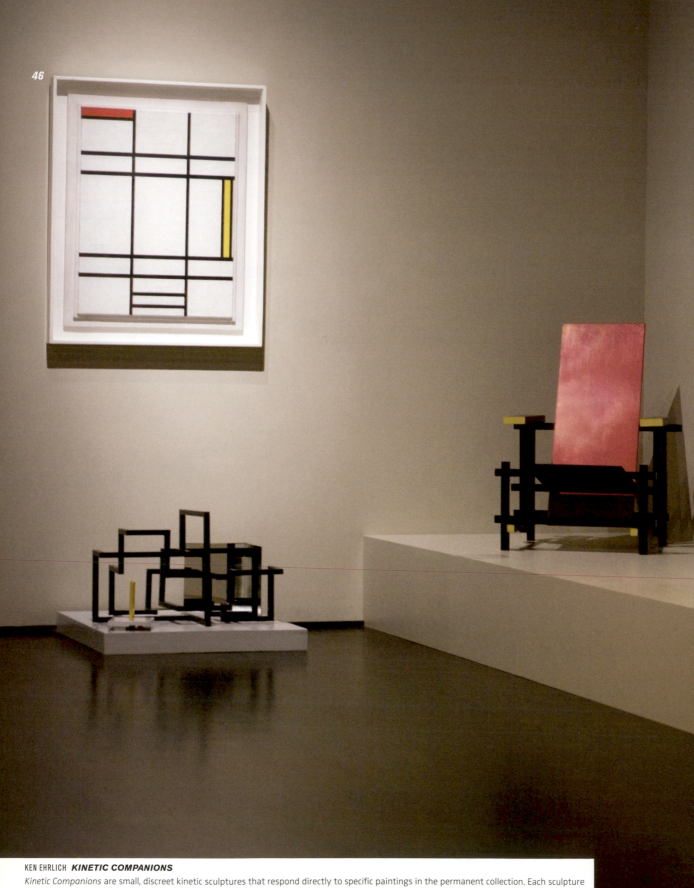

KEN EHRLICH *KINETIC COMPANIONS*

Kinetic Companions are small, discreet kinetic sculptures that respond directly to specific paintings in the permanent collection. Each sculpture acts like an interpretive machine, playfully foregrounding the relationship between two and three-dimensional systems of representation.

(LEFT) *Kinetic Companion: Mondrian Responds to* Composition in White, Red, and Yellow, 1936. In the Rosalinde and Arthur Gilbert Gallery
(RIGHT) *Kinetic Companion: El Lissitzky Responds to* Proun 3A, 1920. In the Modern and Contemporary Art Council Gallery

8. (p. 162)

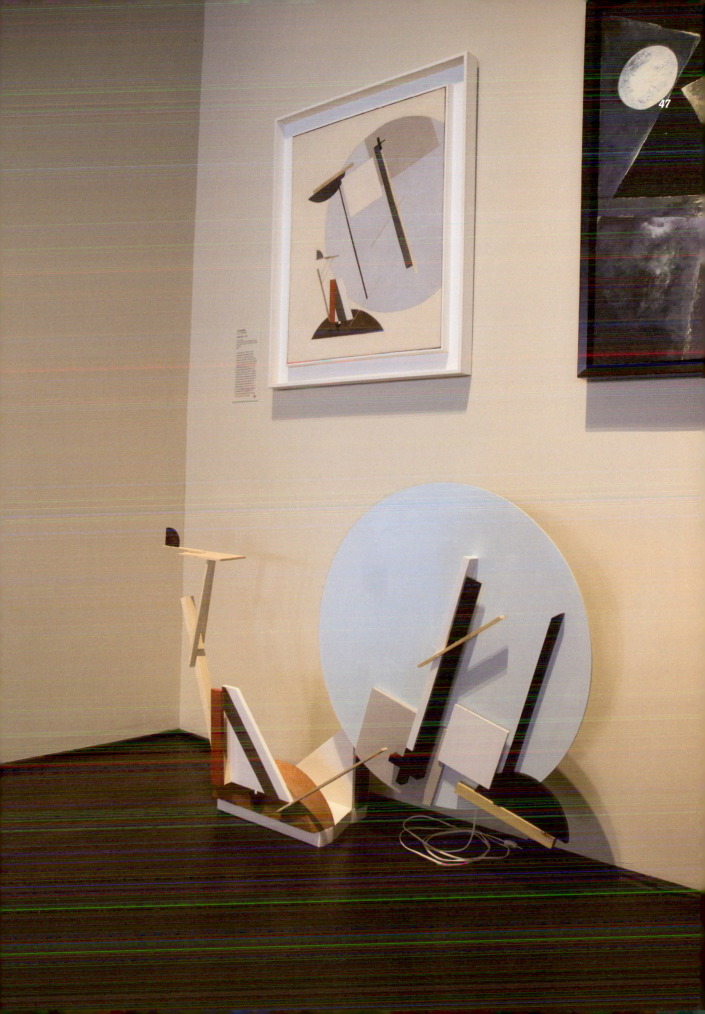

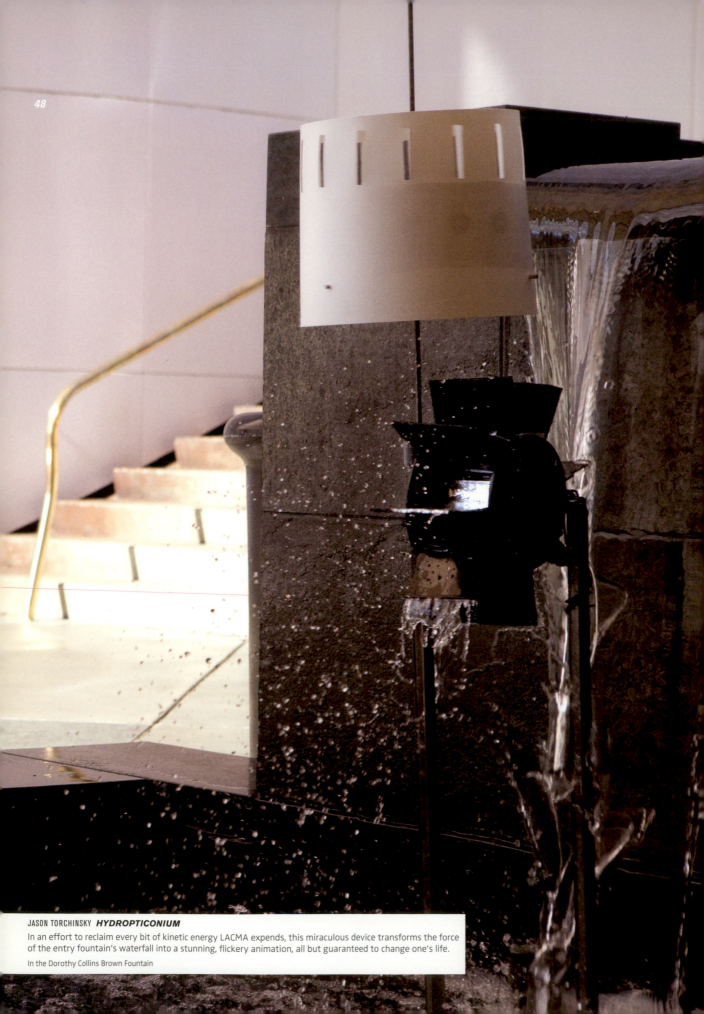

JASON TORCHINSKY *HYDROPTICONIUM*

In an effort to reclaim every bit of kinetic energy LACMA expends, this miraculous device transforms the force of the entry fountain's waterfall into a stunning, flickery animation, all but guaranteed to change one's life.

In the Dorothy Collins Brown Fountain

HYDROPTICONIUM *JASON TORCHINSKY*
Breath-powered make-your-own flimsy version

zoetrope drum

wheel sides

wheel flaps (don't fold down the tabs with dots)

BLOW HERE

wheel sides connecting struts

right leg

left leg

shaft support

wheel axle

toothpick

base

gear p.1

gear p.2

shaft hole

right

left

front

shaft

toothpick hole

MICROPHONE
INPUT

LOOPING PHONEME SEQUENCE
FROM URSONATE SCORE:
OUTPUTS PHONEME GROUP
NUMBER AND DURATION

AMPLITUDE
DETECTION

LOUDER THAN
SILENCE
THRESHOLD?

YES

*Write input from microphone to
current record buffer position.*

DANIEL RICHERT / MATHEW TIMMONS **URSONOUS DISRUPTIONS**

Using Kurt Schwitters's score *Ursonate* as a guide, prerecorded performances are mixed
with user-generated audio and played back according to the poem's phonetic structure.

Installed in the Mr. and Mrs. Edwin M. Pauley Gallery

TRIGGER
"COIN TOSS"

HEADS
OR
TAILS?

HEADS

TAILS

PRE-RECORDED
PHONEME DATABASE

Play a randomly selected phoneme from the phoneme group specified by the phoneme sequence, sped up or slowed down so that its playback time is the same as the corresponding duration parameter received from the phoneme sequence.

10-SECOND LOOPING
RECORD BUFFER

Play a segment from the record buffer for the duration specified by the phoneme sequence.

SPEAKER
OUTPUT

MICHAEL DERAGON, CARMINA ESCOBAR, AND JEWL MOSTELLER **BARBERSHOP HUM QUARTET**
Overtone singers harmonized wordlessly with the flickering lights, hidden fans, and LACMA's electrical current.

3.

A Conversation between

MARK ALLEN AND ANTHONY McCANN

Anthony McCann So the first thing I wanted to talk about is how you feel when people ask when you are going to be doing the LACMA show again.

Mark Allen It makes me sad!

Anthony Why does it make you feel sad?

Mark Well, I think some of it is all the emotional energy that was put into something that big. It's like being at the reception for your wedding and somebody saying, "Oh, that was fun. Can we do that again next weekend?" But I think also the show required the element of surprise; it has to do with the museum operating differently in a way that's not the normal operation of the museum.

Anthony Well, if you know what's going to happen, it tames it. Not that the effect of the *Field Guide* was a savage confrontation or anything, but something new burst out of the site. Once that's happened and you're doing it again, you're making something orthodox out of it.

Mark Yeah; we had talked about the idea of a festival. That the festival is something which exists outside of daily life…. What's the function, anthropologically, of the idea of the festival?

Anthony I suppose there's one sort of idea that would have it sustaining the everyday order by providing a release valve, but that kind of functioning for the Machine LACMA show would suggest doing it again and again, so I think it has a different kind of function. It's not there to help solidify the order of being or whatever the museum represents.

Mark I think about that in terms of my own relationship to the museum. Once I started this project my use of the museum shifted so radically. I'm not there to look at the art as much as I'm there to dig for opportunities to intervene. The museum becomes the studio.

Anthony We would like to imagine that something has changed, and that now people who came that day will look at museums differently and imagine interacting in different ways with the museum on their own. But we can't say that that necessarily happens, obviously.

Mark That's interesting, though. The idea is that you can suggest that possibility. What was odd about it was that everyone had a different experience, but everybody kind of had the same emotional experience. Like the tone of it was very even, in a sense. It was much less about the audience kind of being staggered by the brilliance of the presentation as much as there being a sense that it's something everyone did together.

Anthony Something I know from talking to you is that a critique of museums as such was not necessarily of interest. But the way that the show functioned rose out of some

of the dilemmas that museums have, like what doesn't happen there.

55

Mark I think there was the desire to present experiential work in a way that more formal situations don't allow. Almost all the pieces at the LACMA show really were engineered to take place in the space of the audience. So it's not about replacing the paintings in the museum with the performance; it's that we interject the performers in to the space that the audience occupies.

Anthony Do you want to talk about that in relation to some specific things in the museum?

Mark Something that I was thinking about was wanting to use the museum as a civic space, like a park. In a park you have all this territory which can be used by whoever shows up. The uses of the park aren't particularly clearly defined.

I thought it was kind of liberating in the LACMA show to use the spaces like hallways or elevators which might have been sites of non-meaning. Areas that are just used to transport someone to another place. By activating all those as aesthetic spaces I felt like it induced a giddy uncertainty of where the aesthetic experience is located.

Anthony A space like an elevator is also a space that is so interstitial that it's not even part of your day.

Mark Yeah; it's a non-space. When you're in the elevator you make an agreement with everyone else in the elevator that you're not there. If you greet someone in the elevator it's traumatic or you are some kind of hick; it's like you didn't understand the deal of the elevator that we're not here.

Anthony You're in a cartoon straw hat with a piece of grass in your mouth!

Mark Is that how human beings deal? If you and I are in an embarrassing situation, the way that we deal with it is we both mutually agree that it's not happening, right? What was so fun about the elevator performances is that they were the opposite of that.

Anthony Everyone was very much pressed up against each other and very much all together agreeing that this was happening. *[Laughter]*

Mark They didn't want to experience the elevator as a performance. They wanted to be in that performance. In some cases it was hilarious because when the Revolutionary War fife and drum corps—Jackson [Fledermaus], Jade [Thacker], and John [Barlog]—came to rehearse, they were so loud that I was like there's no way we can have them each in their own elevator. I'm thinking about all these poor people coming to the museum and they just want to ride the elevator, they don't want to have somebody drumming in their ear. But when we came to the day of the event, there was no room because everyone just jammed into that one elevator. The other two elevators would open and no one would get in them.

This other behavior that I noticed, which I thought was just so fantastic, is the two things people did when the elevator opened was they rushed in and they plugged their fingers in their ears. *[Laughter]* Which I thought was just so funny.

Anthony That's great. So it became like an "ow, it hurts, do it again."

Mark The other really loud piece was the *Gothic Arch Speed Metal*. There's this Gothic arch in the museum. Looking at it I started thinking about the kind of Nordic Scandinavian death metal where there's the white face make-up and the symbology

is so intense. We had this vision of sticking the metal guitarist in this arch and they would just play. In the beginning that piece was all about how it looked. I wasn't thinking about the sound of it at all.

We went back and forth with the curator of that area. Turns out they didn't really want to have the guitarist in front of the arch. This was different than most of the proposed projects in the show, where the concerns which came up were pretty much logistical. But there were a few pieces like the arch where it became clear after you worked through all the logistical problems…

Anthony You find out underneath that they were just…

Mark It's actually they just don't like the idea.

Anthony It was the content. This was the curator who said that it was stupid. *[Laughter]*

Mark That was really, really great actually to hear, because to me, what's more valid than that? It's like, you think our idea is stupid, and I'm not going to try and make you do something you hate. The whole show was really never about being antagonistic towards the museum.

So finally Charlotte was like, "This piece, this is not going to happen. You can find a dwarf guitarist that plays really quietly. It's still not going to happen. You can make like a six-inch animatronic goth metal guitarist. It's not going to happen."

So, Christy McCaffrey and Sara Newey, who I'd known for years—I was walking back to my apartment and I just realized those two can make anything. Anything.

Anthony Recently they made a forest.

Mark Yeah. Every Halloween they have these epic Halloween parties where they completely transform their environment. They're kind of into metal and geniuses at set design, so they seemed really perfect for it. I had talked to both Christy and Sara about doing something for LACMA, but we hadn't thought of something until this came up.

I called Christy up and I said, "I now have the perfect idea for you guys." They were really into it. So they carved it out of foam in two days and painted it. We staged it out on this balcony on the edge of the Art of the Americas building.

Anthony And it's a big weird porch that's totally un-utilized. Actually it seems like nobody's ever allowed to go out on it.

Mark I think it used to be a sculpture patio. They had one sculpture. I think it's even labeled. I'll have to check this, but it's the Director's Patio or something. You can see it from inside the museum in the American Crafts section, but there's a door and it's locked. And if you try and go up to the door, the guards say, "That's locked."

Anthony That's one of those great doors that exist for people to tell you not to open it.

Mark Yeah, exactly. I realized you actually can get up there by a stairwell, which is really hard to find. So you don't even have to go into the building to go up there. So we staged it up there.

Then probably about a week before the show we started auditioning people to be the metal guitarist for it. I got one kid, Alexy Yeghikian, who was in a metal band, a

guitar virtuoso from Cal Arts. Then the other guy, Mark Richards, we found from our Craigslist ad, and he sent me a video of himself rockin' out.

So for one minute every hour they would just play incredibly loud. It was so fun because you could hear it around the entire museum. People would rush away from whatever thing they were looking at to catch it.

Anthony It became like the village clock. So when you would be listening to somebody sing or looking at somebody doing something, you were seeing it with a small group of people, but when the guitar went off you would become aware of how many other people were at the museum and that you were doing this thing together.

Mark Yeah, so that was really satisfying. It's like acknowledging both the private and public aspect of being a person in a city, or being in a community.

Anthony Or that a whole public scene is constellated by the intersection of a bunch of subjectivities. Then the clock tower was a locking together of those subjectivities for a moment.

Mark It's the opposite of "let's observe a moment of silence" at the beginning of the school day, but it serves the same function in a way.

Maybe they should do that in school. "We will now observe a minute of—"

Anthony Noise.

Mark "Death metal." *[Laughter]* We'll try that at my school.

Anthony It was oddly hot that day, too. That was the day of the Sylmar fire.

Mark Some of the performances didn't happen because we had so many people coming from Cal Arts, and the fires closed parts of the freeway north of LACMA.

Anthony Or they did get down. But they got there late and just spontaneously started doing performances in the bathrooms and stuff. Like the opera singers did that.

Mark The guards kind of gave up on trying to determine what was or wasn't allowed behavior.

Anthony I'm sure it became hard for them. The normal functioning system of rules of a museum had been suspended, but only partially suspended. It seemed like some of them decided that they were just going to have to trust everybody not to put their face through a painting, which contributed to the feeling that the law had been suspended.

Mark One of my biggest anxieties about it was that the guards would be—

Anthony Freaked out?

Mark Freaked out in trying to manage what was happening. I think they ended up just deciding it's all going to be okay. I had a dream the night before the show. Did I tell you this? That I came to the museum and there were all these sort of super hipstery style L.A. kids who were painting over the paintings. *[Laughter]*

Anthony This is before?

Mark This is the night before. Charlotte was like, "I trusted you with my museum!"

But the main content of the dream wasn't this. This was the lead-up. The substance of the dream was me making phone calls trying to find a conservator who could come in and fix the paintings. I remembered our friend Allison Miller, who is a painter, used to work as a conservator. I remember in my dream trying to get hold of her. Phone kept ringing. Like, "Has anybody seen Allison? I need to talk to her before LACMA finds out…" The show seemed very blessed in the way that nothing disastrous happened.

Anthony I felt like you could do whatever you wanted there, but it didn't instill the desire to do something that would cause problems.

Mark Yeah; people played well. Maybe in the same way that you seldom see people chopping trees down in a public park.

Anthony Though it might occur to people if you put up a sign that said, "Don't cut down these trees."

Mark Do you think we could talk about what the process was like for the artists? I've been thinking about how comfortable collaboration is for musicians and how antithetical in some ways that is for writers, for artists.

Anthony Musicians clearly are people who need to be in communion with each other in order to do what they do. They don't want to only play solos all the time. It's part of what makes them who they are, that drive towards togetherness. With other art forms often it's a drive towards solitude that motivates or precedes the practice.

Mark Increasingly that's one of the most interesting things about the way Machine's evolved, as this mechanism to facilitate collaborations between people who might not be collaborating otherwise.

Like the murder mystery. I had seen Dawn do these live dead performances. When we were invited to the show that was one of the first artists I thought of—"I want to have Dawn Kasper impaled on a sculpture." And I knew that I wanted to do a piece with Jessica Hutchins because I loved her writing. I just sort of decided, "You two are going to be great together; you guys figure this out."

Anthony And that ended up working.

Mark And that worked great. The LACMA show was really about bringing artists together to wander around the museum and try and come up with ideas. We didn't even know who would make the piece in a lot of cases. The arch or the elevator were ideas that emerged out of the collective brainstorm and these ideas were orphans, in that they had no author particularly attached to them. Then the author becomes Machine Project.

Anthony The people who came to see the show are part of what happened, too. What they did with it, from people sneaking their replicas into the antiquities room, or finding places in the gallery to practice with their synthesizers, to the way people interacted with us on the phone. And things I didn't expect; how many people would hang out and watch other people being read poems on the phone, for example.

Mark I loved how we had that setup for people soldering together those little audio synthesizers. One thing I didn't anticipate at all was how everyone who made one of those would then wander around the museum and play them. It became this backdrop that was happening through the whole museum.

Anthony I was talking to you today about another instance where a curator saying no yielded something interesting to think about, but in this case they actually said no and shut down the project. The Jesus singing thing.

Mark That was one of the projects I thought was so innocuous.

Anthony It was very, very interesting the wrath it raised.

Mark Yeah; the brief of it was that Emily Lacy would park herself in front of the most gnarly of—

Anthony I think it was the *Mocking of Christ*.

Mark Yeah, and she would sing religious songs from the '70s which were very gentle. This was one of these projects where it's like—well there can't be any possible problem with this. It's just someone singing in the museum, but the curator of that department—I became very interested in this and I wish we had interviewed him— he was dead set on not allowing that to happen. We couldn't figure out why. Finally we heard it was because these paintings were not religious objects and that it was important that they weren't contextualized as such. This was a painting of—

Anthony Of Jesus, I believe with the crown of thorns on already and bleeding.

Mark Yeah; and it's interesting because in the museum of course it's not a religious object. It's a cultural artifact or an aesthetic object. And what's fascinating about that objection is it presumes that the art is very fragile—that its meaning is very fragile, and that if you disrupt the fragility of that meaning then something untoward happens to it.

Anthony Right; that somehow Emily singing a Jesus song will make people realize oh, that's Jesus, and it won't be art anymore. Its value will disappear and it will just become a utilitarian worship accessory or something.

We don't know this person, but you can imagine the curator experiencing this as their role: to protect this art from people who want to turn it into a sacred object, which ironically is something he sees as profane.

But the art in the painting is in the intersection of the two. I was thinking of it in terms of another Jesus painting that I love—Caravaggio's *The Supper at Emmaus*. If you think of the standard way a Caravaggio painting is talked about in traditional art history, it does try to push the religious stuff away a little. What's talked about more are his technical innovations, the psychological, humanistic content of the paintings and, in almost any discussion of Caravaggio, his own craziness, his biography...

Mark The narrative biographical aspect of it.

Anthony What gives a lot of that painting its power is [that] it's Jesus as a human being, which is this strange revolution that Christianity is. I mean, it's not an historical illustration of Renaissance humanism and so forth, or it's not only that, it's a representation of what the central revolutionary content of Christianity is and always was. Now often the church does a lot of work to occlude this; the revolutionary impact of the Christian thing—that God as Father is really gone and God has become a person. So what the curator was doing in prohibiting the Emily thing was operating like a priest. What a priest does, in this sense of a priest, is try to tame and codify the

untamable so that it can be integrated into a particular order of being. In this case, that would be the order of being and system of values the museum acts as a support of.

Mark You know Liz Glynn in her essay talks about there being the museum which you go to and then there's the hidden museum, and that our show in a way mapped that. It's like the museum is this invisible man that we slowly throw darts at. As the dots of blood appear he takes form, and doing our show revealed the contours of the museum for us in a way that we couldn't see before. Some of the institutional relationships to the religious work were so revealing in that way of this invisible museum, these operations which you don't see.

Anthony I was talking with Jim Fetterley and Emily Lacy about the feeling that was going through us. Like "Oh wow, this can happen." Our description of our feeling of the event just referred back to the fact that it had happened.

Mark And in that way it seems very different from a festival. There wasn't that kind of wild permissiveness that I associate with something like a carnivale.

Anthony It wasn't run wild at the museum day. It's not about critiquing the museum, breaking all the rules that we can break. It was something that burst forth out of the given ground of the museum's contradictions and out of Machine's just happening to be invited to be there at that time.

But it's almost like looking for the causes is attempting to tame what happens and would be also part of trying to reproduce it. The pleasure of the LACMA show was that when you were there you so firmly had that feeling like it's not going to be like this tomorrow.

Mark We're not going to do it again. It's that uniqueness of it, which actually I think forms a really specific kind of temporary community that's very binding to people.

Anthony That's one thing that I like about how Alain Badiou describes St. Paul and the early church and the Event of the Resurrection. The Event happens and then a new subject is formed, and bound together with other subjects in mutual recognition and fidelity to the Event.

Mark It's like being in a car crash with someone.

9. (p. 162)

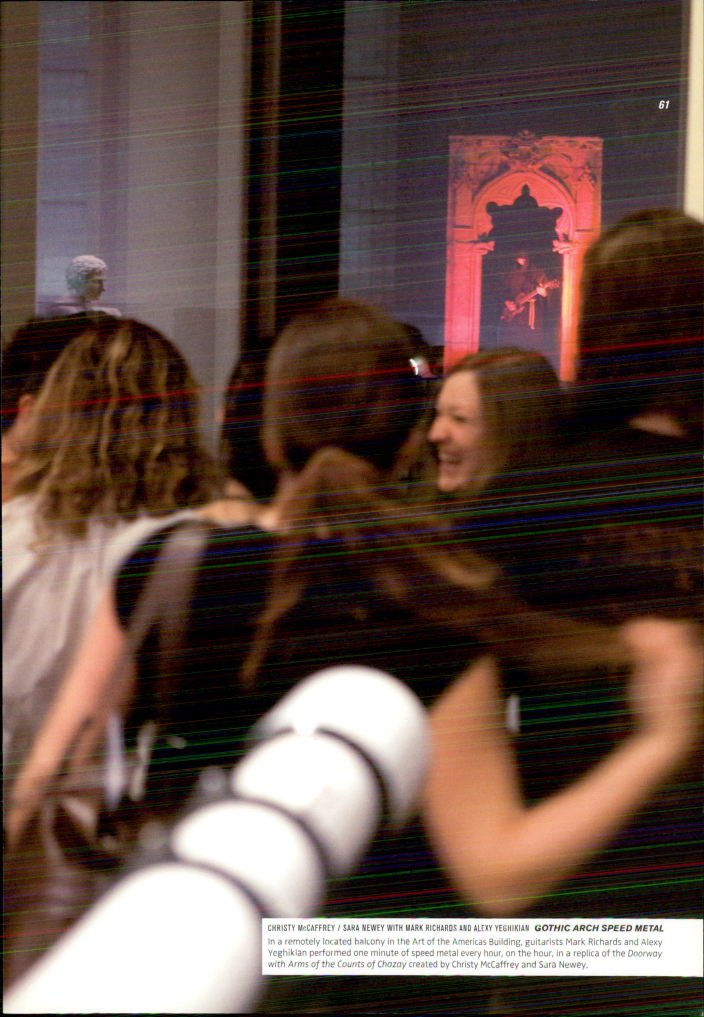

CHRISTY McCAFFREY / SARA NEWEY WITH MARK RICHARDS AND ALEXY YEGHIKIAN *GOTHIC ARCH SPEED METAL*
In a remotely located balcony in the Art of the Americas Building, guitarists Mark Richards and Alexy Yeghikian performed one minute of speed metal every hour, on the hour, in a replica of the *Doorway with Arms of the Counts of Chazay* created by Christy McCaffrey and Sara Newey.

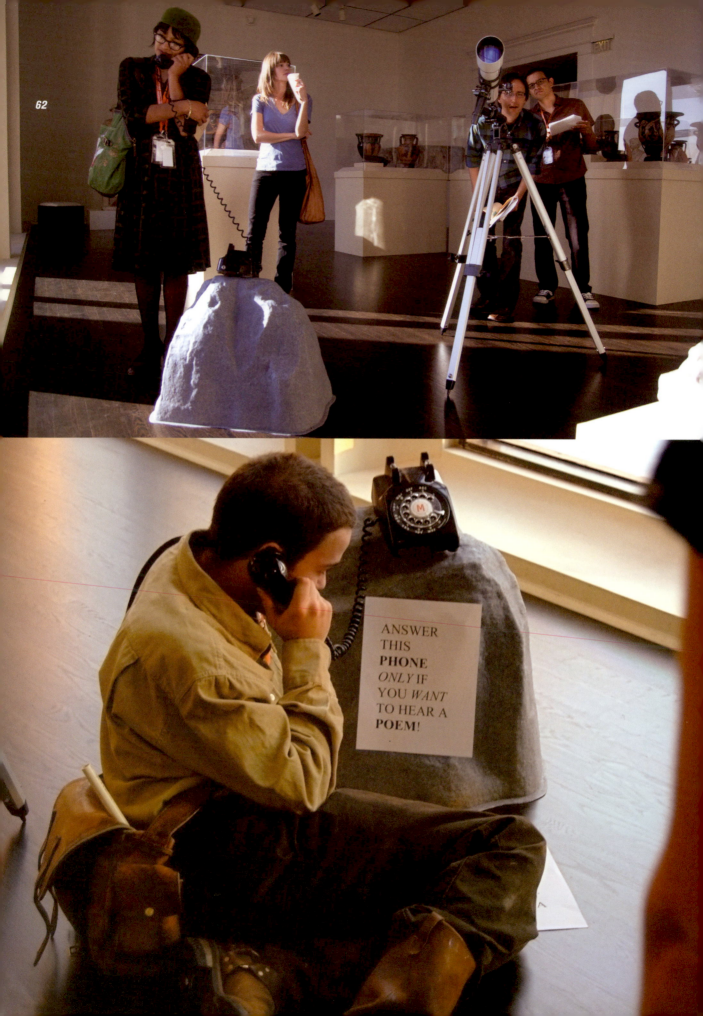

ANSWER THIS **PHONE** *ONLY* IF YOU *WANT* TO HEAR A **POEM!**

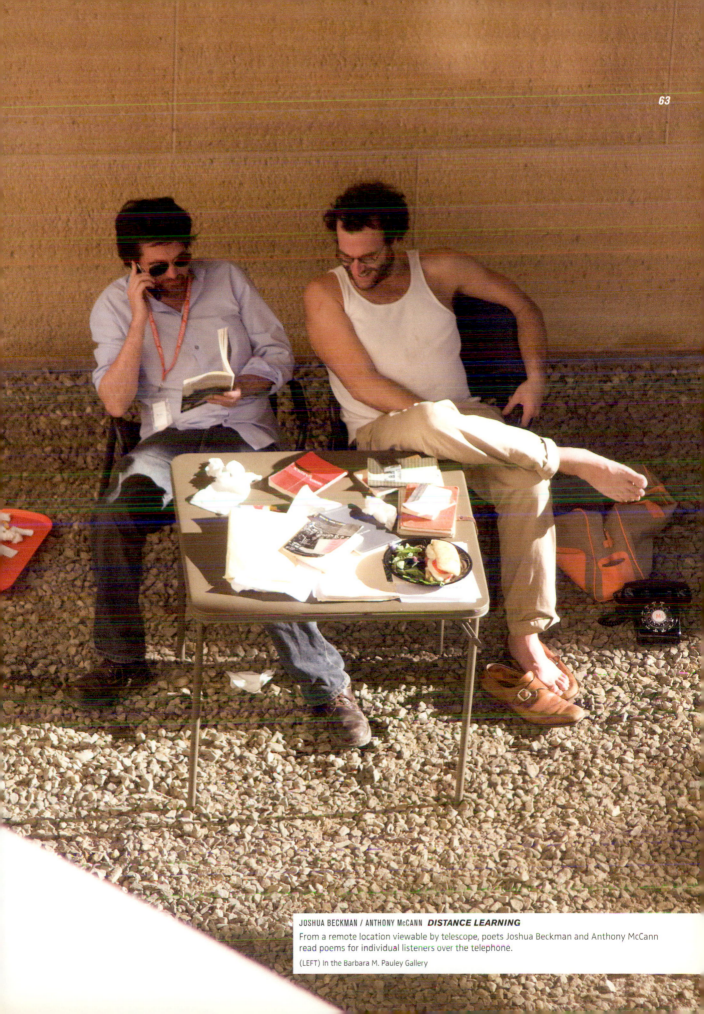

JOSHUA BECKMAN / ANTHONY McCANN *DISTANCE LEARNING*

From a remote location viewable by telescope, poets Joshua Beckman and Anthony McCann read poems for individual listeners over the telephone.

(LEFT) In the Barbara M. Pauley Gallery

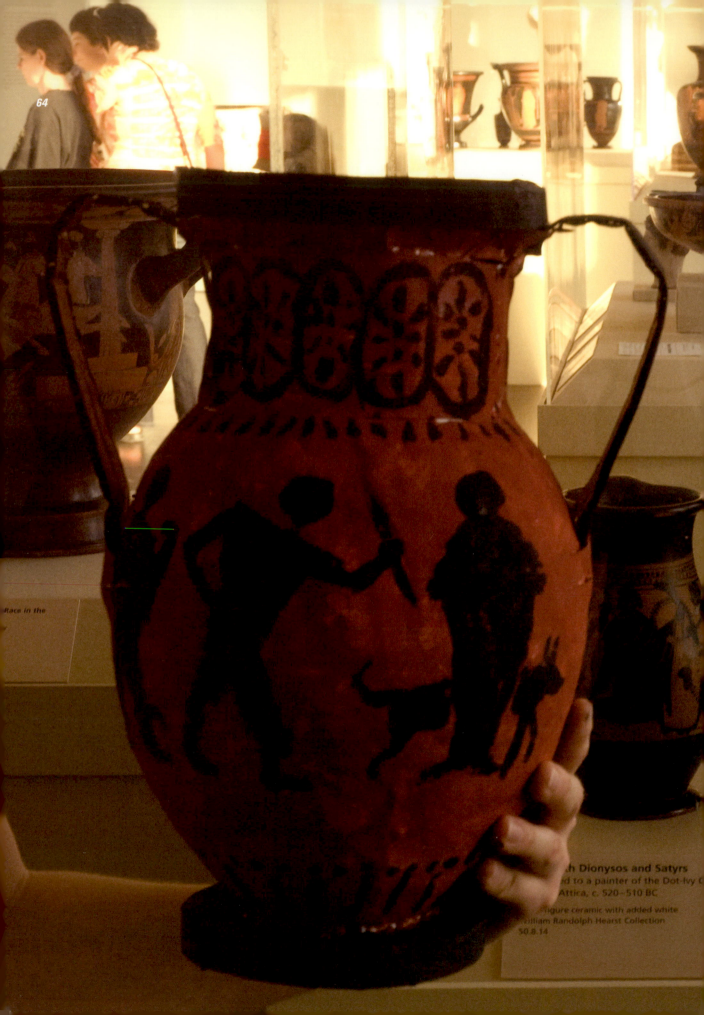

h Dionysos and Satyrs
d to a painter of the Dot-Ivy G
Attika, c. 520–510 BC

figure ceramic with added white
William Randolph Hearst Collection
50.8.14

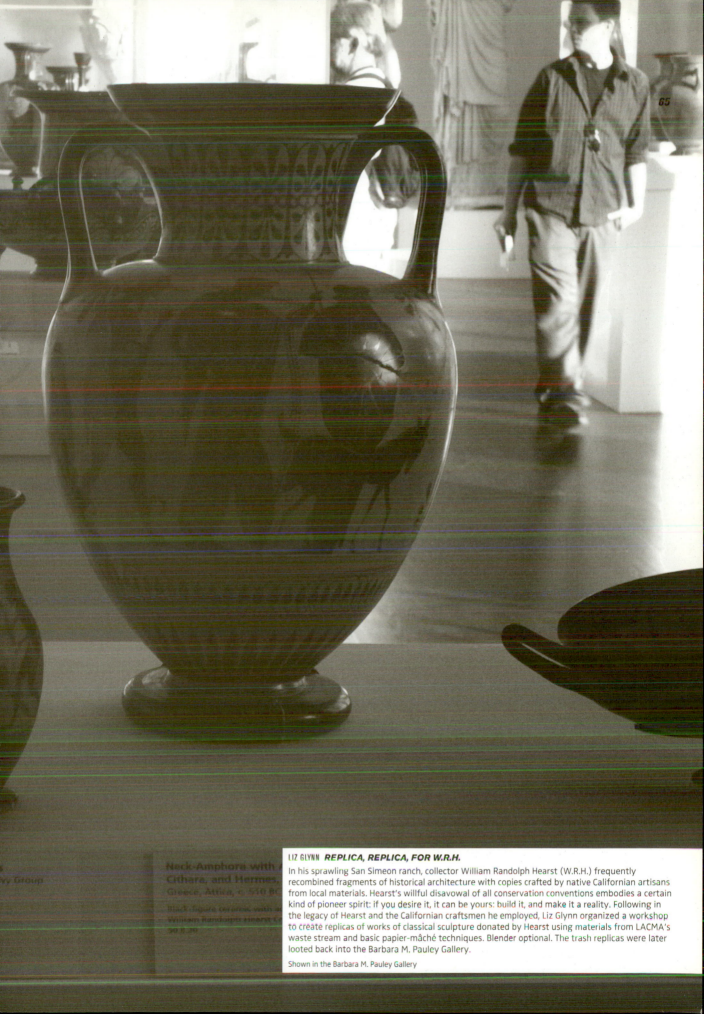

LIZ GLYNN *REPLICA, REPLICA, FOR W.R.H.*

In his sprawling San Simeon ranch, collector William Randolph Hearst (W.R.H.) frequently recombined fragments of historical architecture with copies crafted by native Californian artisans from local materials. Hearst's willful disavowal of all conservation conventions embodies a certain kind of pioneer spirit: if you desire it, it can be yours: build it, and make it a reality. Following in the legacy of Hearst and the Californian craftsmen he employed, Liz Glynn organized a workshop to create replicas of works of classical sculpture donated by Hearst using materials from LACMA's waste stream and basic papier-mâché techniques. Blender optional. The trash replicas were later looted back into the Barbara M. Pauley Gallery.

Shown in the Barbara M. Pauley Gallery

Radio Shack Security Wand Body scanners/metal detector wands such as this one are used to divine the presence of hidden weapons and other metallic items without physical touch. Unlike older forms of divination technologies that often depended upon the user's abilities, the Security Wand features an adjustable sensitivity control and a low-battery alert.

NexxTech Remote Presentation Wand with Laser Pointer Through the use of light amplification by stimulated emission of radiation (laser), the presentation wand enhances communication and allows the user to remotely interface with a PowerPoint program via infrared beams.

RCA Universal Remote Control This wand is RF-capable with extended range for achieving maximum control over a wide array of entertainment media electronics. It includes an extensive code library and features Gemstar Guide Plus Gold. In antiquity, some wands allowed the user to channel remote beings from other cosmic planes; today, this universal remote control allows the user to rapidly switch between hundreds of channels.

Streetwise SW3N1 Rechargeable Security Guard This 3-in-1 self-defense wand features a flashlight, a high-decibel alarm, and a 600,000-volt stun gun. It offers the user protection from an attack by shooting a beam of light, a sonic blast, or a bolt of lightning.

Pagan Wand Wands used by contemporary witches and occultists vary greatly in design, material, and designated purpose. This spiral wooden wand was handcrafted from a fallen vine branch after being ceremoniously charged during an electrical storm. The vine is symbolic of tenacity and flexibility, thereby offering the user the potential to channel a wide range of energies for use in ritual magick, witchcraft, and modern occult practices.

10. (p. 163)

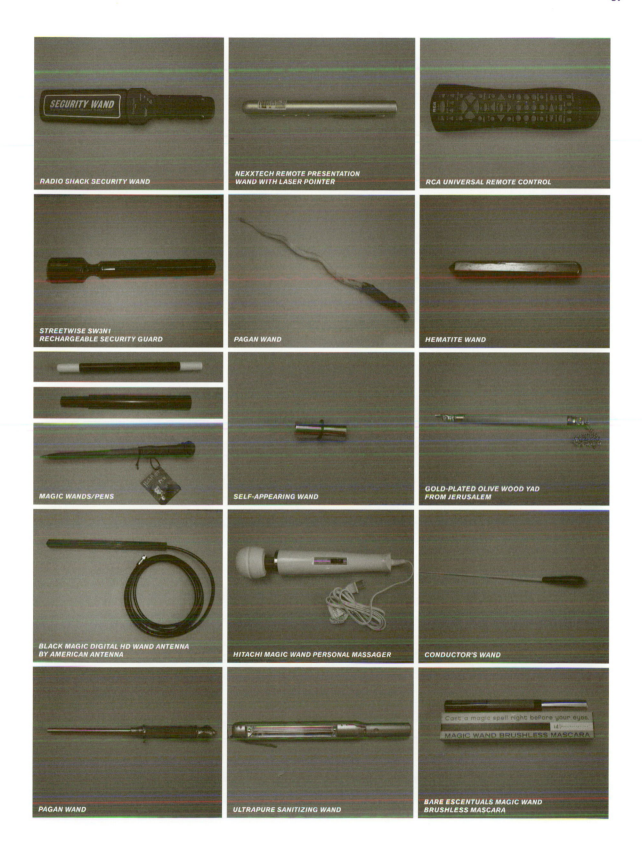

RADIO SHACK SECURITY WAND

NEXXTECH REMOTE PRESENTATION
WAND WITH LASER POINTER

RCA UNIVERSAL REMOTE CONTROL

STREETWISE SW3N1
RECHARGEABLE SECURITY GUARD

PAGAN WAND

HEMATITE WAND

MAGIC WANDS/PENS

SELF-APPEARING WAND

GOLD-PLATED OLIVE WOOD YAD
FROM JERUSALEM

BLACK MAGIC DIGITAL HD WAND ANTENNA
BY AMERICAN ANTENNA

HITACHI MAGIC WAND PERSONAL MASSAGER

CONDUCTOR'S WAND

PAGAN WAND

ULTRAPURE SANITIZING WAND

BARE ESCENTUALS MAGIC WAND
BRUSHLESS MASCARA

Hematite Wand Commonly used as a tool for massage or other healing arts, this hefty hematite wand weighs nearly two pounds. Valued by ancient Romans as a protective stone, hematite is regarded by crystal-users today as a powerful grounding stone that deepens the connection between spirit and body while deflecting the emotions of others.

Magic Wands/Pens Writing implements are among some of the earliest yet lasting examples of magic wands. By putting ink to parchment one could record thoughts and events, create laws and bureaucracies, or even speak poetry, imagination, and revolution to the eyes of millions. Here we see: the magician's wand/pen with two colors of ink; the Harry Potter wand/pen; and a magic marker.

Self-Appearing Wand This unassuming cylinder expands rapidly to form an 18-inch black wand with silver tips for use by stage magicians.

Gold-Plated Olive Wood Yad from Jerusalem Literally, "hand" (in Hebrew), a *yad* is a Jewish ritual pointer, used to point to the text during the Torah reading from the parchment Torah scrolls. It is intended to prevent anyone from touching the parchment, which is considered sacred. Similar wands are occasionally used to read holy texts among other religions as well.

Black Magic Digital HD Wand Antenna by American Antenna This Digital HD (high definition) antenna wand comes with eight feet of quad shielded coax cable and a standard F connector to help manifest a clear vision by tuning into invisible transmissions beamed through the air.

Hitachi Magic Wand Personal Massager This vibrating massage wand has helped millions of users reach altered states of consciousness through personal muscular relaxation and/or erogenous stimulation since it was first introduced in 1970.

Conductor's Wand Handcrafted from birch and ebony with an inlaid "Parisian eye," this wand is waved before an assembly to guide in the creation of a harmonious musical composition.

UltraPure Sanitizing Wand This germ-killing wand is wielded to create a sanitized indoor living environment. Designed to reduce and control disease-causing bacteria, viruses, and fungi, it emits a pure ultraviolet glow that produces a 99.9 percent kill rate of microscopic bacteria, viruses, dust mites, and bed bugs.

Bare Escentuals Magic Wand Brushless Mascara The unique design of this cosmetic wand helps create a mask of beauty around the eyes that can be used to conceal age, natural imperfections, or ugliness. It also works like magic when layered over your favorite mascara for added volume. The overall effect is like wearing false eyelashes.

Welch Allen ScanTeam 2380 Wand This bar code scanning wand uses a fixed light and a photosensor to decode the optical machine-readable symbologies affixed to consumer goods. In addition to using this wand to decipher codes, it is also used to save time (not pictured).

Social Light Butane Lighter Wand Perhaps one of the earliest magic wands was a glowing stick pulled from a fire. This decorative lighter wand produces a traditional 1800ºF flame useful for setting fire to those hard-to-reach places without getting burned (not pictured).

Brass Divining Wand Similar to a dowsing rod or pendulum, this divining wand features solid brass elements connected by a flexible stem for augmenting and enhancing one's divine abilities (not pictured).

Double-Shooting Wand Used by a theatrical magician or conjuror, this wand packs a flammable load into either end, enabling the performer to shoot fireballs across the room with a flick of the wrist (not pictured).

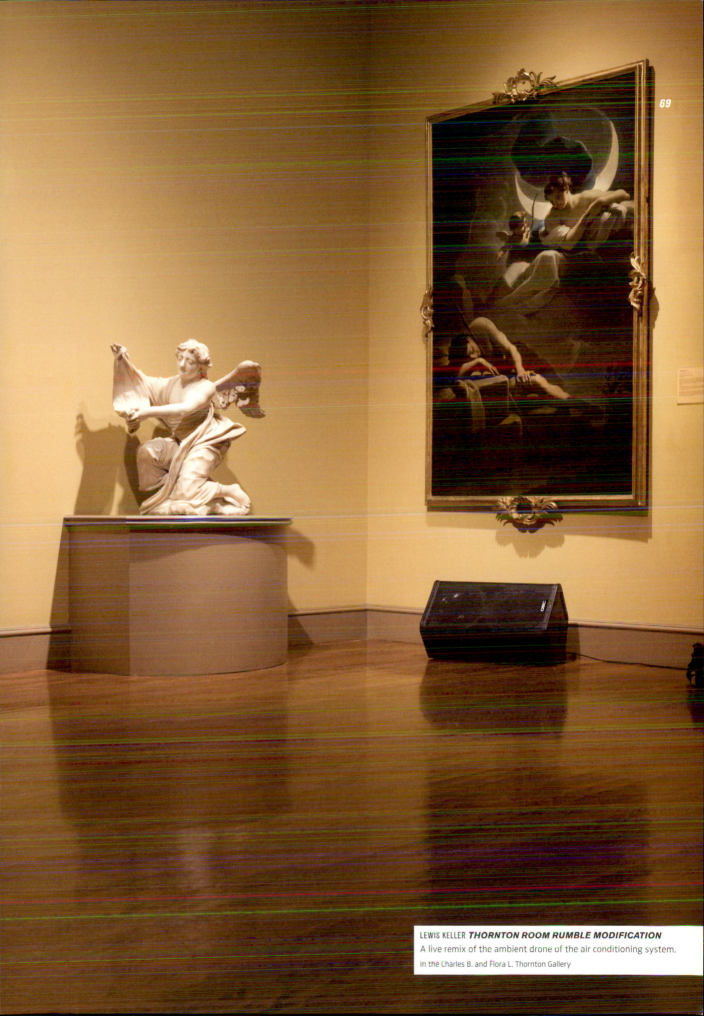

LEWIS KELLER *THORNTON ROOM RUMBLE MODIFICATION*
A live remix of the ambient drone of the air conditioning system.
In the Charles B. and Flora L. Thornton Gallery

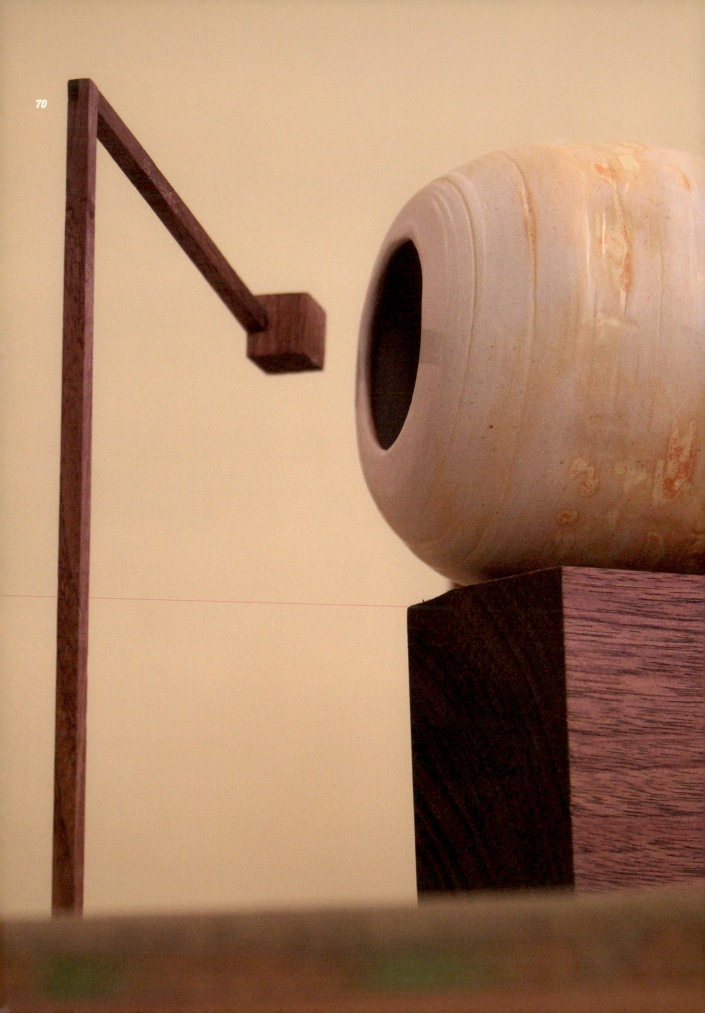

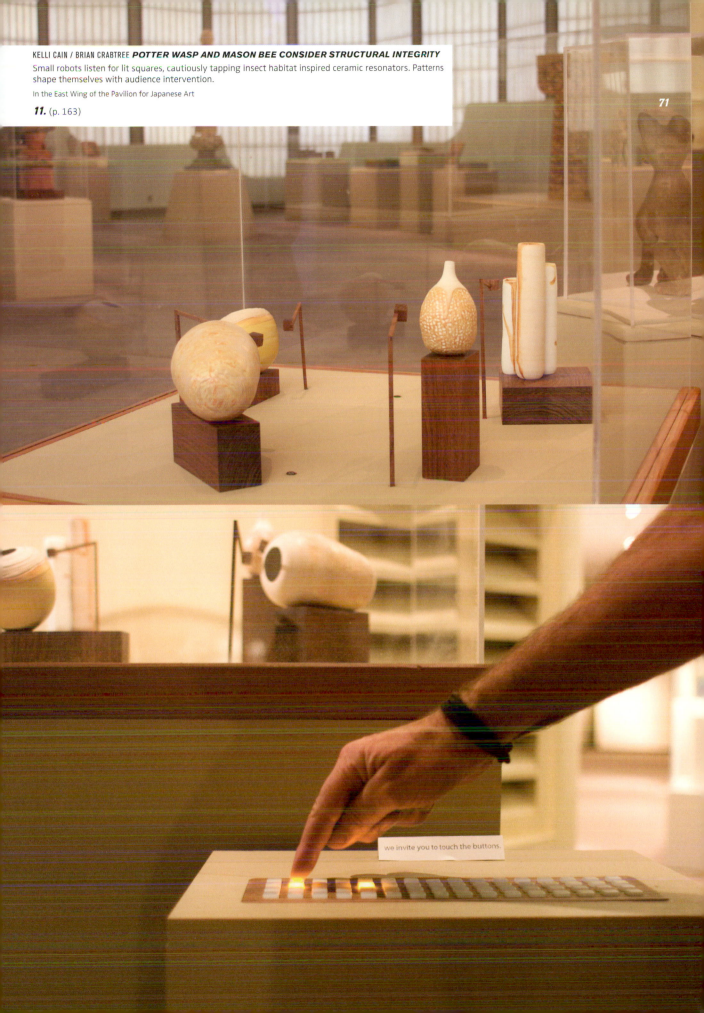

KELLI CAIN / BRIAN CRABTREE *POTTER WASP AND MASON BEE CONSIDER STRUCTURAL INTEGRITY*
Small robots listen for lit squares, cautiously tapping insect habitat inspired ceramic resonators. Patterns shape themselves with audience intervention.

In the East Wing of the Pavilion for Japanese Art

11. (p. 163)

we invite you to touch the buttons.

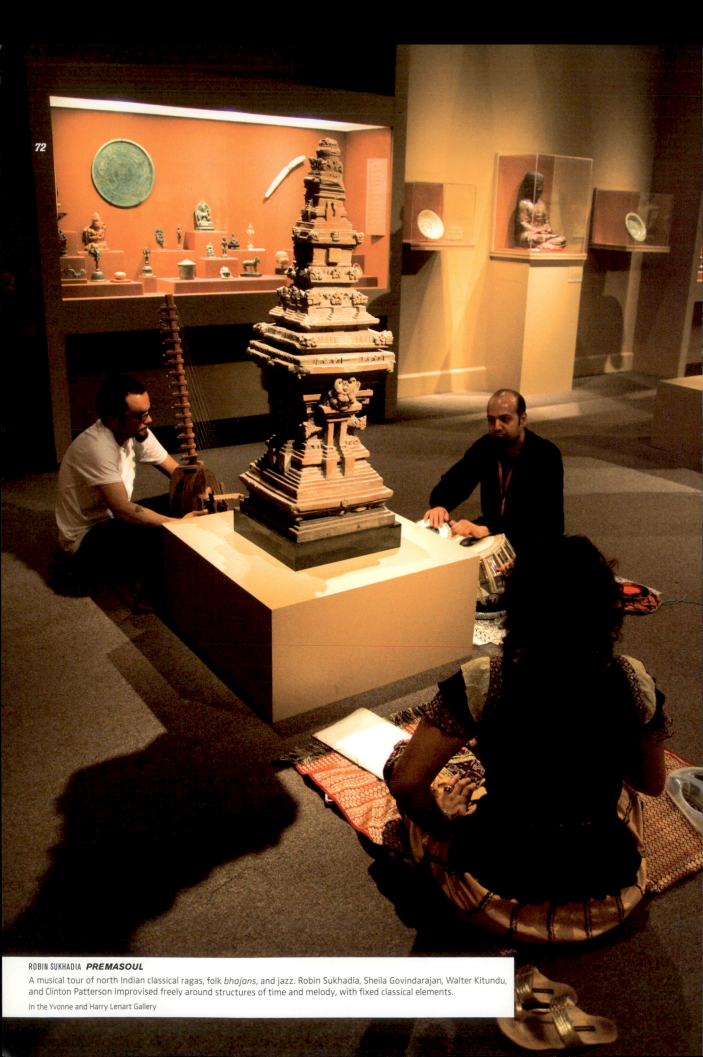

ROBIN SUKHADIA *PREMASOUL*

A musical tour of north Indian classical ragas, folk *bhajans*, and jazz. Robin Sukhadia, Sheila Govindarajan, Walter Kitundu, and Clinton Patterson improvised freely around structures of time and melody, with fixed classical elements.

In the Yvonne and Harry Lenart Gallery

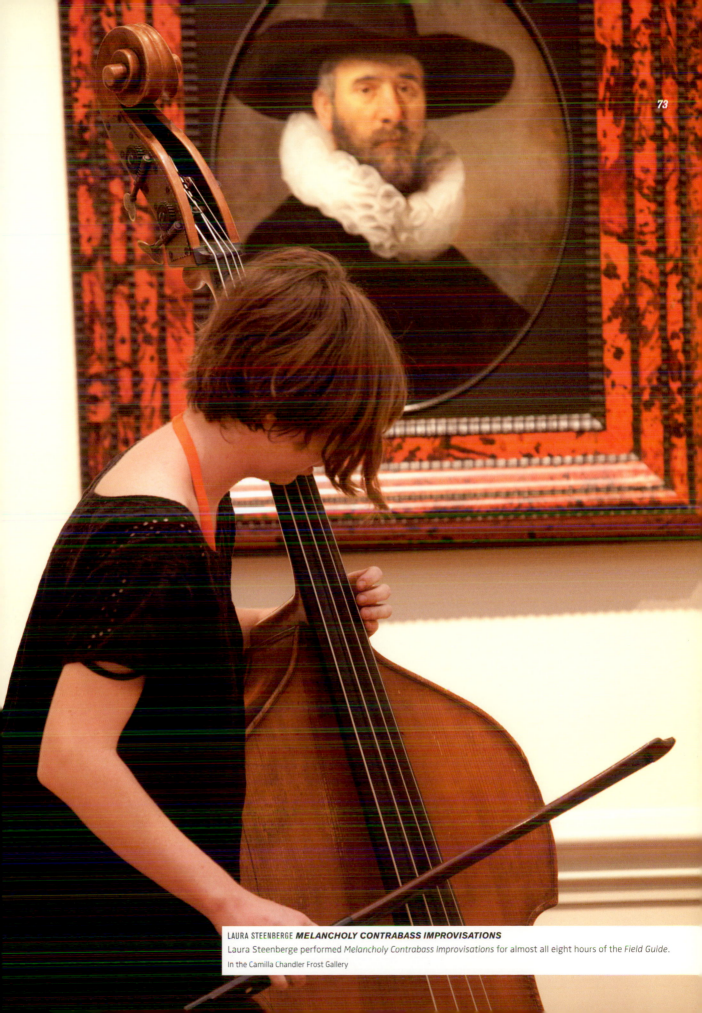

LAURA STEENBERGE *MELANCHOLY CONTRABASS IMPROVISATIONS*
Laura Steenberge performed *Melancholy Contrabass Improvisations* for almost all eight hours of the *Field Guide*.

In the Camilla Chandler Frost Gallery

CLAPPING GUIDE *JOSHUA BECKMAN*

WELCOME TO LACMA

Today, November 15, 2008, all visitors to the museum are invited to clap for the pieces they enjoy.

In most museums there is an implied sense of the need for quiet decorum. Viewers are often encouraged to enjoy the work in near silence. In the late 1970s a group of graduate students from the University of Stuttgart began a research project meant to investigate the effect of this silence on both the viewer and the art. In numerous tests in museums throughout Europe it was concluded that not only did the average visitor retain (or keep silent) more than ninety percent of their emotional and intellectual response, but also that the retention of these energies was most likely the cause of *Glauben ermüdet* (or "that tired feeling") of which many museum-goers complain. Continuing this research for nearly three decades, now Doctors Wiener and Krier have narrowed their study from a variety of emotive functions to focus solely on clapping. In recent years the doctors proposed a second benefit to museum clapping; it has long been known that the mind works in relation to its surroundings, and that just as quiet in a loud environment can ease and gather the mind, so too a loud noise in a quiet environment can direct and focus the attention. This "sonic focusing," when combined with the renewed vigor of released emotions, has proven to enhance the viewing experience for countless viewers throughout the world. LACMA is proud to be the first American institution to participate in the Wiener Krier Project.

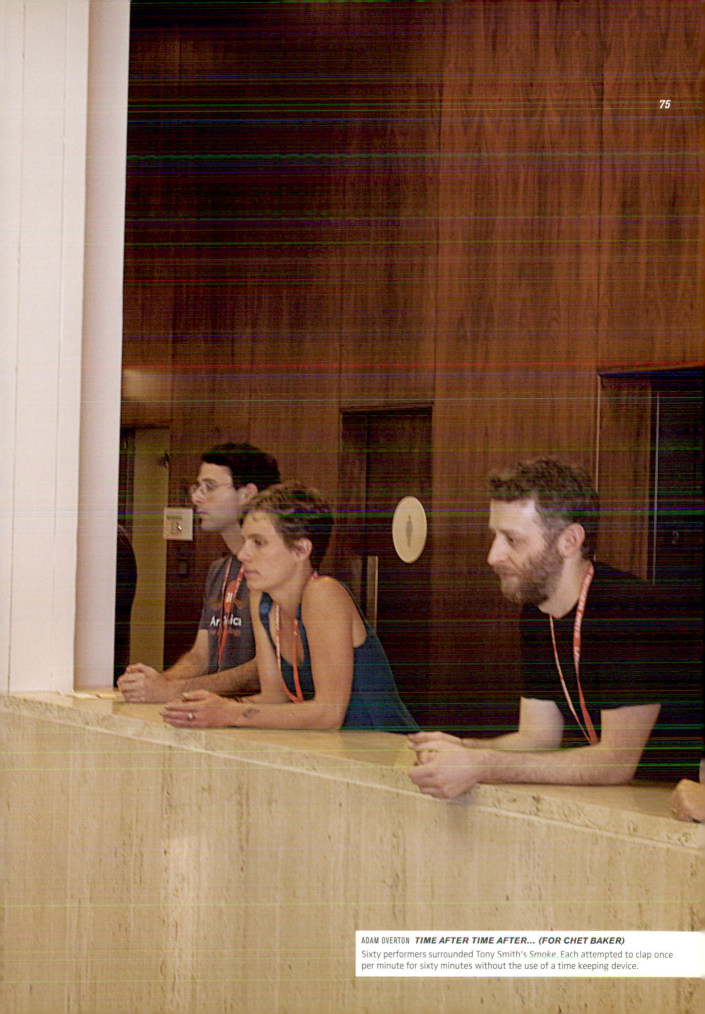

ADAM OVERTON *TIME AFTER TIME AFTER... (FOR CHET BAKER)*
Sixty performers surrounded Tony Smith's *Smoke*. Each attempted to clap once
per minute for sixty minutes without the use of a time keeping device.

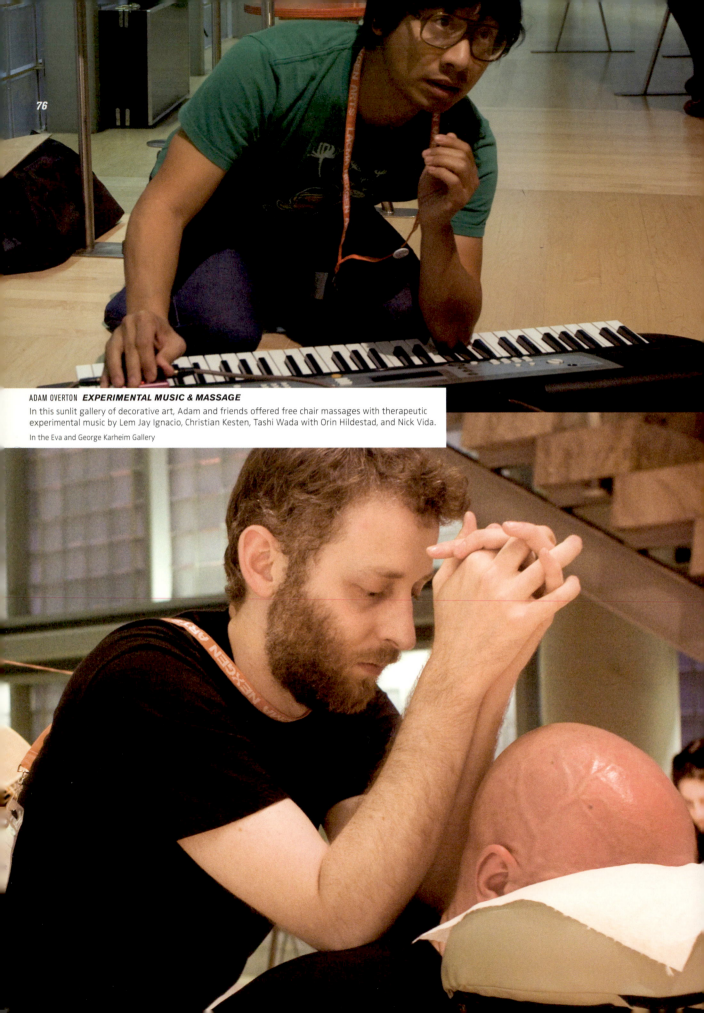

ADAM OVERTON *EXPERIMENTAL MUSIC & MASSAGE*

In this sunlit gallery of decorative art, Adam and friends offered free chair massages with therapeutic experimental music by Lem Jay Ignacio, Christian Kesten, Tashi Wada with Orin Hildestad, and Nick Vida.

In the Eva and George Karheim Gallery

INVISIBLE PERFORMANCES
EXCERPTED FROM ADAM OVERTON'S LACMA PERFORMANCES

```
at any point today
or any other day
publicly or privately
for as long as necessary
some, all, or none.
```

Don't Forget To Smile Performance
(Overheard Series)

Repeat this mantra to yourself as you walk around
today: "don't forget to smile... don't forget to
smile... don't forget to smile..."[1]

"I feel sorry for the aminals [sic]" Performance
(The The Tar Tar Pits Series)[2]

Visit the Observation Pit out back, and truly deeply
feel sorry for the aminals (sic) still trapped in
the tar below.[3]

1. Taped to all the registers in the Plaza Café.

2. Directly translated, "la brea" means "the tar," therefore "The La Brea Tar Pits" translated
 is "The The Tar Tar Pits."

3. Overheard in the Observation Pit, from a 5- or 6-year-old.

Moral Support Performance
(The The Tar Tar Pits Series)

If the paleontologists are working out back today (out at Excavation Pit 91), show your support for them by crooning along with whatever music is currently playing on their boom box.

If You Get Bored Performance No. 1 (this is all just temporary)

If you're getting bored, or don't understand the art you've been looking at inside, go outside to smell the tar pits, and silently weigh the fact that we're probably just going through a very brief phase here today.

NEW MACHINES

JASON BROWN

On November 15, 2008, governor Arnold Schwarzenegger said of Southern California, "it looks like hell." Fire surrounded all of Los Angeles. From the northwest, a vast haze of smoke rose into the sky from Montecito, the sun bathed orange with the ashes of mansions and art treasures. To the southeast, the freeways were shut down by an inferno in Orange County. And north of the San Fernando Valley, winds whipped fires into a maelstrom across the Newhall Pass, a burning thread of infrastructure connecting Los Angeles to water and power, causing rolling blackouts in parts of L.A. as the transmission lines roasted in flames.

But at LACMA, the smell of burning brush was a distant spice in the warm autumn breeze as tables marched around the courtyard, as musicians marched around lunch eaters, marching bands squeezed into elevators, children beeped gizmos, and guitarists fired off smoke machines over Wilshire.

Directly in the Path of the Fallout

It was a particularly odd coincidence to have blazing apocalypse threaten the infrastructure of Los Angeles on the day of the *Field Guide*, because LACMA's ancestor originated with this infrastructure running over Newhall Pass. On November 6, 1913, the Los Angeles Museum of History, Science, and Art opened in Exposition Park. One day before, the Los Angeles Aqueduct began delivering water into the San Fernando Valley.[1]

The museum was only built once this mechanism began threading through the desert, the foundations of a megalopolis dangling from a cascade of wires and pipes over the pass. More than an accident of history, the fact that the museum opened the day after the plumbing that made it possible is ripe with symbolic meaning, exposing an often unacknowledged relationship between the physical and cultural conduits of power buried beneath the foundations of our quotidian infrastructure.[2]

The World has Moved Up a Level

Museums are where artifacts go once they can be fixed into the narratives of cultural history. In a sense, they are where art goes to die, mausoleums for art.[3] Which is not really a critique. Everything dies, and if art didn't change and grow, it would be a fate worse than death—the uncanny horror of undead art. And living art is often at odds with the ongoing preservation of dead art's fragile bones, so museums are rightfully protective of their artifacts, keeping them away from the loud, sticky, clumsy fumbling artists.

But the art of museums themselves is not in their artifacts—it is in the systems which preserve, catalog and interrelate the artifacts, the tubes and vents, stairways and courtyards, taxonomies and bureaucracies. At their core, museums are machines for demonstrating interconnectedness, a physical infrastructure for diagramming the threads of historical accident.

The Effort to Implement Ridiculously Impractical Ideas

In the case of LACMA, the museum materialized at the same time as a new network shape, a new form designed for apocalyptic survivability. In 1961 the Museum of History, Science and Art divided into two museums—the Los Angeles County Museum of History and Science and the Los Angeles County Museum of Art. This was the same year Paul Baran presented his ideas on distributed networks to "selected Air Force audiences."[4]

While working as a researcher at the RAND corporation in the early 1960s, Baran wrote a series of reports describing a network architecture that would be able to survive a nuclear attack by routing packets of data around the post-apocalyptic ruins of the command-control system. Baran's reports on distributed communication were collected into a book in 1964, the same year the Santa Monica freeway opened connecting downtown L.A. to the ocean.

The Way a Fungus Grows

Distributed information networks and the integrated freeway system became a new mode of sprawl, a cityscape based on individually owned cars and a network based on individual packets of data, a lattice of routing and flow designed for disaster and survival, with semi-autonomous machines scurrying around the smoking craters of civilization's remains.

In 1965 LACMA opened its Wilshire Boulevard[5] campus, just coincidentally on a site dense with physical memory, located on top of ice age butterflies and mammoths, the bones of dire wolves and giant sloths poking through the parking garage.[6] It's easy to feel lost inside the galleries of the original LACMA buildings. The layout is asymmetrical,[7] full of folds and crevices, the dark, depopulated, short-sighted spaces of a video game, a vast crenellated labyrinth designed to contain a spatial representation of cultural history, but with the uncanny feeling of being lost within a map.[8]

Exoskeletons of Cybernetic Bureaucracy

LACMA's original architect, William Pereira, was the preeminent designer of Southern Californian exoskeletons of cybernetic bureaucracy.[9] His signature concrete latticework served as a concretized totem of Cold War command-control structures, the caprice of an emergent network form. Along with various banks, airports, prisons, and physical plants, Pereira's firms designed CBS Television City, the city of Irvine, the airports of Baghdad, Tehran, Orange Country, and Los Angeles, and the Transamerica Pyramid in San Francisco.

Transamerica Center, one of the first modern skyscrapers in Los Angeles, was designed by Pereira's firm and finished in 1965— the same year as LACMA. The top floor of the main building is a fourteen-legged bug squatting on top of the structure, or perhaps it

(TOP) Opening of the gates of the first Los Angeles Aqueduct at the Newhall Pass, November 5, 1913.

(MIDDLE) 1973 freeway sign.

(BOTTOM) Pipeline of the Los Angeles Aqueduct.

is a computer chip with two missing pins.[10] Today this building is the AT&T Center, a major node in global cybernetic capitalism.

Lost in a Map

One Wilshire (not designed by Pereira) was built a few blocks north of Transamerica Center, at the terminus of Wilshire Boulevard.[11] It was designed as a fancy office building for titans of industry and their servile minions. But over the ensuing decades, the humans were forced out as the entire building filled up with network infrastructure, the fancy offices replaced with floor to ceiling racks of cables, servers and switches.

It is still an apparent office building from the street, but—similar to the way a fungus grows to fill the guts of a tree—only the outer shape remains, and aside from a few caretakers of the equipment, there are no people left inside. Today, One Wilshire is one the most "connected" buildings on the planet, and by the square foot, among the most expensive real estate in the world.

Scurrying Around the Smoking Craters of Civilization's Remains

In 1966—the year One Wilshire opened—LACMA began planning their Art and Technology project,[12] a focused partnership with the Military-Industrial-Entertainment complex[13] which formed the substrate of Southern Californian society. LACMA contacted more than 250 corporations and technical organizations, and received about eighty artist proposals. Only about twenty of these "arranged marriages" ended up producing some kind of finished project, but the effort to implement ridiculously impractical ideas may have been even more interesting.

For example, Sam Francis wanted to create an elaborately programmed "strobe environment," which he eventually decided should take place in the sky over all of Los Angeles.[14] LACMA consulted with the physicist Richard Feynman on a scheme to fire a salvo of strobing rockets over Southern California, and Feynman even made calls to friends at NASA who estimated the cost at around a million dollars. It didn't work out.[15]

The Uncanny Horror of Undead Art

As part of the Art and Technology project, John Chamberlain went to RAND as visiting artist in 1968.[16] He suggested things like cutting off the phones for a day, dissolving the entire corporation, or having everyone spend the day outside taking pictures. His ideas were not well received. He decided to screen his new film, *The Secret Life of Hernando Cortez*. One reviewer offered this description:

> Taylor Mead and Ultra Violet star in this independent
> production that features nudity and gymnastic sexual liaisons
> in a variety of places, including trees. Most likely this trashy

(TOP) Aerial view of the Occidental Center (1968), later known as the Transamerica Center.

(MIDDLE) One Wilshire.

(BOTTOM) Rand Corporation Headquarters, Santa Monica, California.

underground film is of no interest to those other than naked-flesh fanatics.[17]

Chamberlain planned to screen his film during the RAND lunch hour for five days. It lasted three. He then distributed an ambiguous questionnaire to the RAND corporation staff, who mostly used it as an opportunity to attack his film:

> The world has moved up a level. They now call stag movies "ART." GO TO HELL, MISTER!

> You're sick! While you were up in the Tree in your love scene, you should have STAYED

> You have a beautiful sense of color and a warped, trashy idea of what beauty and talent is.[18]

Paul Baran probably received Chamberlain's memos. Maybe he saw the film at lunch. Maybe he was even among the outraged reviewers. At the time, the film may have seemed like a goofy provocation and the reviews a reactionary backlash. But in retrospect, how poetically prescient to get into a flame war over Conquistador porn with the very engineers who were at that moment designing what would become the Internet.[19]

An Odd Coincidence

In an unintentionally revelatory remark, John Chamberlain described the staff at RAND as "very 1953... you know, like the girls wear too much underwear."[20] He probably intended this as a dismissive comment on how culturally out-of-date he considered most of them. But his offhand remark referenced a deeply interwoven nexus of the Military-Industrial-Entertainment Complex, which includes the death of John Wayne.[21]

In 1953, a sequence of above-ground atomic tests called Operation Upshot-Knothole was performed at the Nevada Test Site—the famous images of a house blown apart by a nuclear explosion came from one of these tests. One "shot" in particular, codenamed "Harry," released the greatest amount of fallout of any of the Nevada nuclear tests.[22]

In a strange accident of history, the film *The Conqueror* was shot in St. George, Utah, in 1954, directly in the path of the fallout from Harry. The actors and crew knew they were rolling around in radioactive dust, but accepting government assurances, they assumed it was safe. Within a decade, at least half the people involved with the film developed cancer, and its director, Dick Powell, and several stars—including John Wayne—eventually died of cancer, most likely caused by the fallout.[23]

(TOP) Ultra Violet and Taylor Mead in a still from the film, *The Secret Life of Fernando Cortez.*

(MIDDLE, BOTTOM) "Some of you have been inconvenienced by our test operations. At times some of you have been exposed to potential risk from flash, blast, or fall-out. You have accepted the inconvenience or the risk without fuss, without alarm, and without panic. Your cooperation has helped achieve an unusual record of safety." From the pamphlet *Atomic Test Effects in the Nevada Test Site Region*, published by the United States Atomic Energy Commission in 1955.

(TOP) The tail section of U.S. Navy dirigible blown out of the sky on August 7, 1957 by the Plumbbob/ Stokes test shot, visible in the background.

(BOTTOM) Leonard Bessom of the L.A. County Museum digs a prehistoric tusk, May 16, 1958.

The Sun Bathed Orange with the Ashes of Mansions and Art Treasures

The Machine Project Field Guide to LACMA was unintentionally post-apocalyptic.[24] Four decades after artists from LACMA entangled themselves with the corporations of the Military-Industrial-Entertainment complex, architectures of survivability and re-routable control have brought us to a point of strange vulnerability. Distributed communications are now a global weather system with their own patterns of rumor and paranoia, and the foundations of once-solid cultural institutions have dissolved in the storm. Encyclopedias effervesce into clouds and chat-rooms, museums effloresce into capstones and filigree, encyclopedic museums shard into guesswork and parties.

What was the field of this guide? Of course it was about leaving our little Echo Park storefront, going "out in the field," and it was a study of the expanded field of LACMA, the architecture and artifacts, the frameworks woven through and beneath. But more importantly it is an examination of the field of connections between us, the coincidences and tangled relationships that intertwine our seemingly banal infrastructures into an unseen but powerful network of meaning.

We tried to examine the mechanism of the museum, to read the fossils of public space with a sidelong gaze,[25] examine the shape of something that has yet to be directly perceived, a pattern emerging first as noise, and perhaps over time becoming recognizable as new cultural infrastructures, new mythologies, new machines.

1. "Olé! Olé! Olé for Mullholand! / See the water fall / Hooray, hooray the sky is falling / Down on Bradbury's mall." Frank Black, *Teenager of the Year* (4AD/ Elektra, 1994). The term *olé* comes from an Arabic oath والله (w-állah)— "by Allah!"

2. *Apophenia* is the experience of seeing patterns in random or meaningless data, sensing meaningful connections where none exist. The term was coined in 1958 by Klaus Conrad, who described it as the "specific experience of an abnormal meaningfulness." It's a diagnosis, a schizophrenic symptom. But it can be turned around—where there seems to be a meaningful connection, a connection has actually been made. If enough of these nonce connections are interwoven, the patterns inscribed by this imaginal lacework can be as powerful as the freeways, the aqueducts. They can grow into concrete form, though often not as originally intended.

3. Watching workers chisel donor names into the marble at LACMA—could there be enough donors to keep skilled stoneworkers workers busy? But of course they also do gravestones.

4. www.rand.org/pubs/research_memoranda/RM3420/RM3420.preface.html

5. Henry Gaylord Wilshire was an outspoken socialist. *Really* outspoken. He left Los Angeles after being attacked by the police while delivering socialist speeches in a park in 1900. Later in life, after gaining and losing several fortunes, he returned to L.A. to capitalize on the fame of his increasingly central street. Wilshire also marketed a quackish medical device called the I-ON-A-CO, which consisted of an electrical wire strung through an inner tube and plugged in to a lamp. Patients would wear the electrified inner tube for a period of time, allegedly curing them of all manner of ills. The fact that Robert Kennedy was assassinated across the street from the hotel which still bears Wilshire's name (The Gaylord) is just one of those things.

6. The La Brea Tar Pits are used as a metonym of forgetting, a place where things disappear into a cartoonish hole of black oblivion, like Flintstones animals toppling in with a fading howl. Of course the tar pits were never pits—they were (and often still are) seeps of tar that ooze out onto the ground in a broad pools. They are tar plateaus. And far from being zones of loss, they are the most dire and physical sites of memory, dense with compressed time. Diagrammatic dirt.

7. Although we were immediately interested in using the strange attic-like feeling of the upstairs galleries of the Ahmanson Building for the *Field Guide*, we didn't fully realize they were an asymmetrical maze until we constructed a complete architectural model of the buildings.

8. Behind a revolving bookcase, you find a hidden room with a whole new interpretation of things filigreed on the walls. It happens. More often than you might think. You'd like to believe this whole history thing is nailed down, solid, that the walls are nonporous, that it's an architecture you can count on, an honest architecture like a parking garage, its bones and its purpose out there in plain view. But you know how it goes. Contractors! So hard to find one you can count on over the course of a thousand year historiographic project. Things pile up. Things skip out. Things slide behind something else, slip into oblivion. Till you push on a hidden lever—so obvious now that you see it—and a wall moves aside, the world moves up a level, a new array of connections are revealed.

CAST OF A SKELETON OF MEGATHERIUM AMERICANUM.
Plate XVII. Set up in the Natural History Museum.

(TOP) William Mulholland as an old man (date unknown) in a lab containing equipment used to build the L.A. Aqueduct.

(MIDDLE) Henry Gaylord Wilshire, circa 1924.

(BOTTOM) Giant Ground Sloth. From *Extinct Monsters; a Popular Account of Some of the Larger Forms of Ancient Animal Life*, 1893.

(TOP) Preditor drone at Riverside air show, 2007.

(MIDDLE) Soviet Union 6-kopek stamp commemorating Venera 3 (1966).

(BOTTOM) Close-up of John Wayne statue in front of the Flynt building in Beverly Hills.

9. William Pereira's firm designed the headquarters for General Atomics in San Diego, finished in 1958. His firm also designed buildings at Nellis Air Force Base in Nevada, finished in 1957. Half a century later, General Atomics would build the Predator unmanned drone aircraft, which was originally piloted by remote from Nellis Air Force Base. Just one of those things.

10. The Transamerica building was used for the external shots of the Encom building in the 1982 Disney film *Tron*, and in particular for the final scene in which the entire city is depicted as turning into the world of the programs, a city of woven light comprised entirely of networks and data.

11. Because it abuts the end of Wilshire Boulevard, the address of One Wilshire is actually on Olive Street. But in programming, counts always begin with zero, so from a cybernetic perspective, the first unit in the "Wilshire" series would come before the street address count of Wilshire actually began. Although this makes *perfect sense* given the building's current use as a carrier hotel, it's probably just an accident of history.

12. http://collectionsonline.lacma.org/mweb/archives/artandtechnology/at_home.asp

13. The term Military-Industrial-Entertainment complex was first used in *The X-Files*, Season 3, episode 20, "Jose Chung's *From Outer Space*," which aired on April 12, 1996.

14. For the *Field Guide*, LACMA's conservators opposed bringing flowers into the museum to recreate Sam Francis' abstract painting *Toward Disappearance*. After assurances that the flowers would come from florists, it all worked out.

15. In 1966, the Soviet space probe Venera 3 crashed into the surface of Venus—the first spacecraft to land on another planet's surface. However because it crashed, it was unable to send back any data, reducing the entire effort to an extravagant cultural gesture.

16. During the *Field Guide*, the pair of alien tourists (ing) were particularly enamored with the bright colors of Chamberlain's crushed car sculptures.

17. Dan Pavlides, All Movie Guide. www.allmovie.com/work/secret-life-of-hernando-cortez-141174

18. Pamela M. Lee, *Chronophobia: On Time in the Art of the 1960s* (Cambridge: MIT Press, 2004), p. 19.

19. www.rand.org/about/history/baran.html

20. *A Report on the Art and Technology Program of the Los Angeles County Museum of Art*, (Los Angeles: Los Angeles County Museum of Art, 1971) p. 72.

21. There's a monumental statue of John Wayne astride a horse on Wilshire Boulevard in Beverly Hills. It's in front of the former Great Western building (now the Flynt building), a dark glass oval tower designed by William Pereira. One of the only other monumental statues of John Wayne

in the Los Angeles area is at what is now called the John Wayne Airport. The original Eddie Martin Terminal (built 1967, now demolished) was designed by William Pereira's firm.

22. The 26-kiloton atomic bomb used in the "Harry" test was code named Hamlet. So technically, Hamlet killed John Wayne.

23. As producer of *The Conqueror*, Howard Hughes was said to have felt immensely guilty about the deaths of the cast. In his later, most deranged years, he watched the film over and over in his suite in Las Vegas.

24. On November 15, 2008, Rob Lowe said of Southern California, "it was just like Armageddon." www.nbclosangeles.com/news/entertainment/Rob-Lowe-It-Was-Just-Like-Armageddon.html

25. "For some of the deposits, she noted, they had to wear oxygen tanks with full gas masks because of unusually high levels of hydrogen sulfide escaping from the soil." http://articles.latimes.com/2009/feb/18/science/sci-fossils18

"Atomic pinup girl" in front of a mushroom cloud of the Dixie test shot of Operation Upshot-Knothole, April 6, 1953.

ART & TECHNOLOGY

LOS ANGELES COUNTY MUSEUM OF ART

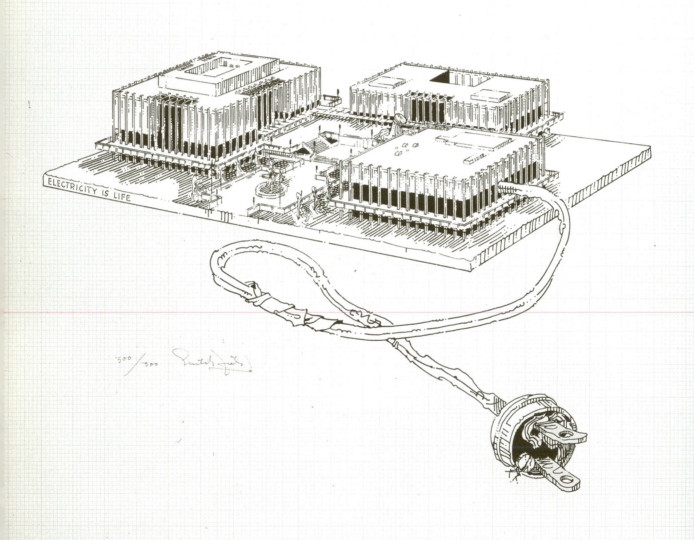

ELECTRICITY IS LIFE

500/500

WILLIAM CRUTCHFIELD *ELECTRICITY IS LIFE*
Published in *A Report on the Art and Technology Program at the Los Angeles County Museum of Art, 1967–1971,* by Maurice Tuchman (New York: Viking, 1971).

4.

RICHARD SERRA READING ROOM *THE PUBLIC SCHOOL*

The Public School is a school with no curriculum. The Public School is not accredited, it does not give out degrees, and it has no affiliation with the public school system. It is a framework that supports autodidactic activities, operating under the assumption that everything is in everything.

At the moment, it operates as follows:

FIRST Classes are proposed by the public (*I want to learn this* or *I want to teach this*);

THEN People have the opportunity to sign up for the classes (*I also want to learn that*);

FINALLY When enough people have expressed interest, the school finds a teacher and offers the class to those who signed up.

The first class, on October 4, reviewed all proposals and decided to offer the following classes:

214 The Democratic Museum A Half-Day Seminar
Instructor **Elysa Lozano**

Drawing from sociologist Joyce Rothschild's definition of a democratic workplace and Heckscher and Donnellson's post-bureaucratic network organization, we will look at artist co-ops and project spaces that exemplify these structures. Is it possible to design a complex museum or gallery structure that retains the non-hierarchical attributes of start-up exhibition spaces? In the second part of the seminar we work in groups to build several proposals for new museum organizational structures.

222 Blubber, Bowlines, and Boat Hulls
Instructors **Adam Katz and Caleb Waldorf**

This course would involve reading selections from Herman Melville's 1851 novel *Moby Dick*, plus a self-guided introduction to boat hulls, fluid dynamics, and nautical knots. Each session would focus on a specific section of *Moby Dick*, a partial overview of technologies/histories of boat construction, and nautical knot-tying techniques. The course would meet four times at LACMA with the possibility of continuing at The Public School afterward.

224 ***One Place after Another (Is Never the Same Place)***
Instructor **Robert Summers**

This two-meeting course, which will, I hope, take place first in one space of the Serra in which we will perform a close reading of and discuss Miwon Kwon's essay "One Place after Another" and a selection from Fredrick Jameson's *Postmodernism, Or, the Cultural Logic of Late Capitalism* on the Bonaventure Hotel, and in the second Serra space, on a different day, we will perform a close reading of and discuss Amelia Jones's "(Post)Urban Self Image," which critiques the (conscious or unconscious) blind spots of Kwon's essay and Jameson's chapter section and moves out toward a feminist-postcolonial-poststructuralist reading of space/place and so-called "site specificity."

225 ***The Economy of Giant-Ass Sculptures***
Instructor **Kelly Marie Martin**

A conversation in four parts, each part in a different cavity of the *Band*: "Economy of Material," "Economy of Culture (I): Serra," "Economy of Culture (II): Hirst & the Market," "Econ of Icon." I would like to facilitate a discussion about the shape-shifting duality of the word "economy" as it applies to Serra's *Band* in terms of material, the artist, and the current economic crisis. I would like to do this by moving through the sculpture.

> "You cannot separate a Picasso or David Smith sculpture from the welding torch. You cannot separate the *Spiral Jetty* from the bulldozer used to move those rocks into place." —John Perrault

230 ***Ekphrasis/Filling in Serra's Spaces: Writers as Artists Reacting to Art***
Instructor **Erika Szostak**

First, what is *ekphrasis*? Simply put, ekphrasis is "the vivid and poetic response to and description of a work of art."

I propose an *ekphrasis* workshop in which we compose artistic responses to a piece of art while we sit inside that art. As we sit inside Serra's piece, literally filling in space, we can figuratively fill in untold pieces of the narrative. *Ekphrasis* often functions as a sort of *midrash*, telling the stories that get left out of the original: what came before the feeling/scene depicted in the piece, what came after, what came beside?

www.thepublicschool.org

THE PUBLIC SCHOOL *RICHARD SERRA READING ROOM*

In the weeks leading up the *Field Guide*, Machine invited Telic Arts Exchange's The Public School, an autonomous educational entity, to host a series of classes inside Richard Serra's monumental installations.

Inside Richard Serra's *Sequence*, 2006

LEARNING FROM LEARNING

Machine Project Workshops as a Laboratory in Context KEN EHRLICH

A group of crocheters in the courtyard making cloth birds to inhabit Chris Burden's *Urban Light*. Nearby, a boisterous bunch huddling around tables learning to solder components for a simple hand-held synthesizer. Between BCAM and LACMA West, a flurry of activity as visitors study images of ancient artifacts and produce cardboard and papier-mâché replicas. Families congregate on a second story balcony to learn basic woodworking techniques to create homes for nesting bird species. A cluster of crocheters hunched over tables surrounded by modernist paintings, acquiring techniques to transform strips of plastic bags into a hyperbolic coral reef. Near the entrance to BCAM, groups figuring out how to cut wood, operate small motors and put simple hardware to use in the creation of ambling automatons.

The workshops that took place during the *Machine Project Field Guide to LACMA* event, which are documented in this catalogue, are an extension of Machine Project's ongoing and evolving commitment to offering classes and workshops in a wide range of subjects, from sewing and electronics to computer programming and musical instrument construction. The usual format of advance registration and fee structure that Machine typically employs gave way to more porous and open-ended workshops at LACMA, in which museum visitors could engage a workshop as a participant or a viewer and the number of "students" fluctuated dramatically throughout the day. Museum-goers wandered in and out of the workshops, looking, listening, curious and amused. The unique circumstances of the Machine Project workshops at LACMA might be best understood in relation to existing educational programs in museums. The difference between the standard format of a museum's education department programs and the workshops designed for Machine Project's takeover of the museum is the investment in the cultural value of the objects within the museum. Traditionally, museum education programming, however dialogic or critical, aims to invest the objects held by the museum with cultural value. Machine Project's pedagogical offerings, by contrast, had no such investment. What, then, is their goal? I want to focus here on the educational programming at Machine Project, and the particular instance of the workshops offered at LACMA, within the larger context of alternative education experiments and a recent "pedagogical turn" within contemporary art practice and institutions.

Each workshop offered during the *Machine Project Field Guide to LACMA* was conceived by an individual artist or artist collective. In *Birds for Chris Burden*, Cheryl Cambras transformed her practice of crocheting cloth birds into a do-it-yourself learning session during which museum visitors complimented *Urban Light* with colorful strings of fuzzy companions. In *Synthesizer Workshop with the Machine Project Electron Wranglers*, Clay Chaplin, Pelle Henkle, Lewis Keller, Phillip Stearns, and Henry Solis instructed participants on basic soldering techniques for constructing small handmade synthesizers. Liz Glynn oversaw the transformation of the museum's trash into replicas of the classical sculpture collection in workshop called *Replica, Replica, for W.R.H.*, referencing William Randolph Hearst, who donated much of the museum's classical collection. Ryan Taber presented *Phylogeny and the Multiplex*, which he described as "a hands-on demonstration of avian nesting box building techniques using

materials recovered from the LACMA grounds and your favorite materials from home, culminating in the construction of a sculptural nesting box community space. For birds." Christine and Margaret Wertheim of the Institute for Figuring led the workshop on how to crochet plastic bags into models of hyperbolic space to be integrated into their ever-evolving Crochet Coral Reef Project, which combines feminine handicraft, higher geometry, and environmental awareness. In his workshop entitled *Foal Army (Budget Cuts)*, Douglas Irving Repetto helped participants transform simple materials into walking wooden creatures. In all of these workshops, the process of participation enabled museum visitors to become more than spectators. The line between artist and audience blurred slightly, and through experiential learning, an unusual shift in the terms of museum spectatorship occurred.

To hear Machine Project founder Mark Allen describe it, the initial impulse to offer classes and workshops in Echo Park came out of a basic experience probably not so uncommon in graduate art programs. Interested in electronics and looking for ways to integrate his art practice with experiments in technology, Mark began to teach himself basic electronics. It was a slow and somewhat grueling process—without the classes he needed, he had to invent the classes he wanted. In the process, he realized that if someone could teach the very fundamental aspects of even a complex subject, one might more quickly begin the process of self-education. In this way, the classes at Machine began both with an eye towards demystifying ever more complex technologies and as a way to share forms of knowledge. The do-it-yourself ethos that surrounds Machine Project workshops is part of a much larger cultural context that seeks a democratization of technology. It's not surprising, then, that many of the computer-related classes at Machine are based on open-source software. The variety of classes offered at Machine indicates, however, that the inspiration for learning is motivated by a broad interest in the intersections of art, science, and music rather than a specific agenda related to the politics of proprietary software.

Machine Project's classes and workshops can be related to and situated within the dynamic of Southern California art schools. The evolving social network around Machine Project classes—and Machine Project in general—is in many cases an outgrowth and extension of art school education. In a sense, the informal education program is a parallel to the formalized art education model that has exploded in Southern California in recent years. In response to the growing corporatization, professionalization, and bureaucratization of art education, some critics have condemned the increasing proliferation of MFA art school programs. They argue that, through the MFA programs, students are asked to accept certain educational conventions in the same way they are asked to accept the logic of the market: *there is no alternative*.

But rather than simply critique the existing art school models, a more interesting question might be: How are various models of pedagogy informing artistic practice? Or more generally, what is it that leads artists toward an engagement with pedagogy as part of an artistic practice? In fact, beyond the growing numbers of artists who teach alongside their artistic practice, there are those whose artistic practice in fact consists in a kind of engagement with critical pedagogy. It is precisely *through* an engagement with institutions that pedagogy has become an integral aspect of contemporary artistic practice. Whether formal or informal, the classroom seems to be a space where artists are attempting to embody theory as activity. And besides, who can deny the seduction of the pedagogical mode that resists reification or the impulse to learn from learning?

Over the last several years, Los Angeles has seen the rise of a number of alternative educational experiments. In many ways, Machine Project classes and workshops are at the center of this activity. Importantly, all of these endeavors were initiated by artists and operate either as an extension of artistic practice or alongside an art career. Needless to

say, none of these institutions are accredited, nor do they offer degrees. The Mountain School of Arts, founded in 2005 and operating out of a loft above a Chinatown bar, accepts fifteen students for a three-month term, charges no fees, and encourages engagement with other educational institutions. Sundown Schoolhouse began in 2006 as artist Fritz Haeg shifted gears away from the generative salons he had been hosting at his domestic hilltop dome and towards an educational framework structured on flexibility. Initially housed in Haeg's geodesic dome and eventually taken on the road to a variety of art venues around the country, the Schoolhouse offered seminars, classes, and workshops that ranged from day-long affairs to longer series and included classes in everything from yoga and dance to sustainable food practices and marine ecology. Artist Anton Vidokle has also initiated a series of events based on the model of the seminar and workshop, including the Night School, a temporary school in the form of an artist commission at the New Museum in New York, and United Nations Plaza, a series of seminars organized in Berlin. Vidokle also is an editor of the journal *E-flux*, which has published articles on the "pedagogical turn" in contemporary art and on the notion of research as art. Perhaps most interesting in structure in Los Angeles is the relatively new Public School, a project of Telic Arts Exchange. The Public School creates a curriculum framework simply by inverting the usual process through which course offerings are determined. That is, anyone may propose to teach a class and if enough students are interested in the class, the class is organized. A student may also propose a class they would like to take and the facilitators of the Public School will try to find someone to teach it (the Public School organized reading groups in Richard Serra sculptures at LACMA in the weeks preceding the *Machine Project Field Guide to LACMA*). This model takes the informal structure and the "open to suggestions" model common among these experiments a step further by activating a distribution of the hierarchy of the pedagogical program. Machine Project classes often end up informally organized in a similar way; someone who takes a class may end up proposing another class to teach.

It is within the broader context of these educational experiments that we can think about Machine Project's program of classes and workshops. While there seems to be an obvious connection to the visionary utopianism of pioneering art school predecessors like the Bauhaus and Black Mountain College in terms of refusing the conventional disciplinary boundaries of a typical art education, a more meaningful network of associations might be found through a reconsideration of the liberation pedagogy of the Brazilian activist and author Paulo Freire. In *Pedagogy of the Oppressed*, Freire attempted to describe an active, dialogical model of education in which the standardized, stale dynamic between students and teachers—what he called "the banking model of education," which treats students' supposedly "empty" minds like a bank waiting for the deposit of meaningful knowledge from the teacher—is reconsidered through a process of "critical consciousness." Developed in the 1970s in the context of postcolonial discourses and heavily influenced by Frantz Fanon, critical consciousness relied on Marxist class analysis to develop a framework for revolutionary education. To reimagine the student as an active agent rather than a passive recipient in the formation of new structures of knowledge was, for Freire, the first step towards a total transformation the social order.

In an article titled "Cultural Action and Conscientization," describing highly technological, complex societies, Freire states:

> In order to function, these societies require specialties, which become special-isms, and rationality, which degenerates into myth-making irrationalism.
> Distinct from specialties, to which we are not opposed, specialisms narrow the area of knowledge in such a way that the so-called specialists become generally incapable of thinking.[1]

It seems obvious that neither Marxism, nor strict class analysis, nor revolutionary rhetoric, nor even radical pedagogy itself hold the sense of potential they did in Freire's heyday. And yet if it is possible to retain a certain amount of idealism regarding the potential for *learning*, then Machine Project's educational endeavors might simply demonstrate by example an argument against "specialisms." Machine Project does not explicitly reach out to the "oppressed." Instead, through workshops it offers highly refined knowledge and specialized skills in a manner that is broadly accessible. In its programming in general, and especially through classes and workshops, Machine spotlights the specialties of members of an extended community of artists, scientists, musicians, programmers, and others in a process of learning that actively discourages the narrowing of knowledge.

The integration of lifelong learning is one of the educational concepts that has motivated and structured workshops at Machine Project. Learning is not seen as something outside of the process of everyday life. The fact that participants of all ages were able to drop in on the workshops throughout the day at LACMA highlights this informal quality. Mark Allen suggests that "there are parallels between models of education and models of spectatorship: just as people learn differently, people see differently." An interest in experiential learning and the search for ways to make esoteric knowledge accessible to as broad a public as possible remain fundamental principles that guide Machine Project. The workshops offered at LACMA taught practical skills in the service of impractical objects. While teaching participants to do and to make, the workshops remained unprogrammatic. It is precisely this engagement with curiosity, as opposed to results, that produces a meaningful pedagogical program. With its experimental pedagogy and through the workshops offered at LACMA, Machine Project asks questions through doing: What do we imagine education to be? What needs to be unlearned? Can we educate ourselves to think and do things we can't yet imagine? These are questions that are not easily answered but may simply require further active learning.

1. Paulo Freire, *The Politics of Education: Culture, Power and Liberation* (South Hadley, MA: Bergin and Garvey, 1985) p. 88.

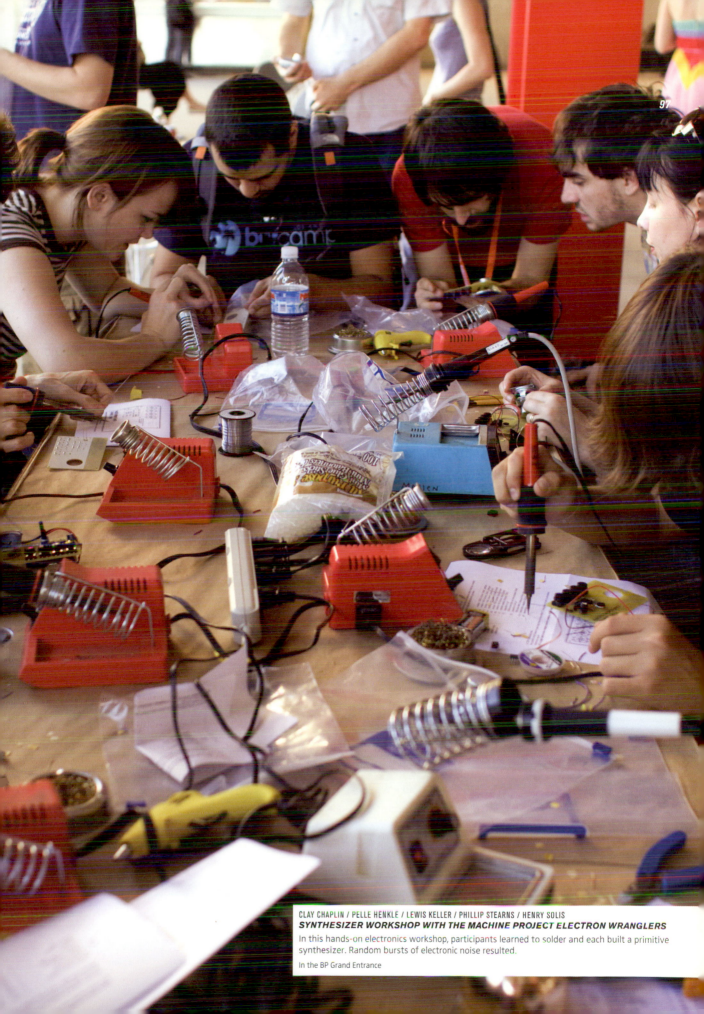

CLAY CHAPLIN / PELLE HENKLE / LEWIS KELLER / PHILLIP STEARNS / HENRY SOLIS
SYNTHESIZER WORKSHOP WITH THE MACHINE PROJECT ELECTRON WRANGLERS
In this hands-on electronics workshop, participants learned to solder and each built a primitive synthesizer. Random bursts of electronic noise resulted.

In the BP Grand Entrance

HAPPY CUTE AMIGURUMI BIRD
PATTERN BY CHERYL CAMBRAS

<div>

Materials

Worsted weight yarn (pictured birds made w/4-ply Lily's "Sugar 'n Cream" 100% cotton):

- ☐ 1 skein in color of your choice (body) MC
- ☐ 1 skein orange (beak & legs) CC
- ☐ 1 skein black (eyes, optional—can also use buttons or other items)

Plus:

- ☐ Crochet hook—size E (3.5 mm)
- ☐ Plastic yarn needle
- ☐ Soft stuffing material
- ☐ Stitch marker

</div>

CC = Contrast Color
CH = Chain
CONT = Continue, Continuing
DEC = Decrease
DPNS = Double-Pointed Needles
INC = Increase
K = Knit
MC = Main Color
REM = Remaining
REP = Repeat
SC = Single Crochet
SL = Slip Stitch(es)
ST(S) = Stitch(es)

Body (using MC)

Slip knot

CH 4, use SL ST to connect 4th ST to 1st ST, to make a ring

Rnd1: SC 8 in center of ring

Rnd2: 2 SC in each ST (16 STS); place stitch marker on last stitch and continue to place on last stitch of each following round

Rnd3: SC 1, 2 SC in next ST, REP 8 times (24 STS)

Rnd4: SC 2, 2 SC in next ST, REP 8 times (32 STS)

Rnd5: SC 3, 2 SC in next ST, REP 8 times (40 STS)

Rnd6–Rnd11: SC in each ST, REP for 6 rnds

Rnd12: SC 8, DEC 1, REP 4 times, (36 STS)

Rnd13: SC 7, DEC 1, REP 4 times (32 STS)

Rnd14–Rnd18: SC in each ST, REP for 5 rnds

Attach Legs

Legs (using CC)

CH 15, turn and SC one row; tie knot; thread yarn needle; pull approx. 1/2 inch of top of leg from outside bottom of body to inside; sew securely in place (make 2).

Embroider beak and eyes

Rnd19: SC 3, DEC 1, REP 6 times, SC REM 2 STS (26 STS)

Rnd20: SC 3, DEC 1, REP 5 times, SC REM 1 ST (21 STS)

Remove stitch marker and stuff body

Rnd21—top of bird's head: SC 2, DEC 1*, REP until 7 STS remain

Finishing

Add final stuffing; leave a tail of 6 inches; thread yarn needle; tie knot; weave yarn through outside of each of 7 STS; tie knot; pull yarn end through body to hide and cut.

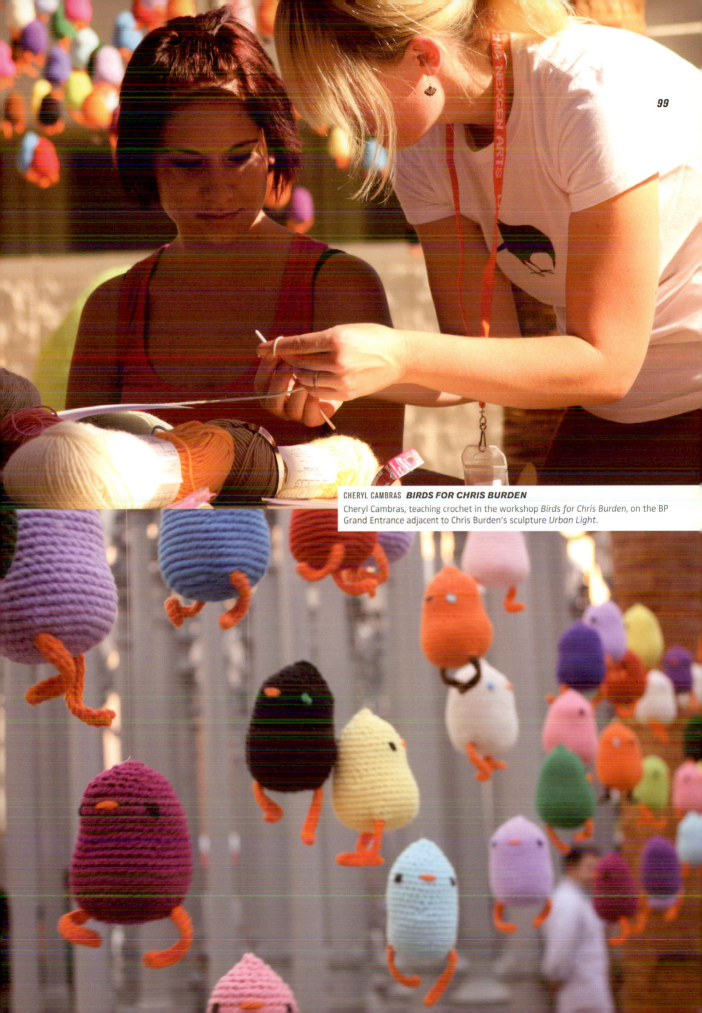

CHERYL CAMBRAS ***BIRDS FOR CHRIS BURDEN***

Cheryl Cambras, teaching crochet in the workshop *Birds for Chris Burden*, on the BP Grand Entrance adjacent to Chris Burden's sculpture *Urban Light*.

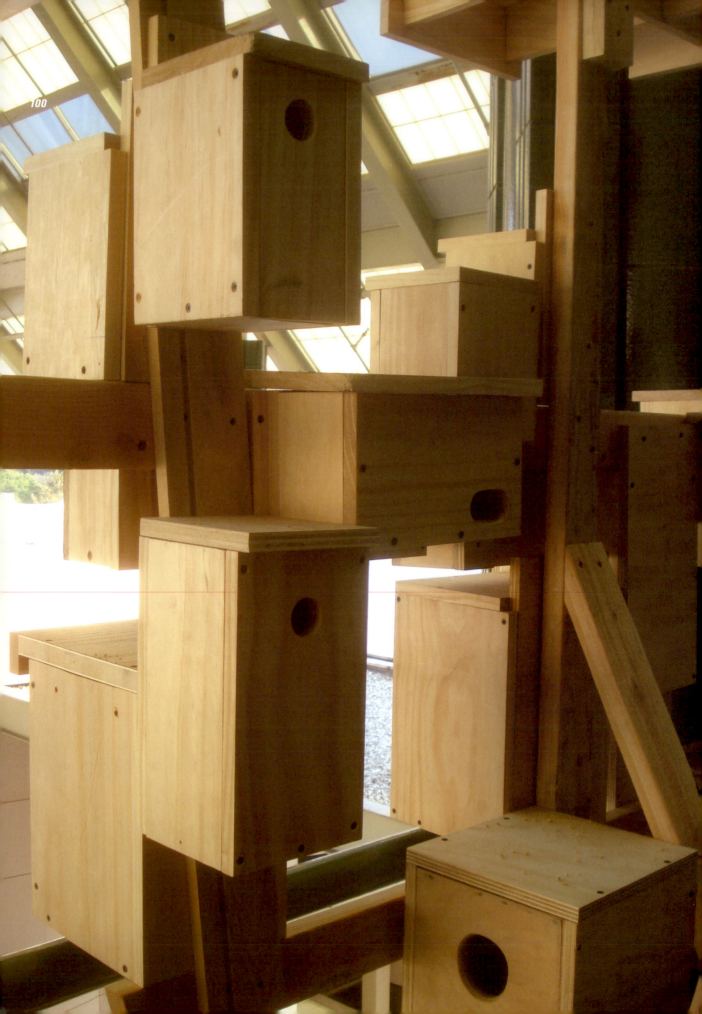

PHYLOGENY AND THE MULTIPLEX
Building a Nesting Box Community Demo *RYAN TABER*

In approaching the LACMA show, I started with a common strategy: to look at the expanse of the museum grounds, its collection, its architecture, and ask "What's missing?" What sort of interpretation can I add to this place that would be so outlandish that its absence has never occurred to museum visitors?

When I first mentioned to Mark Allen that I wanted to do a project that included building nesting boxes, I knew I wanted to do something that wouldn't require spending money or using any new materials. I didn't want it to be disposed of after the show, and I didn't want to store it. I also knew I wanted to do something that would have a life following a day at LACMA.

Before Mark and I walked through the museum, I had come to fancy the balconies on the fourth floor of the Art of the Americas Building. My friend Noah Peffer and I had spent some time up there about a year before the Machine Project event strategizing ways to climb from this point out onto the roof, purely as recreation. At the time, I'd noticed these strange-looking

speakers mounted around the eaves. We figured they were probably some sort of sonic device to keep birds away, as I realized that there was literally not one bird in sight.

So the balcony was a logical starting point when looking for good Machine Project workshop spaces. After Mark and I visited the balcony on our trip, we went inside the fourth floor to look at the installation of Mesoamerican art from the museum's permanent collection that had been designed by Jorge Pardo. Having worked in carpentry shops for years, I started to calculate the number of 4x10-foot sheets of fiberboard that had been used to create the displays, and started thinking about the amount of energy that went into producing just one of those sheets.

At this point I decided to use scrap from LACMA's carpentry shop to construct bird houses. I like the idea of using the waste from the museum's display apparatus to create a new form of cultural production. I went to the shop twice and collected scraps, then set to work turning fiberboard into as many nesting boxes as I could with as little waste as possible.

To do this I designed a series of kits that could be used to build nesting boxes for nine different bird species. These species were determined by two criteria. First, the dimensions of their ideal nesting boxes would allow me the highest yield from the dimensions of the wood I'd collected. Next, I chose species that were rare, extirpated, or undocumented breeders in Los Angeles county. I was really interested in the idea of encouraging species that are not part of the local ecosystem to occupy or return to Los Angeles County as well as the implications of this gesture. Finally, I made a total of fifty-four nesting box kits and headed to LACMA.

On the day of the exhibition, some friends and I set up a series of tables on the balcony, played a CD of birdcalls, and began building a temporary nesting box community. All the scrap that I'd collected that had been unsuitable for boxes went into creating the infrastructure for the community. I built birdseed fountains and pools along armatures that were used for the completed nesting boxes. Visitors to LACMA were invited to select a kit for their home environment and assemble it using the tools we had set up. When a visitor completed a box, he or she would choose its position on the armature and the box would be attached. At the end of the evening, these boxes had come together to create a makeshift avian community that hung menacingly over the edge of the balcony, fifty feet over the outdoor dining area on the Los Angeles Times Central Court.

The next day, this miniature favella was taken down and each box was documented. I'm currently undertaking the process of contacting each person who built a box, then delivering and installing the box at a location they've chosen somewhere in Los Angeles County. I delivered the first of these to a participant living in Long Beach. Because he lived in an apartment, it was a challenge for us to figure out where the box should be mounted to ensure the safety of the birds and to allow the box to be visible from the windows of the apartment building. We decided that an adjacent telephone pole would be the best option. After climbing the pole and installing the birdhouse, we were detained by two Long Beach police officers who were surprisingly sympathetic and released us with only a trespassing warning.

Once the last of the nesting boxes are installed, I hope to stay in contact with the participants to document any indigenous species that move into the boxes, taking the place of those for which the birdhouses had originally been built.

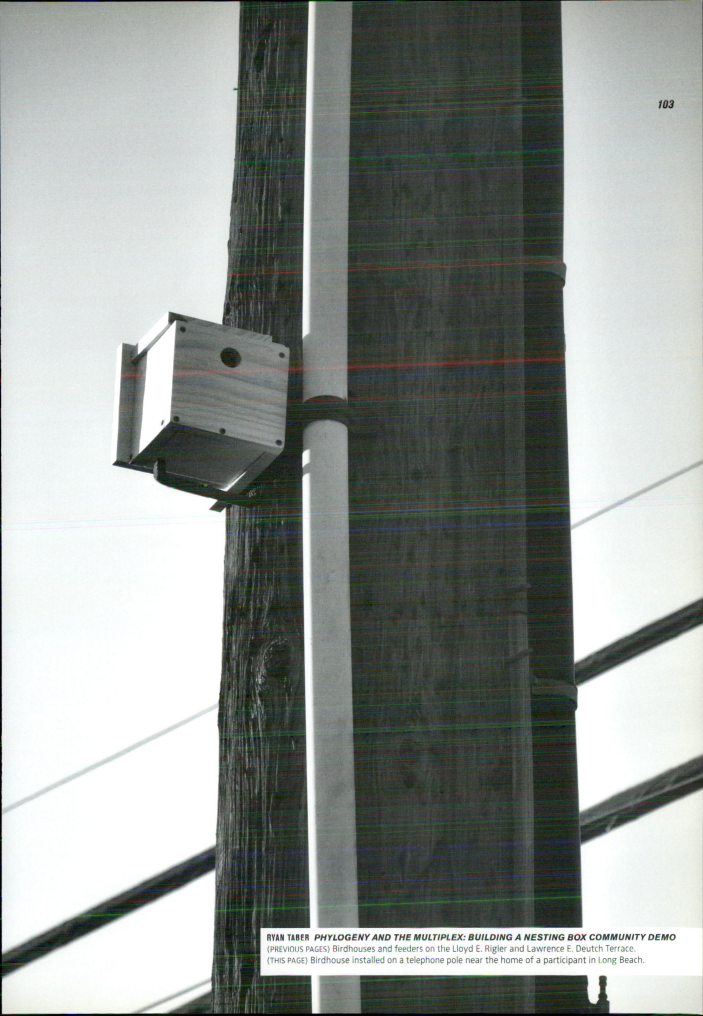

RYAN TABER *PHYLOGENY AND THE MULTIPLEX: BUILDING A NESTING BOX COMMUNITY DEMO*
(PREVIOUS PAGES) Birdhouses and feeders on the Lloyd E. Rigler and Lawrence E. Deutch Terrace.
(THIS PAGE) Birdhouse installed on a telephone pole near the home of a participant in Long Beach.

ANDRE, YOU FORGOT ABOUT THE FIRE MICHAEL O'MALLEY

The mobile oven actions are day-long workshops/conversations on oven-building, naturally leavened dough, gardening, art, and food.

These ovens are based on the Roman ovens and are fantastic for all kinds of food, including making pizza, baking bread, roasting meats and vegetables, and dehydrating vegetables. This version is a temporary oven; refer to Alan Scott's book *The Bread Builders* for great details on making a permanent oven.

Mobile Oven Action Instructions:

1. Begin with a noncombustible substrate.

2. Since the fire will be built directly on this surface, it's important to use a stable brick that is not adversely affected by high temperatures. Lay out firebricks over the noncombustible substrate.

3. Place side walls firebricks on end. For the back of oven, the firebricks are stacked flat.

4. Build an arch that spans the width of the hearth. If the oven is a temporary one, you will need to apply some kind of force to the outside walls to prevent the arch from collapsing. This can take the form of threaded rod and plate or some heavy, noncombustible material that leans against the wall. (Think the flying buttresses of Chartres.) Place shims under the legs of the arch. After all of the bricks are in place and you have wedged little chunks of brick in the gaps formed by the bricks in the arch, pull out the shims. The arch form will drop down and you can move it to the next row. Don't worry about the gaps; these will be filled with a fireclay and sand mix to make the oven airtight.

5. Construct the chimney. Form two stacks of brick, one on either side of the front of the oven. They should be stacked up about 10 inches. Next place a couple of pieces of metal from one stack of bricks to another. The chimney flue will rest on these pieces of metal. Surround chimney with additional bricks for support.

6. Mix fireclay and sand in a 5-gallon bucket in a ratio of 1 part fireclay to 4 or 5 parts sand. Add water and mix together in a thick paste. Smear into gaps and make an airtight oven. This is not mortar, so it breaks down after firing. It is not necessary to wait for the fireclay/sand mix to dry before starting the fire.

7. Build a small fire to start. Use fireclay to plug any escaping smoke. Since the fire in the oven is contained, generally there are no codes about building or firing. Only use solid stock wood; do not use plywood, particle board, or painted wood, all of which are bad for pizza and bad for the environment. Pallets are great: they are made of hard wood and contain no chemicals. Don't worry about the nails. They will get pushed to the back with the bed of coals.

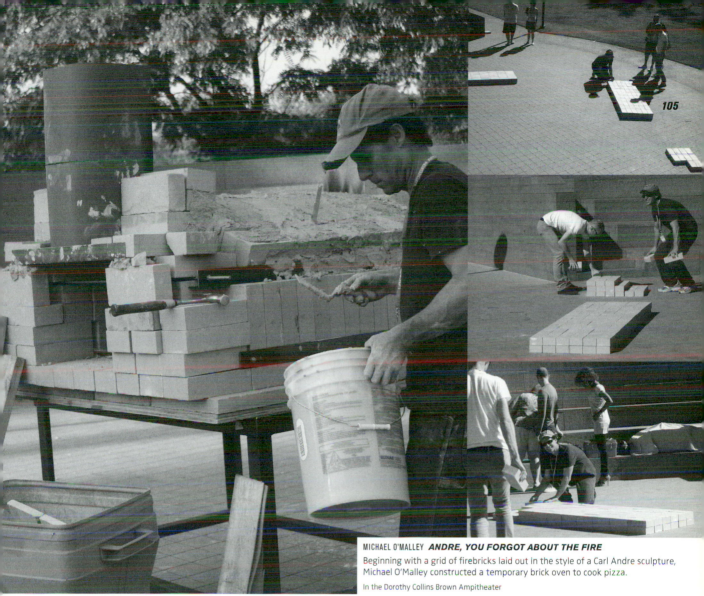

MICHAEL O'MALLEY *ANDRE, YOU FORGOT ABOUT THE FIRE*
Beginning with a grid of firebricks laid out in the style of a Carl Andre sculpture, Michael O'Malley constructed a temporary brick oven to cook pizza.

In the Dorothy Collins Brown Ampitheater

8. When keeping the fire, let the fire do the work. Do not add too much wood. Let the fire burn down and then build it back up. The oven works on the principle of getting heat into the bricks. Fire for a couple of hours.

9. Prepare ingredients.

10. Pizza should take about 2 minutes to bake at 750 degrees. At this temperature, the corn meal burns almost instantly.

RECIPE FOR *LACMA PUBLIC FRUIT SALAD*

*3 cups of grapes, red
 and/or green*
1 c peaches
1 c orange segments
1 c melon
½ c apples, preferably tart
½ c apricots
½ c wild strawberries
½ c cherries, if in season
½ c currents, if available, or
½ c persimmon seeds

2 tbs lemon juice
4 tbs orange juice

Gather fruit carefully, taking care not to damage the art in which it appears. Consider that some fruit may be valued more for symbolic reasons, others for status, and some for pure intensity of flavor. Dice, cube, or segment as appropriate. Combine lemon and orange juice, add fruit, mix, and let macerate for about an hour.

May be accompanied with cheese, cold lobster or oysters, and bread, if desired. Serves 4–6.

FALLEN FRUIT *LACMA PUBLIC FRUIT SALAD*
This fruit salad reflects the combination and approximate proportions of the fruit found in the Los Angeles County Museum of Art. Its purpose is to give you a taste of the permanent collection.

INSTITUTE FOR FIGURING
CARLIN WING

Carlin Wing Tell us about your experience on the day of the event. Was there anything in particular that made it different from the other times you have conducted these workshops?

Margaret Wertheim We had huge amounts of people there from the beginning and all through the day, which I was thrilled and amazed by, but I had very little time to go and see other events. I wish I'd been able to be a participant and an attendee. It was sort of one or the other. What was lovely was that people could come and stay all day or stay for half and hour or ten minutes.

Carlin Is there anything you like about the museum site in particular?

Margaret What is interesting to me is that when one presents workshops in an art gallery or museum setting, one is helping to break down the notion that art is just something done by the experts. I think that we, like Machine and other groups like Fallen Fruit, look at aesthetic experiences as something that everybody can participate in. The *Field Guide* embodied that: it wasn't just about going and viewing the art, it was being involved in the making of art.

Carlin How much of the reef got made that day? The work that was made is not in the traveling show, right?

Margaret It's rare in a workshop that someone will complete something that actually can go in the show, because often they're just learning the techniques. We got a few pieces made out of plastic that got incorporated into the toxic reef traveling show, but it is not necessarily the goal of the workshop to have people to complete the thing. What's important to the participants is the experience. It is important for them to see a confluence of mathematics and feminine handicraft, as well as the environmental aspects of the ocean trash problem and about the way global warming is devastating reefs. The idea that you need to shield people from too much information or too much learning within a context that's meant to be fun is nonsense.

Carlin The emphasis on process over product seems to be where your piece connects with a lot of the projects for the event. These types of projects stand in direct contrast with the way museums operate object-oriented collections and exhibitions most of the time.

Margaret Chrissie [Christine Wertheim] and I coined the term "feral institutions" for an article in *LA Weekly* in 2002 because we thought it was a really important and interesting part of what was happening specifically in Los Angeles. Since then the feral institutional scene has really exploded in Los Angeles with groups like Machine Project, Fallen Fruit, the Shed Research Institute, and Materials and Applications. One of the things that all of these institutions have in common is the emphasis on participatory activity, and the breakdown of the notion that on one side is the

audience and on the other side is the artist. These little institutions are not only bringing about a new model of what artistic engagement can be, but also new models of what artistic organizations can be. These structures are attempting to be a lot more egalitarian, nonhierarchical, and in some sense democratic in practice and idea.

Carlin It seems as if we're in the middle of a shift where some of L.A.'s most established art institutions are paying attention to institutions like you and Machine. Can you imagine how those relationships are going to develop in the future, and do you have any wishes in this regard?

Margaret It was fantastic that LACMA did that event. I think that a lot of big institutions in Los Angeles are now looking to these little feral institutions because I think that the feral institutions are actually where the most vital and interesting things are going on in the L.A. art scene. These big institutions rightly sense that the little institutions are not only doing things in new ways, but they are engaging a wide set of audiences who might not come to their blockbuster shows. I think we will see more of it.

One of the issues that it raises is that the little institutions have operated on almost no budget, and that has been a challenge for all of us. I hope that the success of the *Machine Project Field Guide to LACMA* event might galvanize some funders to understand that little institutions need real structural support, not just on a project-by-project basis. We can apply for little grants to do this show, or publish this book, but what little institutions are really urgently needing is what big institutions have: ongoing support to pay for things like the general overheads like very basic salaries, rents on spaces. This is one of the reasons why little institutions historically have had a half-life which seems to be about five years. I would hope that the success of things like the Machine Project day might convince some funders that there is a new kind of institution coming into being that is truly valuable.

Let me end by pointing to Ant Farm, one of the greatest feral institutions ever. Their actual working career was, I think, no more than five years; it might have even been less than that. They have had an enormous impact and inspired so many things and so many people, and they are one of the things that inspired Chrissie and me to do the Institute for Figuring. It's like what the quantum theorists talk about: this quantum sea of possibility foaming in the city of Los Angeles and these little universes burst into being from out of the quantum foam. But many of them have this bright fizzing life for a couple of years and then they fizzle out. I hope that somehow that there could be a sea change [that] could bring about processes for supporting these institutions and allowing them to exist in their own ways, for more than just a few years.

I think that's a good wish.

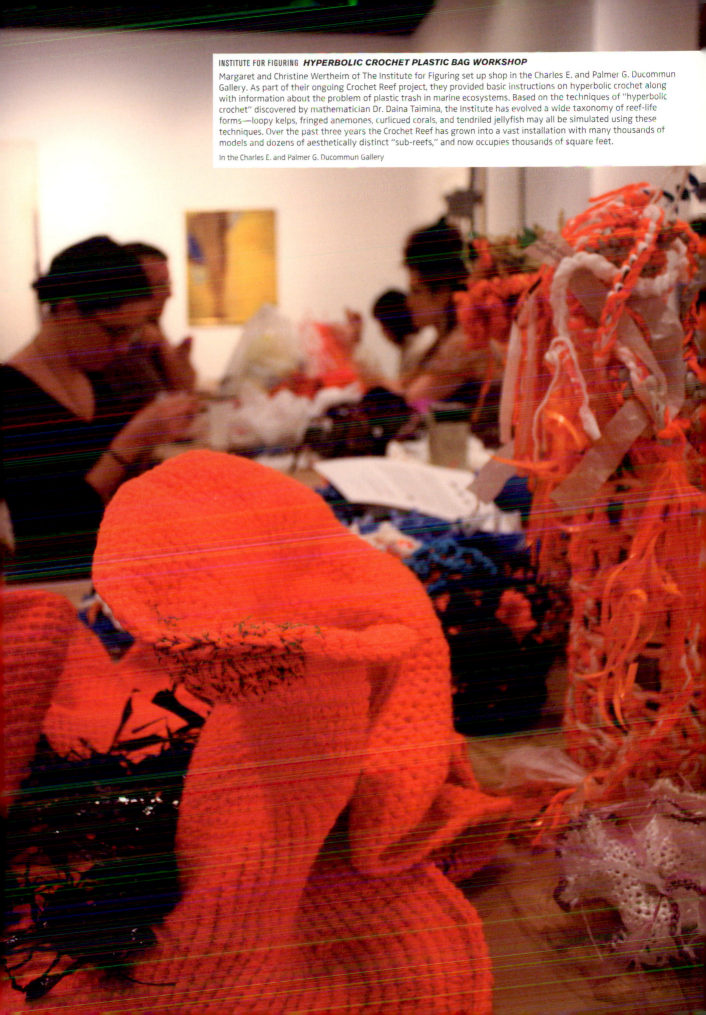

INSTITUTE FOR FIGURING *HYPERBOLIC CROCHET PLASTIC BAG WORKSHOP*

Margaret and Christine Wertheim of The Institute for Figuring set up shop in the Charles E. and Palmer G. Ducommun Gallery. As part of their ongoing Crochet Reef project, they provided basic instructions on hyperbolic crochet along with information about the problem of plastic trash in marine ecosystems. Based on the techniques of "hyperbolic crochet" discovered by mathematician Dr. Daina Taimina, the Institute has evolved a wide taxonomy of reef-life forms—loopy kelps, fringed anemones, curlicued corals, and tendriled jellyfish may all be simulated using these techniques. Over the past three years the Crochet Reef has grown into a vast installation with many thousands of models and dozens of aesthetically distinct "sub-reefs," and now occupies thousands of square feet.

In the Charles E. and Palmer G. Ducommun Gallery

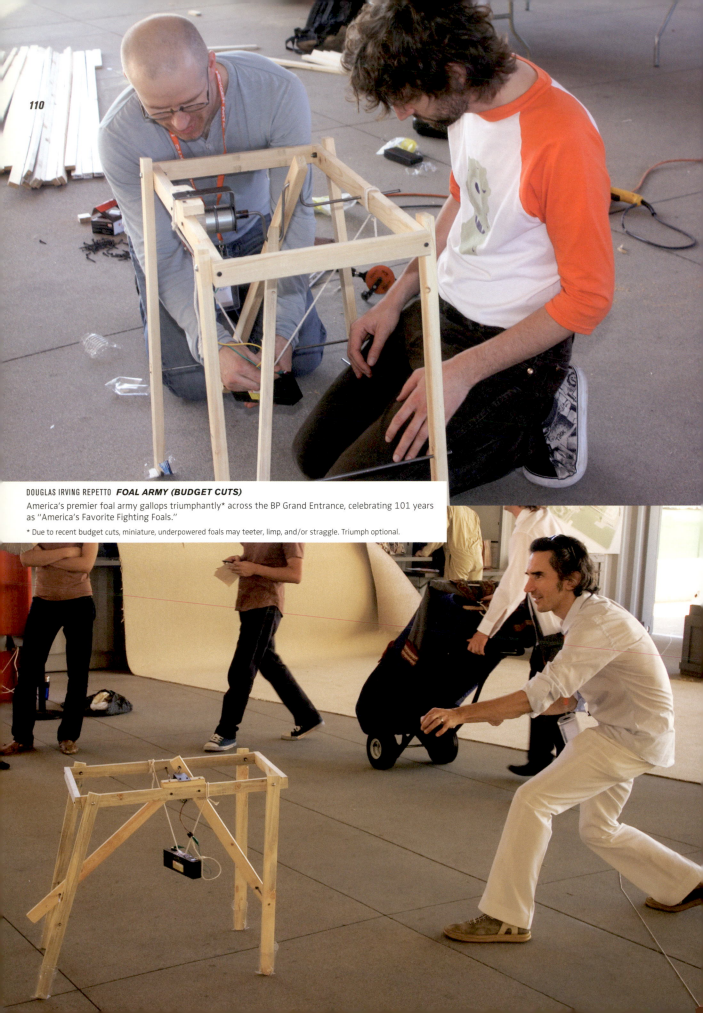

DOUGLAS IRVING REPETTO *FOAL ARMY (BUDGET CUTS)*

America's premier foal army gallops triumphantly* across the BP Grand Entrance, celebrating 101 years as "America's Favorite Fighting Foals."

* Due to recent budget cuts, miniature, underpowered foals may teeter, limp, and/or straggle. Triumph optional.

FOUR-LEGGED BEAST IN SEVEN EASY STEPS

DOUGLAS IRVING REPETTO

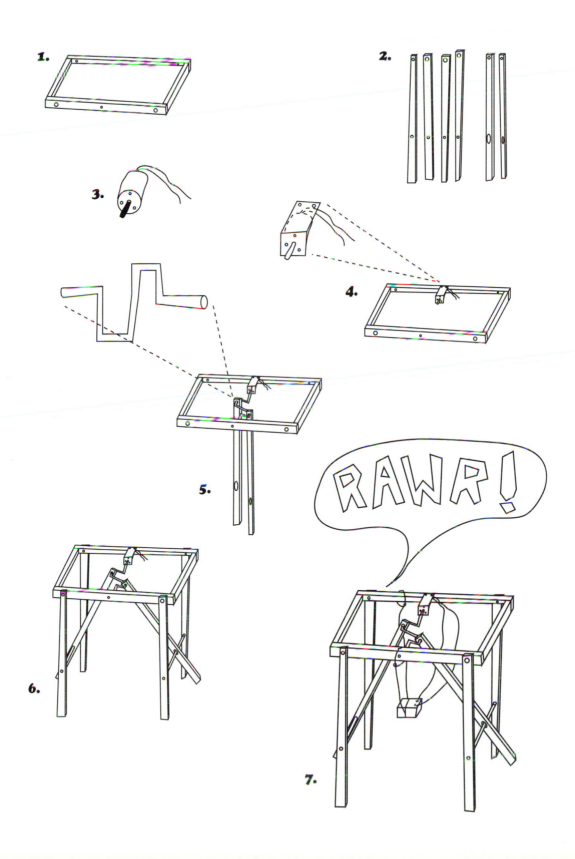

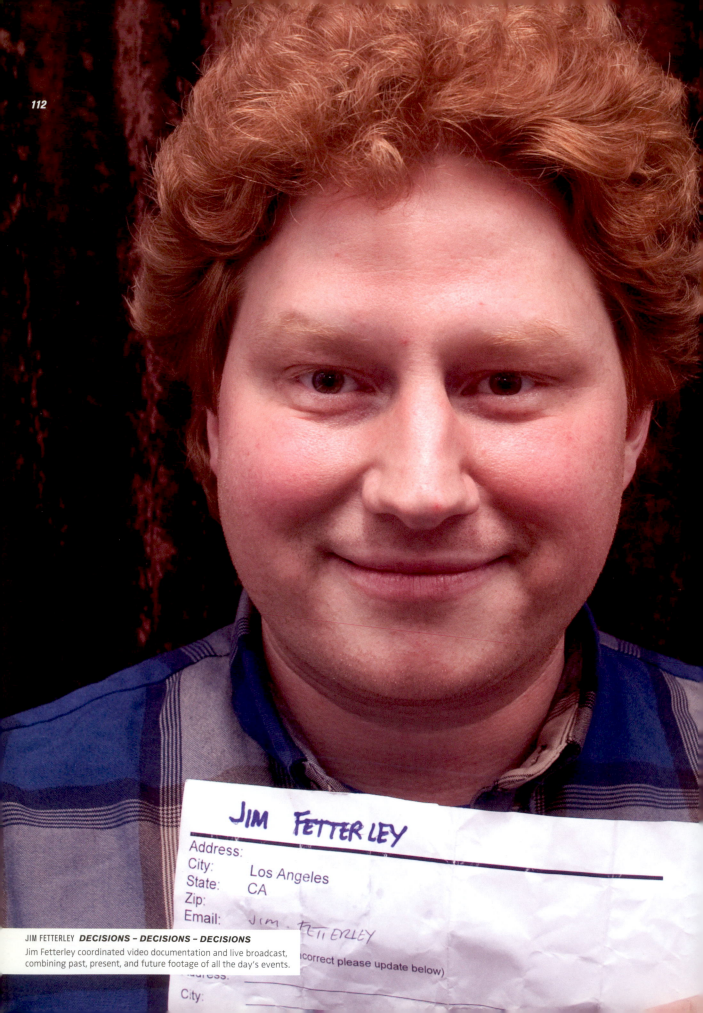

112

JIM FETTERLEY

Address:
City: Los Angeles
State: CA
Zip:
Email: Jim FETTERLEY

(If incorrect please update below)

Address:

City:

JIM FETTERLEY *DECISIONS – DECISIONS – DECISIONS*
Jim Fetterley coordinated video documentation and live broadcast,
combining past, present, and future footage of all the day's events.

5.

SAY IT WITH FLOWERS

CHARLOTTE COTTON

Impresario and showman Edward Steichen was a well-paid and highly influential Condé Nast photographer in the early twentieth century and the figurehead for photography at the Museum of Modern Art in 1940s and 1950s. He was also a passionate horticulturalist, but his devotion to developing new strains and colorations of delphiniums at his Umpawaug Plant Breeding Farm in Connecticut remained almost unknown for the first twenty-five years of his practice. Using his clout as the chair of MoMA's photography advisory council, and seemingly avoiding the museum's exhibition committee process, Steichen staged an eight-day exhibition of almost one thousand of his delphinium blooms from June 24 to July 1, 1936. Steichen was assisted by the museum's librarian, Beaumont Newhall, who became a groundbreaking historian of photography and MoMA's first photography curator in 1940. Steichen's exhibition divided its huge audience between those who comprehended the joy of breathtaking natural forms and were encouraged to appreciate and experience avant-garde and abstract art with the same pleasure, and those who saw the invasion of the country fair into the rarefied halls of MoMA as an attack upon its values.

Steichen's *Delphiniums* exhibition was on display after Alfred Barr's *Cubism and Abstract Art* and before *Fantastic Art, Dada, and Surrealism*, and I can't help thinking that Steichen, the master of timing, was offering up, with both wit and flair, a way into appreciating modern art forms through the visual language of flowers. I think that Steichen understood that whatever methods will get an audience to engage profoundly with art and culture are the ones that a sentient curator must follow.

In the late 1980s, I had my first truly meaningful museum experience when I visited the Boilerhouse Galleries at the Victoria and Albert Museum in London—at the time, a separate, temporary scheme for addressing "contemporary" culture within the matrix of world histories of art and material culture that the museum held in perpetuity. It was in this archetypal encyclopedic museum, where I began working as a curator of photographs a few years later, that I learned that there was ample space within a somewhat dusty institutional setting for conventions to be turned on their heads, and for the hybridization of culture, pleasure, and play to be magnificently staged.

In my first year at LACMA in 2007, the precedents of the museum's past were an especially galvanizing force for me. I knew that I would find my curatorial soul mates embedded within the museum's history: those now-anonymous figures that made a fertile ground from the juncture of past cultures with the present. I understood that the unique and special make-up of Los Angeles—a city where artistic practice has been strongly anti-institutional—meant that history had to be played out in the urgencies of real time and the present culture. There was the museum's Art and Technology program that ran from 1967 to 1970 and its eloquent garnering of creative reactions from artists and thinkers of that period about the climate for, and fusion of, the age-old divide of art and science; the Costume and Textiles department's 1973 commissioning of five photographers to document Los Angeles street style; LACMA's Institute for Arts and Culture in the 1990s; or the program of exhibitions, debates, and conversations within LACMALab from 1999 to 2006. They were all examples of how the permission to express a creative moment could be played out within the campus and collections of LACMA on its own terms.

For me, breathing life into LACMA was bound up in the magical, vernacular symbolism of flowers. At two fundraiser weekends (in the spring of 1991 and then 1992), close to fifty creative florists interpreted and intervened in the riches of LACMA's permanent galleries with their floral sculptures displayed through the museum's permanent galleries. I loved that these projects gained access to the museum and temporarily stood in for its "official" voice, via the gentrified art of flower arranging. This rather random and out-of-time manifestation of people doing their own thing at LACMA fueled my desire to make the *Machine Project Field Guide to LACMA* happen.

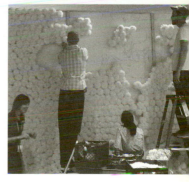

Over the course of the year that I worked with Machine Project and their cohorts to realize their *Field Guide*, my curatorial life at LACMA was inspired by the remembrance of what it felt like to engage with museum collections and spaces with fresh, playful eyes and the precedents already set by encyclopedic museum curators and the theatrical leaders of photography. It didn't feel irreverent or at all out of keeping with the city and its creative energy to offer up the museum as a site for our celebration of contemporary energies. Just as Machine Project embodies the spirit of artistic practice and the closeness art-making has to the lived experience of the city, LACMA's collections felt ripe for its harvesting.

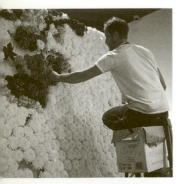

I was entirely seduced by the idea of replicating the homoerotic form of Thomas Eakins's *Wrestlers* painting in feminizing flowers and creating a floral critique. I was so seduced that I forgot the constraints of the space in the Arts of the Americas galleries, the scale of the painting, and how a work of art could lend itself to the participatory and theatrical aims of the *Field Guide*. Holly Vesecky and Josh Beckman kindly humored me by at least attempting to work out that recreating the *Wrestlers* painting was a logistical nightmare. They understood better than I how public and participatory (and even decadent) their floral gesture could be.

Holly and Josh instead settled upon the grand abstract Sam Francis painting *Toward Disappearance* in LACMA's newly installed modern galleries in the Ahmanson Building. The painting is predominantly white, with delicate traces of blues, reds, and greens, and the operatic scale of the work and its dynamic abstraction was a much better counterpoint to the floral endeavor. We rolled in the big frame and hundreds of water-filled vials containing debugged flowers into the gallery in readiness for our midday opening. During the course of the day, Holly and her team created a mesmerizing performance of sorts, each flower building her abstract "canvas" and the experience of every painting in the galleries for those who saw her at work entirely animated by the mimicry of the action and thought embedded in these precious museum objects. The gap between rarefied works of art and what it means for all of us to make and create was magically shortened into a heartbeat. I did, of course, think of Edward Steichen and hope that he was watching from his breeding farm in the sky at how marvelously the precedent he set was reactivated at LACMA.

By 6:30 on the evening of the *Field Guide*, as Holly and Josh's temporary masterwork stood complete and commanding in the gallery, it became pretty obvious to us that the work was too heavy for us to wheel out of the gallery safely in one piece. The only way to remove the canvas was to remove all the flowers. It was part of the magic of the *Field Guide* that what we had planned was transformed by both the pragmatics and the poetry of the unfolding day. A group of us removed the flowers into their carrier boxes and went about the Ahmanson building giving the flowers to our guests. By 7:30, there was the incredible sight of people carrying small posies of mainly white chrysanthemums, just like the tail end of a great wedding or very peaceful protest march. The following morning, as we cleared the final remnants of an amazing day at LACMA, the last remaining signs were the fragrant trail of petals through the galleries. The indelible mark upon the minds of those of us who were there on November 15—the who and what we are—had poetically and pragmatically fused the lived experience of creativity with the treasures of our material past.

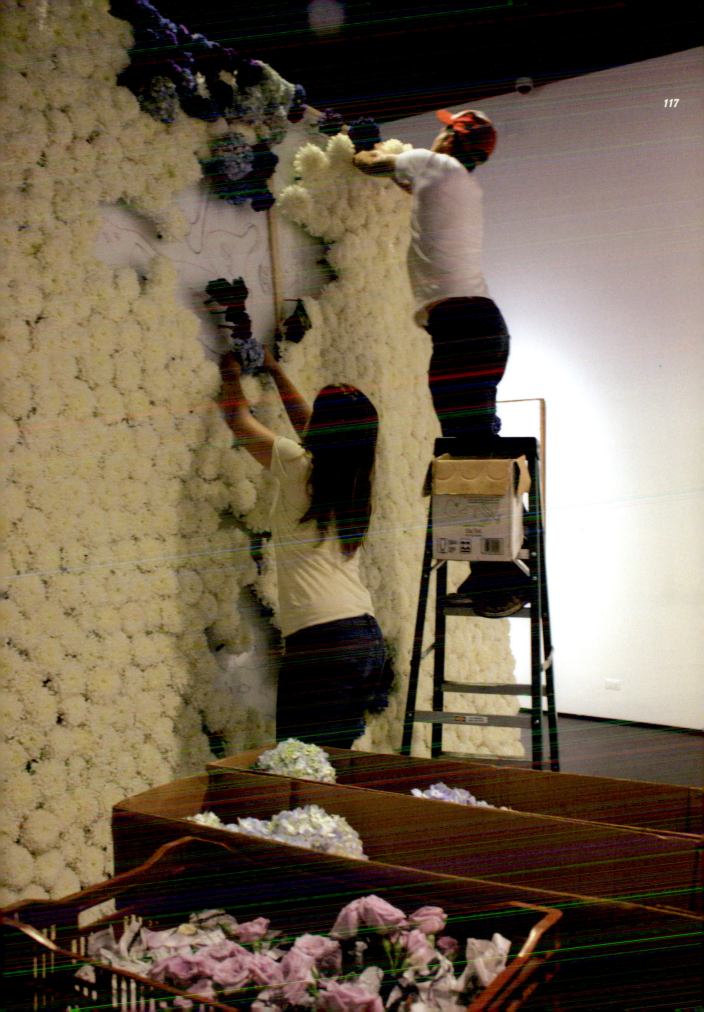

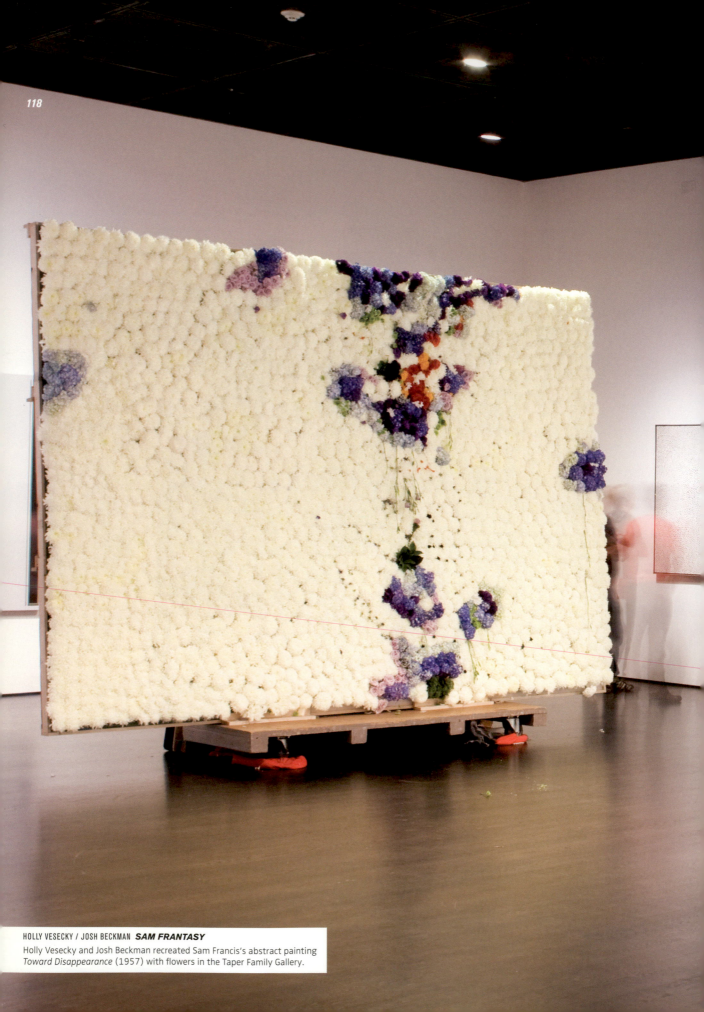

HOLLY VESECKY / JOSH BECKMAN *SAM FRANTASY*
Holly Vesecky and Josh Beckman recreated Sam Francis's abstract painting
Toward Disappearance (1957) with flowers in the Taper Family Gallery.

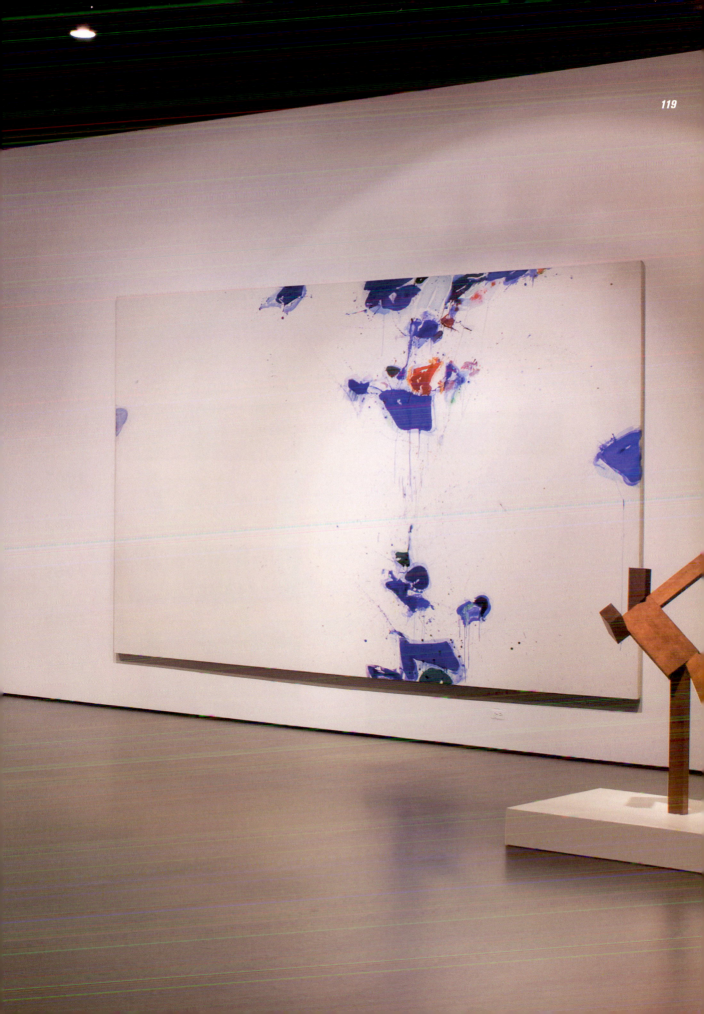

FOLK SONGS OF THE MODERNIST PERIOD EMILY LACY

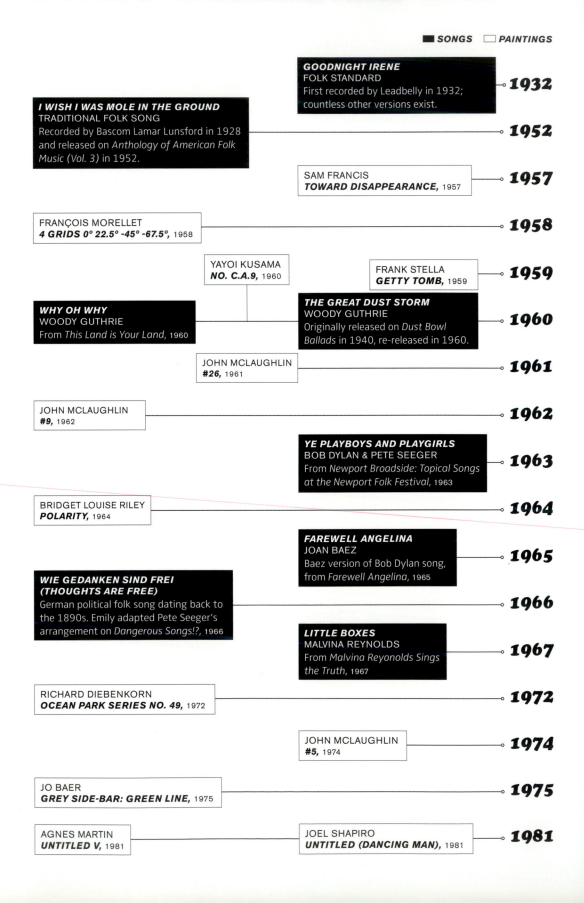

■ SONGS ☐ PAINTINGS

GOODNIGHT IRENE
FOLK STANDARD
First recorded by Leadbelly in 1932;
countless other versions exist.

1932

I WISH I WAS MOLE IN THE GROUND
TRADITIONAL FOLK SONG
Recorded by Bascom Lamar Lunsford in 1928
and released on *Anthology of American Folk
Music (Vol. 3)* in 1952.

1952

SAM FRANCIS
TOWARD DISAPPEARANCE, 1957

1957

FRANÇOIS MORELLET
4 GRIDS 0° 22.5° -45° -67.5°, 1958

1958

YAYOI KUSAMA
NO. C.A.9, 1960

FRANK STELLA
GETTY TOMB, 1959

1959

WHY OH WHY
WOODY GUTHRIE
From *This Land is Your Land*, 1960

THE GREAT DUST STORM
WOODY GUTHRIE
Originally released on *Dust Bowl
Ballads* in 1940, re-released in 1960.

1960

JOHN MCLAUGHLIN
#26, 1961

1961

JOHN MCLAUGHLIN
#9, 1962

1962

YE PLAYBOYS AND PLAYGIRLS
BOB DYLAN & PETE SEEGER
From *Newport Broadside: Topical Songs
at the Newport Folk Festival,* 1963

1963

BRIDGET LOUISE RILEY
POLARITY, 1964

1964

FAREWELL ANGELINA
JOAN BAEZ
Baez version of Bob Dylan song,
from *Farewell Angelina,* 1965

1965

**WIE GEDANKEN SIND FREI
(THOUGHTS ARE FREE)**
German political folk song dating back to
the 1890s. Emily adapted Pete Seeger's
arrangement on *Dangerous Songs!?,* 1966

1966

LITTLE BOXES
MALVINA REYNOLDS
From *Malvina Reyonolds Sings
the Truth,* 1967

1967

RICHARD DIEBENKORN
OCEAN PARK SERIES NO. 49, 1972

1972

JOHN MCLAUGHLIN
#5, 1974

1974

JO BAER
GREY SIDE-BAR: GREEN LINE, 1975

1975

AGNES MARTIN
UNTITLED V, 1981

JOEL SHAPIRO
UNTITLED (DANCING MAN), 1981

1981

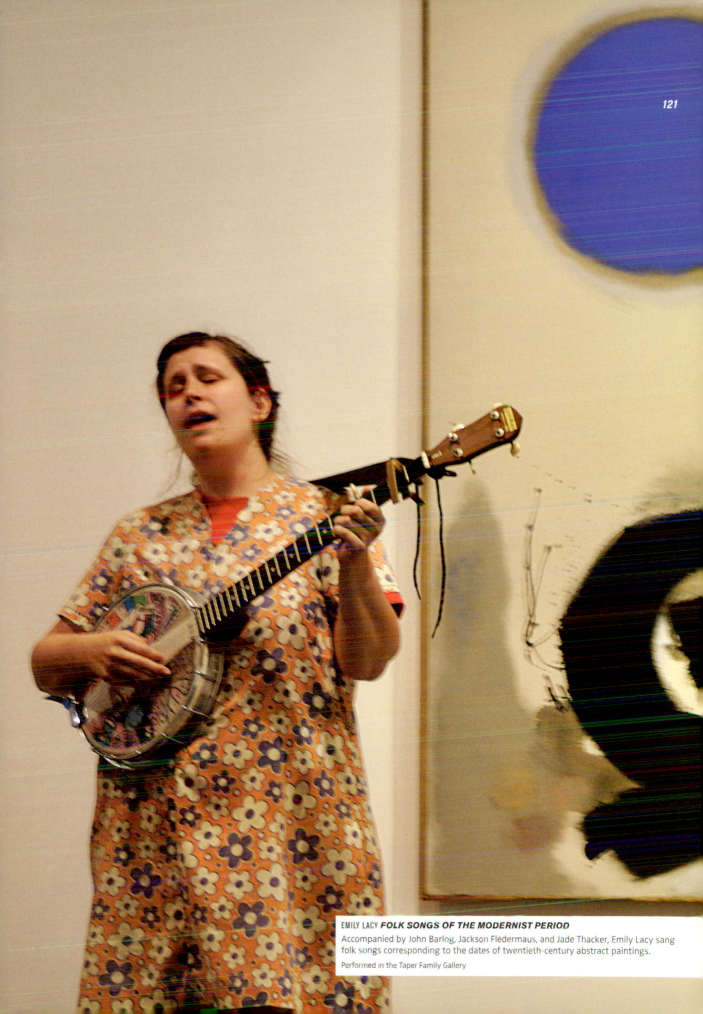

EMILY LACY *FOLK SONGS OF THE MODERNIST PERIOD*

Accompanied by John Barlog, Jackson Fledermaus, and Jade Thacker, Emily Lacy sang folk songs corresponding to the dates of twentieth-century abstract paintings.

Performed in the Taper Family Gallery

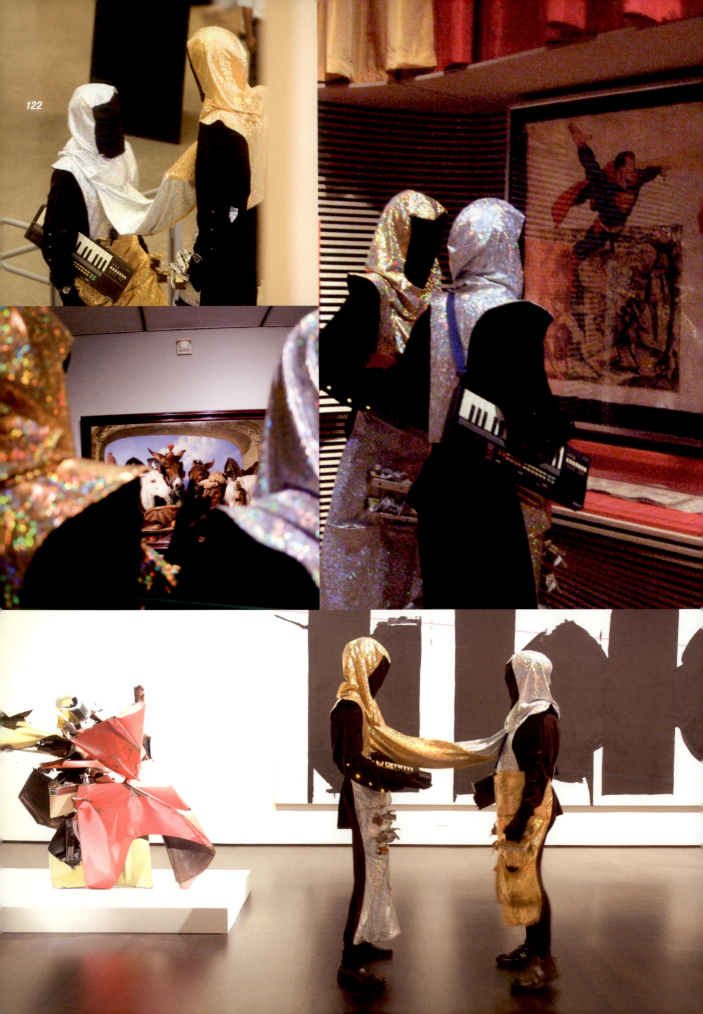

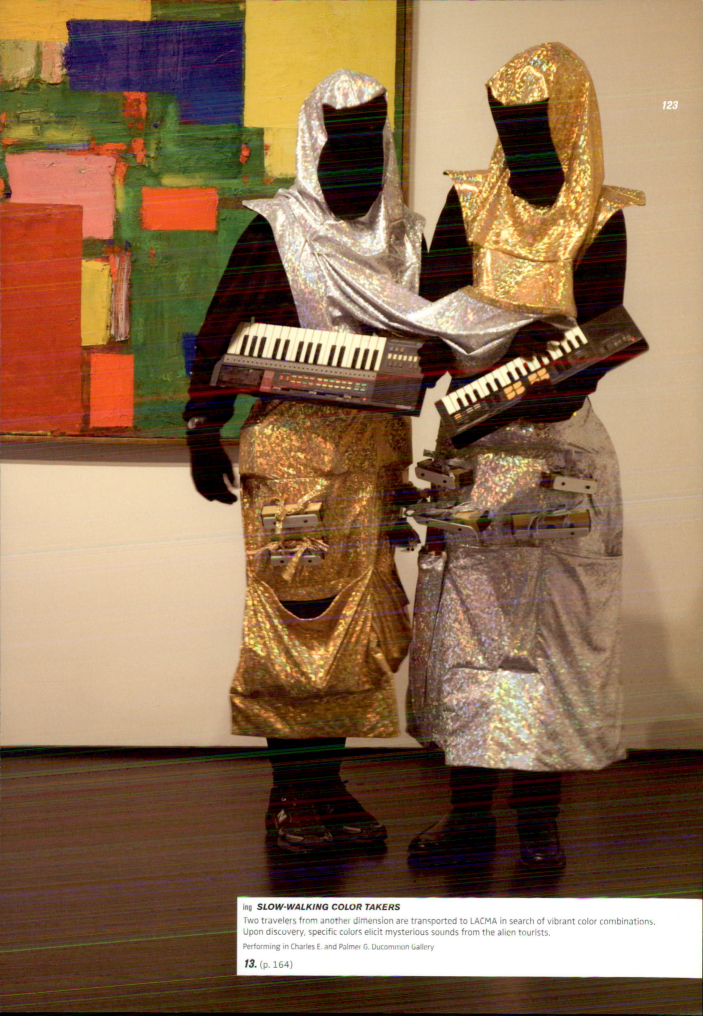

ing **SLOW-WALKING COLOR TAKERS**

Two travelers from another dimension are transported to LACMA in search of vibrant color combinations. Upon discovery, specific colors elicit mysterious sounds from the alien tourists.

Performing in Charles E. and Palmer G. Ducommon Gallery

13. (p. 164)

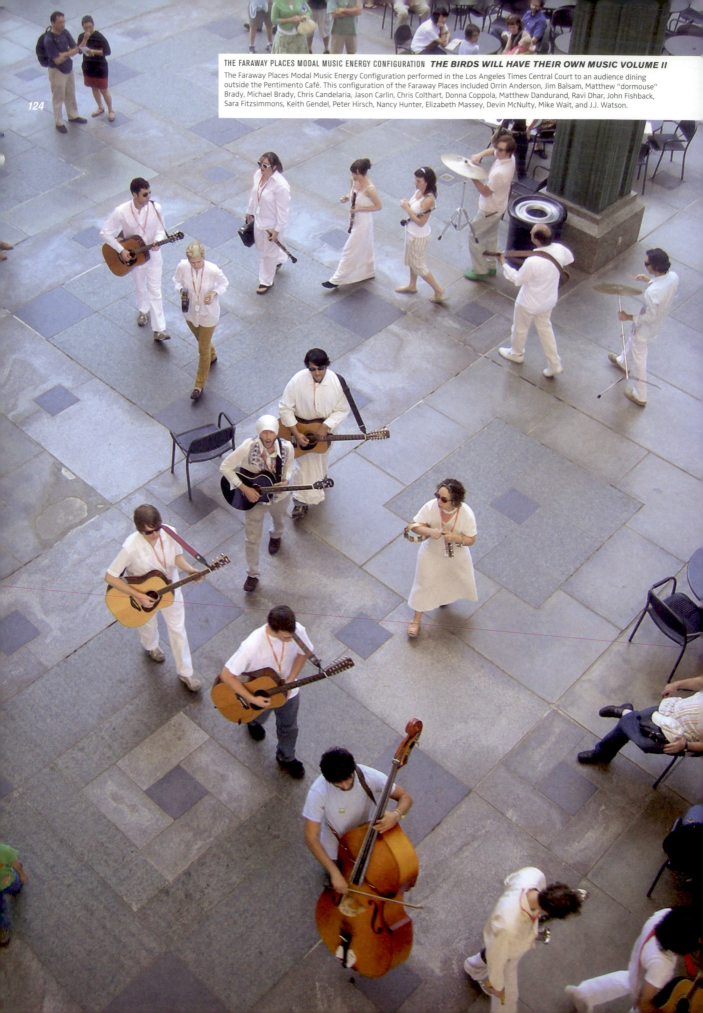

THE FARAWAY PLACES MODAL MUSIC ENERGY CONFIGURATION *THE BIRDS WILL HAVE THEIR OWN MUSIC VOLUME II*

The Faraway Places Modal Music Energy Configuration performed in the Los Angeles Times Central Court to an audience dining outside the Pentimento Café. This configuration of the Faraway Places included Orrin Anderson, Jim Balsam, Matthew "dormouse" Brady, Michael Brady, Chris Candelaria, Jason Carlin, Chris Colthart, Donna Coppola, Matthew Dandurand, Ravi Dhar, John Fishback, Sara Fitzsimmons, Keith Gendel, Peter Hirsch, Nancy Hunter, Elizabeth Massey, Devin McNulty, Mike Wait, and J.J. Watson.

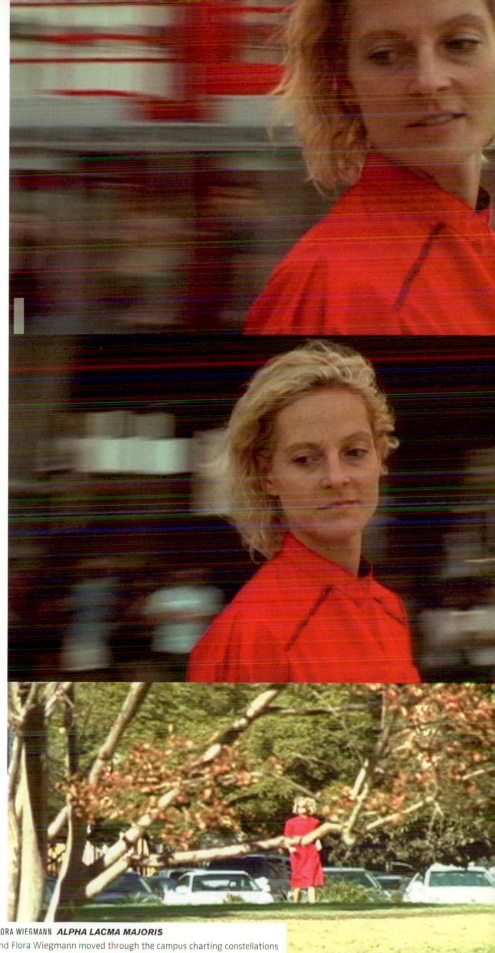

JACINTO ASTIAZARÁN / FRITZ HAEG / FLORA WIEGMANN *ALPHA LACMA MAJORIS*

Jacinto Astiazarán, Fritz Haeg, and Flora Wiegmann moved through the campus charting constellations and star maps. When their performance was viewed as a whole, a collective motivation may have become clear.

On the grounds of the LACMA campus. Video stills from the film created during the performance by Jacinto Astiazarán.

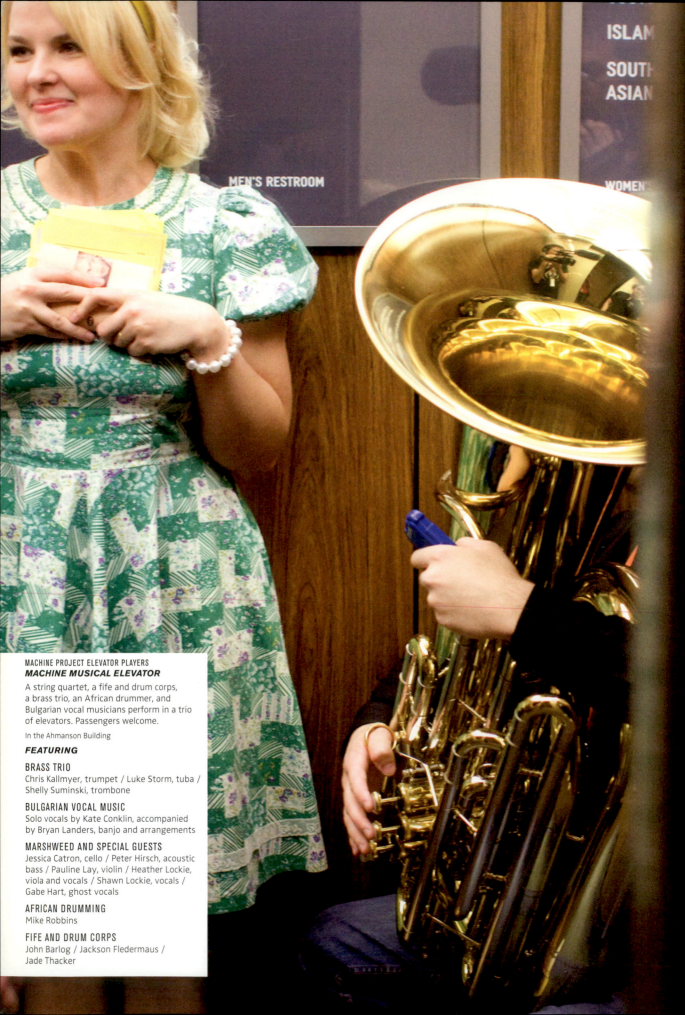

MEN'S RESTROOM

ISLAM
SOUTH
ASIAN

WOMEN'S

MACHINE PROJECT ELEVATOR PLAYERS
MACHINE MUSICAL ELEVATOR

A string quartet, a fife and drum corps, a brass trio, an African drummer, and Bulgarian vocal musicians perform in a trio of elevators. Passengers welcome.

In the Ahmanson Building

FEATURING

BRASS TRIO
Chris Kallmyer, trumpet / Luke Storm, tuba / Shelly Suminski, trombone

BULGARIAN VOCAL MUSIC
Solo vocals by Kate Conklin, accompanied by Bryan Landers, banjo and arrangements

MARSHWEED AND SPECIAL GUESTS
Jessica Catron, cello / Peter Hirsch, acoustic bass / Pauline Lay, violin / Heather Lockie, viola and vocals / Shawn Lockie, vocals / Gabe Hart, ghost vocals

AFRICAN DRUMMING
Mike Robbins

FIFE AND DRUM CORPS
John Barlog / Jackson Fledermaus / Jade Thacker

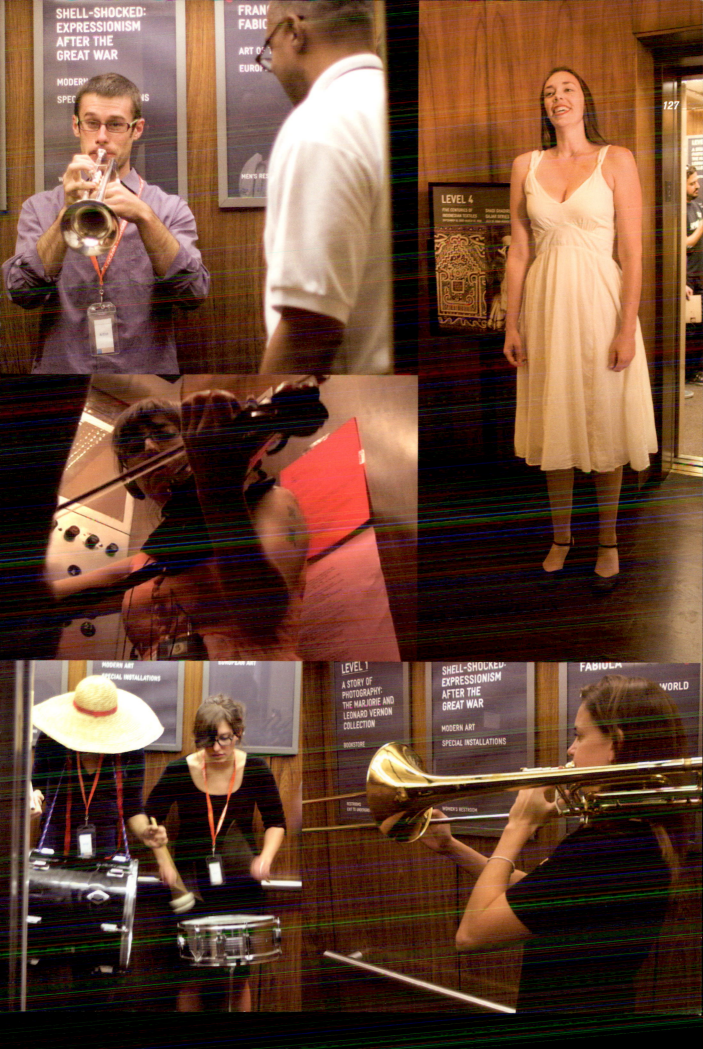

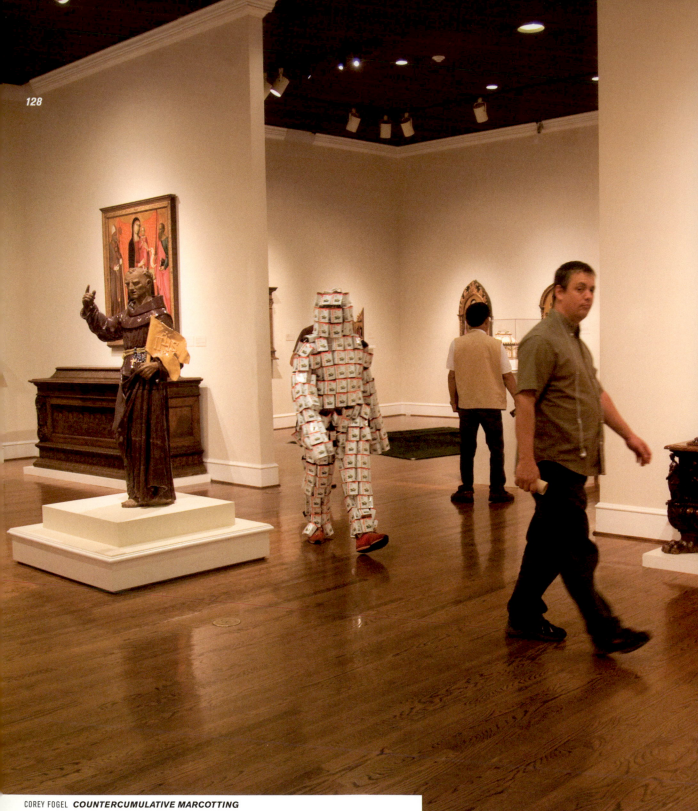

COREY FOGEL *COUNTERCUMULATIVE MARCOTTING*
A dance and noise improvisation for performer and three hundred aluminum black pepper shakers.
A kinetic Corey sculpture with recursive narrative—vertical, and without beginning or end.

Pictured in the Ernestine and Stanton Avery Gallery

14. (p. 164)

COREY FOGEL
AND DAWN KASPER

dawn I was honestly thinking the other day. why pepper cans?

corey because I found them all. something about assemblage, and armies or oceans of one thing is exciting to me but actually feels like kind of a slutty or cheap way to make art "hey, I'll take a whole lot of something, and…!" but I'm not that down on myself about it. I accept the urge.

dawn "repetition never doesn't work"

corey I think it was pretty bizarre and happenstance. repetition is also the mother of study! how do you say in Latin… repetitio est mater studiorum. I learned that in 10th grade.

dawn why in suit form? what made you want to wear them as opposed to say throw them or move them like your drums?

corey I don't know. it probably happened when I first transported them and heard all the noise and I'm usually pretty ready to consider anything as a costume anytime and wa-la. did you know this is our interview?

dawn did you? …

dawn do you enter a trance or are you completely aware of your environment when you perform?

corey I'm fully aware

dawn every action is intended? intentional

corey I think I have some audience requirements, and if those are in place, then I'm inspired to let go, and possibly enter a trance

dawn that's how I work too. mine aren't audience. mine are environmental. my audience has enough to go through. the imagery is really intense. most people think I'm not real, like a sculpture, which is what I want

corey what environment requirements and why do you want people to think you're a sculpture?

dawn environment requirements are that I need to be able to feel safe. I need to be comfortable with letting go. I am prepared for people fucking with me, that always seems to happen. but I need to be able to set up my scene. I need control over what it looks like. I need to control in order to allow myself to lose control over my body. the reason why I want to be viewed as a sculpture are that I believe my body is only an object, a vessel.

corey so tell the eager readers out there how this played out at LACMA…

dawn at LACMA Jessica [Hutchins] set up the scene on paper. first I picked where I wanted to be. it took me a while. I had a hard time connecting to LACMA. I had wanted to die there, but wasn't sure where or how or with what I picked a spot. then met Jessica, then we picked art as clues. then she wrote out the story line. the props the make up the environment. I basically recreated based on what I imagined Jessica's vision was of my death. I worked closely with her to understand what she wanted of me. I never have done that before with this work. I've died something like 26 times, never letting anyone direct my scene.

. . . .

dawn the green turf you were on. why? why not simply be on the floor directly

corey to simulate a dance stage

dawn was it corey-ographed?

corey no. it was improvised. my idea of modern dance improv—unschooled

dawn did you practice? what do you think about?

Corey Fogel with Dawn Kasper between performances.

corey um, no. no practice. I think about how to make something out of each movement

dawn something from nothing.

corey and if I think it's making interesting enough sound to keep it going and develop it. and if I think there's something there to nurture. well, regardless if there is or isn't, you have to nurture your spontaneous improvised creations. that's what I think about. my responsibility and duty to my spontaneous creation. if I make it, then I'm stuck with it and I had better use my communication skills to carefully steer it into evolution or devolution.

dawn seems like you're aware of the time within each action as if instinct, or poetry. I guess I want to know why your movements seem so intentional and also comical

corey I'm not sure. why do they seem comical to you ?

dawn when I saw you, I couldn't help but laugh. it made me feel good. happy. as if I was able to let go it was to me as if I could allow myself to not need to understand the why you weren't directing me or making me view something. I was allowed to learn from you in my own way. you had set up a structured environment that was open to both you and to the viewer not sure why it made me laugh though. maybe some of it was your movement. so subtle and yet direct.

dawn how does this affect your body?

corey my body is what I'm using in this case. so have to identify a set of actions with my body. as opposed to an alphabet, or a drum set. or a Pictionary board.

dawn right. I see. stage, floor, movement.

corey see, its a dance. maybe yours was a dance?

dawn no that wasn't a dance. that was an action; wanting to be something I'm not. I'm not dead. I will never actually ever see what I look like dead. its all surreal. is dance surreal?

corey how long were you performing?

dawn I performed for about 4 and half hours

corey straight?

dawn I stopped a few times. I had to pee

corey what happened when you stopped? how did you get in and out of performance

dawn well usually I meditate. I pick a fixed spot in space and I focus on it. when I break that, it takes me a while to get back to it completely. I basically fall asleep with my eyes open. so I had to pee. i started to shake. it broke my concentration so I told Jessica.

corey what did Jessica say? what Jessica always says?

dawn she got Kimberly and Robby to block both opposing entrances of the Calder. I got up, then moved to the bushes. but people from the cafe were all watching me. Jessica was like "just go; just go." I couldn't. then there was this man and woman. they were taking pictures of me. and I couldn't. I told her there were these people watching me. she had her back to me. then they left and I let it go. Jessica told me it was loud. I didn't even bother to take my suit off. that was the problem. I couldn't simply go inside.

corey you could have had someone cut a pee hole for you, like I did. the camera crew followed me into the bathroom unbeknownst to me. I went in there and dug around through my cans, pulled it out, and realized my angle was not conducive to peeing on target. so I gave up and went back to perform more, and came back later with a big water jug.

dawn I wish I had thought of something like that.

corey you were dead, how could you have?

. . . .

dawn this girl came around and took pictures of me eating. I held onto that for a while. I was really angry. I have been wondering about all of these people that took pictures of me when I was out of character. I felt really out of control that whole day. I usually have people tell me the time. I have someone come around every 15 minutes to tell me the time. nobody did. I felt really alone at times. people fucked me.

corey that's called necrophilia

dawn they took objects from the scene. it wasn't bad though. I just never know how to deal with it.

corey so you have Jessica's vision, and your own ideas about performance/your body, coupled with Jessica's scheme, writing, etc. What made this piece a collaboration? and not two autonomous separate pieces.

dawn good question (thinking) to be honest. Jessica's the brains. I was the brawn. It was a give and take. it worked out as a collaboration because we helped each other. we walked through the entire museum together. we talked at length, getting to know each other before. I had never met her before. She's so very magical. I am grateful to have worked with her.

dawn the collaboration is that even though she was fighting traffic to get the museum because of the [wildfires that day]; it took her five hours to get there from her house; I was still able to set up. She would have done the same for me. Its weird how things just fall into place. I don't think I could have made this work with just anyone. Mark [Allen] knew.

corey Mark always knews

dawn seeing several moves ahead in chess. I realize after doing this project, after working with Jessica and Mark that my views of the art world are so small; so simple. They made it possible for me to believe in bigger things

dawn what did you learn from your experience?

corey I guess I learned a little something about patience… I've never really done the same performance art installation twice. I think its because they take a lot out of me, and are relatively grand in scale. and sometimes I forget that there is more to uncover and experiment with if I were to do it again. So I put them away, and this piece was not very successful for a number of reasons the first time, but there was enough there to say that I did it, document it, and move on for a while. I'm happy I gave it a second chance and worked hard to see it through to more of its potential; my original vision.

dawn I relate. I rarely have ever done the same performance twice, except this past year. I have revisited a number of the same pieces, doing them the same, just in a different place. I used to think it would compromise the integrity of the work, or something. do you feel you've grown in your practice having performed at LACMA?

corey tough one. I feel like a wider audience might have gained exposure and awareness and more seriously considered what I do, but that may be an illusion. I would be excited to see what the entire show should be like in an empty space at LACMA or similar institution.

LE HUNT: CRIME SCENE REPORT

JESSICA Z. HUTCHINS AND DAWN KASPER

> **Le Hunt**
>
> *Wrestlers*
>
> 11/15/08 12:05 a.m.
> From his Budgie-hunting blind in the Park, Sperry
> witnessed "two idiots in suits - probably hipster
> urban foragers" wrestling one of the large,
> brightly feathered birds to the ground.
> "Any real hunter knows a bird won't taste good if
> it's died under stress. That's why I use a sling-
> shot."
>
> **17**

INTRODUCTION: YOU

We begin at the scene of the crime. As you've been alerted, there is indeed a corpse by the Alexander Calder fountain, *Hello Girls*, in the LACMA Sculpture Garden. What you may not yet be aware of is that you are not yourself right now. Look deeply into my eyes. Your name is Shamus Piper, Private Investigator. You don't think the name fits you? I do.

Unfortunately—or perhaps fortunately—for you, Shamus, the LAPD is involved with more important tasks today. I believe most of the force is off at the Annual New Weapons Tactics and Morale-Boosting Retreat in the Mojave Desert, Turbo-Tasing each other and riddling their brothers-in-arms with the StinkPaint Bullets that have recently been put on the market. Maybe this death hasn't even been reported to the police yet. The fuzz can take hours to get to a crime scene.

THE CRIME SCENE

Start with the basics: The victim, lying face-down at the edge of the fountain, appears to be a female in her late 20s or early 30s, but you can't be absolutely sure, because her entire body, save for the face, hands, and feet, is covered with black, sticky tar and a generous assortment of brightly colored bird feathers, along with other animal fur. Victim's arms are stuck to her body. Additionally, the face, hands, and feet, though exposed, are coated with a greasy bronze-colored metallic makeup.

Despite the fact that she is dead, you can't help admiring the fact that she appears positively festive.

MORE ABOUT YOU

Because you're wearing a Donegal tweed overcoat, matching hat, and shined leather shoes; because you have a mustache; and, ultimately, Shamus, because you're smoking a large cherrywood pipe, people tend to assume you're an Authority. You've inadvertently commandeered yet another unfortunate situation.

ONLOOKERS

"Stand back, people, please, just stand back," you mandate, in a low yet authoritative voice, flashing a gold-plated brooch that passes as a police badge. And the people obey, though the crowd consists only of a few school children, a museum guard, and an elderly man leaning on a wheelbarrow filled with gardening equipment. You turn the body over for closer inspection. The elderly man smothers a cry of surprise into a filthy blanket he's been carrying over his shoulder. The victim's breasts have been spared the tarring and feathering, but like her hands, face, and feet, they are coated in dark bronze metallic greasepaint. The children stare in awe at the exposed breasts; the elderly man sobs quietly into his towel.

You secure the perimeter of the scene with the roll of yellow and black CAUTION tape you always carry with you, and, cherrywood pipe clenched between your teeth, politely inform the children and the elderly man that it is their civic duty to remain where they stand so that you can record their statements presently.

INSPECTION OF THE BODY

Muttering to yourself, you search the body for personal effects and other clues, yielding the following:

HELLO, WHAT HAVE WE HERE? (you are speaking with an English accent):

You loosen the victim's right fist, adhered to her side by the tar, to release a wadded-up, handwritten LIST OF ARTWORKS, along with a map of galleries found in the Los Angeles County Museum of Art.

Clutched in the victim's left hand is a BONE-SHAPED PENDANT engraved with the name "Zeisel."

Embedded deep in the tar at the victim's neckline is a portion of a BRAIDED LEATHER STRAP.

TUFTS OF GRAY FUR are also embedded in the tar on the victim's torso, which appears to have been FURIOUSLY ABRADED.

Despite reports of gunshots heard in the area, you discover no entry wounds.

THE SURROUNDING AREA

A PHONE RINGS from somewhere within the surrounding foliage. One of the children moves to look for it, until you command him to stay put. He doesn't want to blow up himself and his little friends, does he?

You drop the victim's head to search for the ringing phone, noting to yourself that the ridiculous ringtone may reveal something of the victim's personality ("I'd Rather Be a Hammer than a Nail"). You discover the phone inside a TOTE BAG sitting in a puddle of MUSHROOM SOUP approximately 25 feet from the victim.

The TOTE BAG is constructed of metallic bronze rip-stop fabric, embroidered crudely yet intricately with the logo TrueFolk™.

The TrueFolk™ TOTE BAG contains, besides the

1. RINGING CELL PHONE:

2. a NUN'S HABIT, made of dark metallic bronze fabric, with the TrueFolk™ logo imprinted on its label (size 6, dry clean only)

3. a CONTAINER OF PRESCRIPTION SLEEPING PILLS, prescribed to patient Dawn _____ by Dr. Douglas Farhad, PhD, MD, PPD.
Park LaBrea, 1021 SouthEast Landmark Tower 14, Los Angeles, CA

4. The BROKEN-OFF HANDLE of a CERAMIC or EARTHENWARE DISH.

INCOMING CALL:

The phone continues to ring. You answer it, Shamus, doing your best impression of the victim's voice, even though you've never heard it, of course.

"Hellooo?" you croon, in falsetto.

"Dawn _____." It is a pre-recorded robotic sounding message. "You have failed to report to your station at Area 92, Farmers Market. You will not receive payment for completion of 12 p.m. to 7 p.m. shift this Saturday, November 15, 2008. Your fellow TrueFolk™ s are disappointed you skipped your shift! Remember, it takes a village to keep our folk traditions strong!"

Energizing and uplifting strums of guitar follow; the call is terminated before the song ends.

You check the phone for the last outgoing call.

November 15, 1:10 a.m.

LAST OUTGOING CALL:

You dial the number. A machine picks up. A free-jazz solo is followed by a woman's voice. "You've reached the residence of Judd and Penelope Dunwood. Please leave us a message."

YOU JOT DOWN SOME NOTES:

Victim's probable name: Dawn _____

Apparently employed by TrueFolk™:

TrueFolk™, as everyone is aware, is a company that manufactures commodities and provides services in the art/craft and folk traditions, nationwide. Examples of TrueFolk™ products would be such ubiquitous items as Mee-Ma-Maw's Afghans™ and The Blind Potter's Tea-Pots™. Services offered by TrueFolk™ include Hobo Joe's Jug Bands™, who busk on busy street corners, and Living Bronzes™—live people posing as sculptures of historically important figures.

The franchise should do well even in the midst of economic crisis, weathering the public's distrust in big industry by disguising itself as the smallest kind of business.

Note to self:

"TrueFolk™—INVEST?"

ESTIMATED TIME OF DEATH:

Sometime past 1:10 a.m., November 15, 2008

You've come up with a novel plan for your investigation. Following up on all viable leads, you invite each suspect for an "informal" stroll of the museum, visiting works on the list pried from the victim's bronzed hand. The truth is bound to be revealed, eventually.

NAME:	The Sculpture: *Hello Girls*, Alexander Calder, 1964
ADDITIONAL POINTS OF INTEREST:	• Kinetic sculpture appears to be under repair or reconstruction. Portions of sculpture spin in the wind—could be dangerous, especially during the Santa Anas. If metal is deteriorated or rusty, pieces could break off and possibly injure bystanders.

NAME:	Sperry
OCCUPATION:	Landscaper, groundskeeper, LACMA
RELATION TO VICTIM:	"We didn't yet have a chance for relations."
ADDITIONAL POINTS OF INTEREST:	• 5-gallon bucket, filled with decaying rodent carcasses and a large bucket of tar, concealed by a crocheted Afghan blanket. • Throughout the interview, this man continues to sob as if he's never seen a dead body before.

NAME:	Group of 3–5 children, won't reveal individual names
ADDITIONAL POINTS OF INTEREST:	• Children appear to be under the stewardship of Sperry; each wears a military-grade helmet, and they seem to communicate with each other in code. They hypothesize that *Hello Girls* serves as a receiver that is able to pick up telephone conversations in the area, heard via walkie-talkies if standing within a 14-foot range of the sculpture.

NAME:	Mr. Sage Argus
OCCUPATION:	Museum guard, LACMA
RELATION TO VICTIM:	"Personal guide"
ADDITIONAL POINTS OF INTEREST:	• Argus sips a steaming hot beverage from a paper cup. • Upon questioning, he offers you a sip. Though you are parched from all the activity, you decline his offer because of the powerful fungal odor of the liquid.

NAME:	Dr. Douglas Farhad
OCCUPATION:	Psychiatrist, private practice
RELATION TO VICTIM:	Dawn's psychiatrist
ADDITIONAL POINTS OF INTEREST:	• Member of MAMA, Men of the Atomic Modern Age, a mid-century modern enthusiast/gentleman's club comprised of professionals living in the Park LaBrea community.

NAME:	Penelope Dunwood
OCCUPATION:	Homemaker, entrepreneur
RELATION TO VICTIM:	"Became acquainted through husband"
ADDITIONAL POINTS OF INTEREST:	• Immaculately coiffed and dressed, in a mustard-colored woolen shift dress with matching high heels. Upper body appears substantially muscular for a woman of her build. Holds a small greyhound dog in her arms.

NAME:	Judd Dunwood
OCCUPATION:	LACMA Conservator, Specialist in Furniture and Housewares
RELATION TO VICTIM:	"Hired Dawn for some freelance work"
ADDITIONAL POINTS OF INTEREST:	• Member of MAMA, Men of the Atomic Modern Age; mid-century modern housewares and furniture enthusiast. Suited in excellent quality vintage wear, appears to be recovering from a hangover; excuses himself to vomit in the nearby bushes.

NAME:	Vinge
OCCUPATION:	Recently released prison inmate
RELATION TO VICTIM:	"We both worked for a mutual friend"
ADDITIONAL POINTS OF INTEREST:	• This man's incredibly unattractive face resembles a wad of chewed bubblegum, freckled and scratched, in the middle of which precariously sits a mashed nose. The large black and blue lump rising out of his forehead actually provides some visual relief.

NAME:	Hans Chestnut
OCCUPATION:	Contemporary artist
RELATION TO VICTIM:	Recognizes victim from art openings in the area
ADDITIONAL POINTS OF INTEREST:	• Hans Chestnut considers his ecological art project, Historical Habitats, a "significant contribution not only to the art world, but to the world as a whole." You are taken aback by the pomposity of this diminutive man who blatantly exudes body odor. His advocacy of animals, he states, extends "far beyond the domestic."

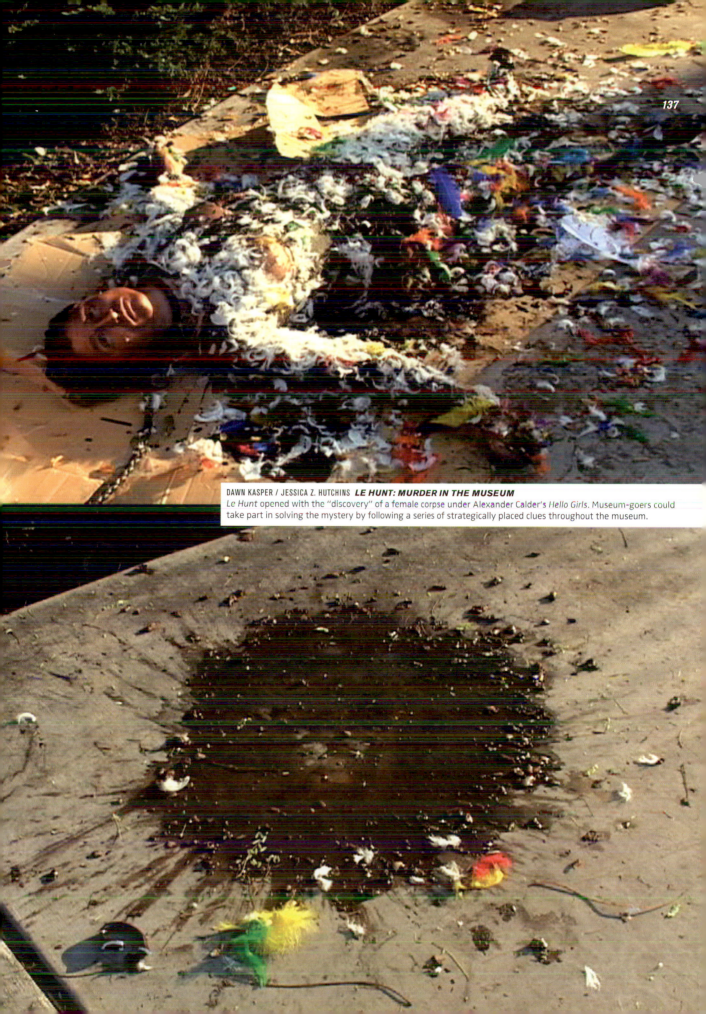

DAWN KASPER / JESSICA Z. HUTCHINS *LE HUNT: MURDER IN THE MUSEUM*
Le Hunt opened with the "discovery" of a female corpse under Alexander Calder's *Hello Girls*. Museum-goers could take part in solving the mystery by following a series of strategically placed clues throughout the museum.

6.

LEVIATHANS *PHILIP ROSS*

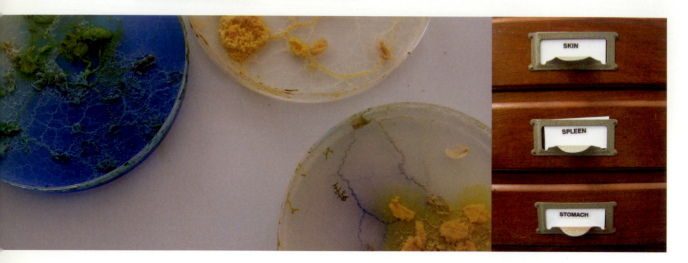

I was invited to participate in a residency at SymbioticA, an art and biology center at the University of Western Australia, and proposed making some videos about colonial organisms. For several months I worked in Cell Central, their imaging center, learning to use the microscopes and all the attendant tools, materials, machines, and software in their laboratory. *Leviathans* is the first of three videos I am making from the footage I captured while at SymbioticA.

All of the images in *Leviathans* were taken from the slime mold *Physarum polycephalum*. It is not really a mold but is actually a myxomycete (mix-o-my-seat). A diverse range of people are really interested in this organism, for an equally diverse set of reasons. The slime mold demonstrates some of the fascinating things that happen when cells act collectively, and is able to solve logic problems and has memory of experience. Countless tiny slime mold cells join up and dissolve their individual cell walls, making a big bag of cell plasma that all of the nuclei shuttle around in, back and forth. Its body pulses and moves; imagine a harmonically rippling jellyfish-like creature, propelling itself along on the oscillating waves of its own body, computing the world through it chemokinetic functions that operate at the border of chaos. And, while diminutive in size, it is able to travel relatively large distances in short periods of time while searching for food.

When I started out I had no idea what in particular I was looking for, but figured that the slime mold was interesting enough to observe. It took me almost two-and-a-half months working twelve-hour days to figure out how to operate all of the necessary equipment in coordination. I would capture numerous amazing still pictures, but it took a great amount of tuning in order to find a sweet spot in the process for getting good video imagery. The organism needed to be subcultured first thing in the morning. Then, I would prepare the cameras, computers, lighting, and software. After everything was set up I would put the slime mold on the microscope's stage and adjust the lighting and environmental controls it would need to stay alive for the long shoot under bright lights. After focusing everything and starting the camera I would have to set up a light-blocking tent around the whole setup and cool it with some strategically placed fans. After lunch I would begin processing the images from the previous day's work, compiling the thousands of images into a few seconds of something.

The video is narrated by three voices in a conversation among alien entities. These aliens reminisce on a range of subjects, including the ecology of living space, the nature of time travel, and the problems with super-intelligent computers.

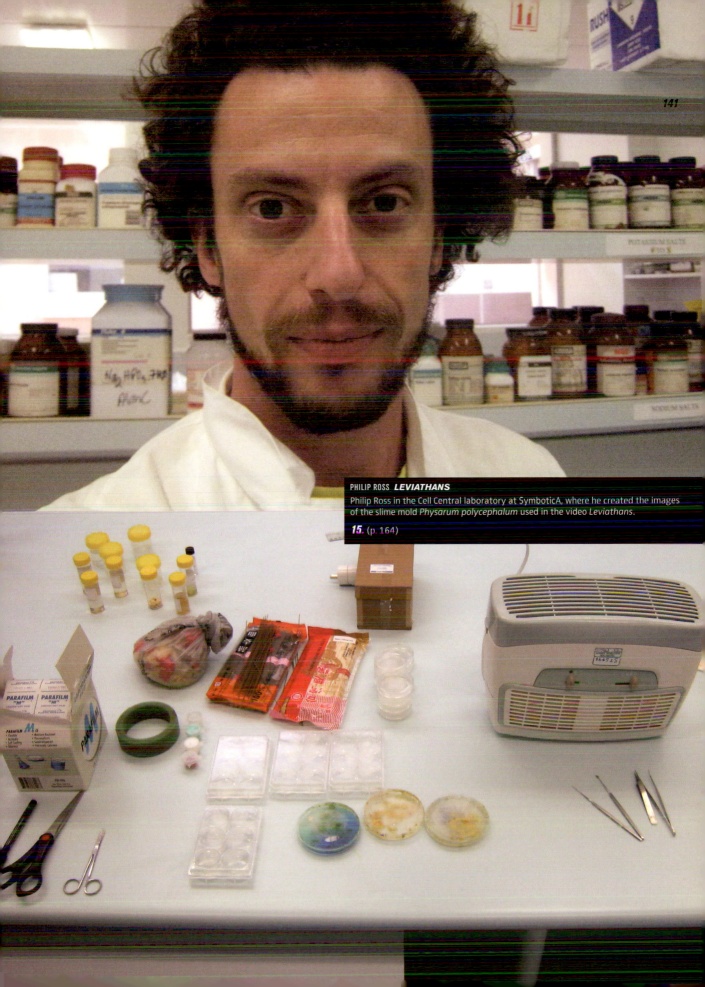

PHILIP ROSS *LEVIATHANS*

Philip Ross in the Cell Central laboratory at SymboticA, where he created the images of the slime mold *Physarum polycephalum* used in the video *Leviathans*.

15. (p. 164)

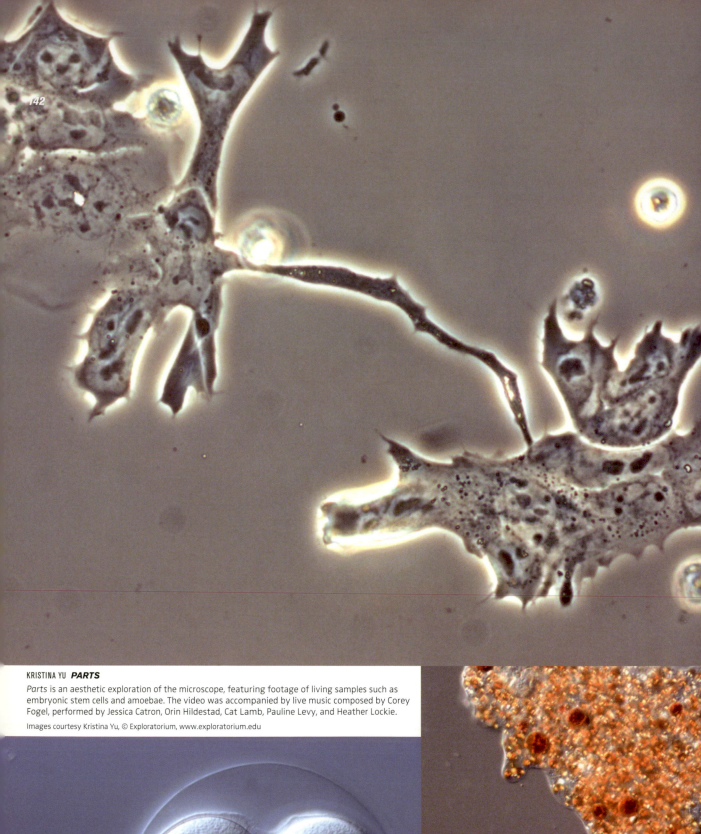

142

KRISTINA YU *PARTS*

Parts is an aesthetic exploration of the microscope, featuring footage of living samples such as embryonic stem cells and amoebae. The video was accompanied by live music composed by Corey Fogel, performed by Jessica Catron, Orin Hildestad, Cat Lamb, Pauline Levy, and Heather Lockie.

Images courtesy Kristina Yu, © Exploratorium, www.exploratorium.edu

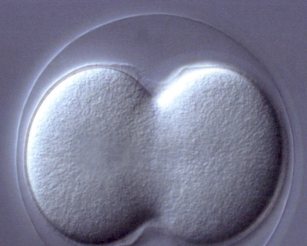

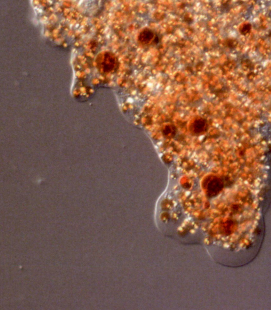

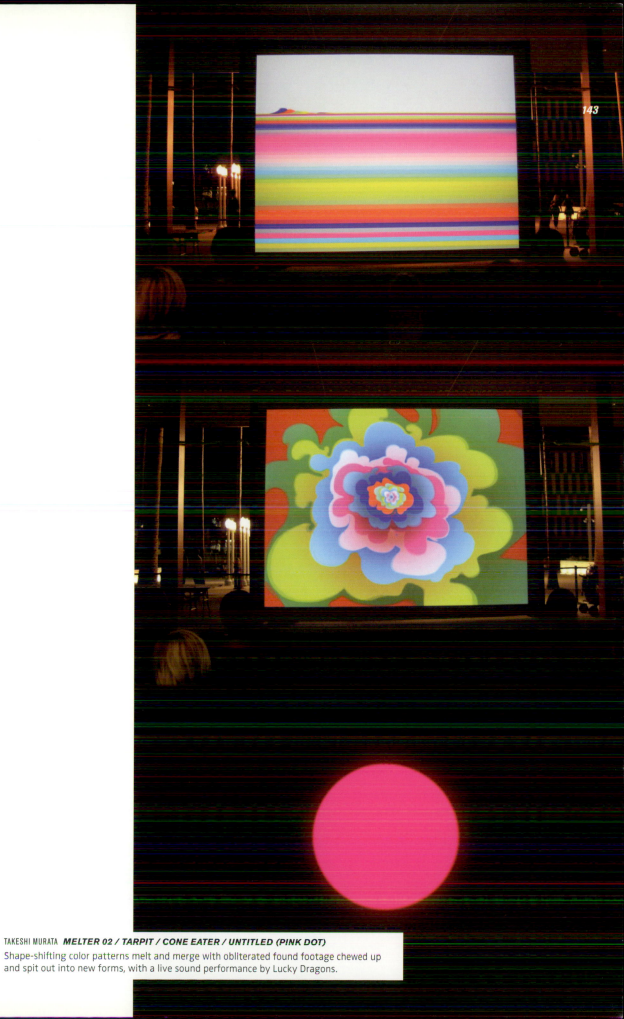

TAKESHI MURATA *MELTER 02 / TARPIT / CONE EATER / UNTITLED (PINK DOT)*

Shape-shifting color patterns melt and merge with obliterated found footage chewed up and spit out into new forms, with a live sound performance by Lucky Dragons.

THE DRIFT *KELLY SEARS*

It was space fever. Forget new cars, second kids, color televisions, the perfect barbeque, and expensive vacations. Space missions were the new high for the country. By now there had been orbits of the earth and landings on the moon. But we wanted more.

We didn't know anything of the real fever down here. The new mission was placed in the biggest ship, filled with the most famous astronauts, and was going to be out in space for a record amount of time. The men were to fully explore, measure, chart, and claim the unknown for us. It would be a rigorous test for men.

Our astronauts covered an immense distance quickly. The further away from ground control they got, the less they looked back to earth for guidance.

Their transmissions to the space agency weakened and got less frequent. Silence filled the control room for days at a time.

The scientists said they went too far too fast. The doctors said the astronauts were pushing their bodies beyond their physical limits. The psychiatrists said they got sick from all the emptiness out there.

The space agency tried to get the astronauts to come back.

The fervor of the early days of the mission started to wane.

And then the instruments showed that our boys were coming home.

The ship returned. The smoke cleared. The doors opened. But only a few of our astronauts had come back. Somewhere along the way, our astronauts had been lost.

The ship was locked up and searched for clues. The returning astronauts were examined. They told the story of their missing shipmates.

Weeks into the mission a hum appeared that gradually turned into a song. A sweet song. Many of the men aboard couldn't resist the tune.

The affected men started loosing touch with the goals of the mission. It became less about gaining control of space and more about losing themselves to a song that sounded like emptiness. The men on the ship started to refer to this condition as "the drift."

This explanation didn't please the space agency. They wouldn't believe a song could make their astronauts turn their backs on a national mission. The space agency sent satellites out into space to track down the men. The satellites pushed further and further out. They never found the men, but they did find the song.

It was transmitted back to satellite dishes all over earth. Special broadcasts were played for the country in an effort to reconnect with our men lost in space. The song became very popular. It was a hit. Everyone started to tune in. Bootleg recordings of transmissions were played on CB radio and passed around parties and happenings. Bands started covering and expanding on the song. A hypnotic effect took hold over the bodies listening. "The drift" had been brought home from space. As soon as the mistake was noticed, the song was banned on the ground. All frequencies were jammed. The government shut down all sound broadcasts and tore down satellite dishes.

But it was too late. Even though the song had been contained, the drift was free. Those affected became known as drifters and continued to drift for years in isolation and avoided communities.

We were told to look away from the drifters and eventually to look away from the sky. We focused on our manicured lawns, Sunday sports, fondue parties, and local parades. The space missions were redirected and became less about majestic gestures and more about practical goals. We were satisfied with earth orbits and moon landings again. We stayed away from dreams that were beyond our reach.

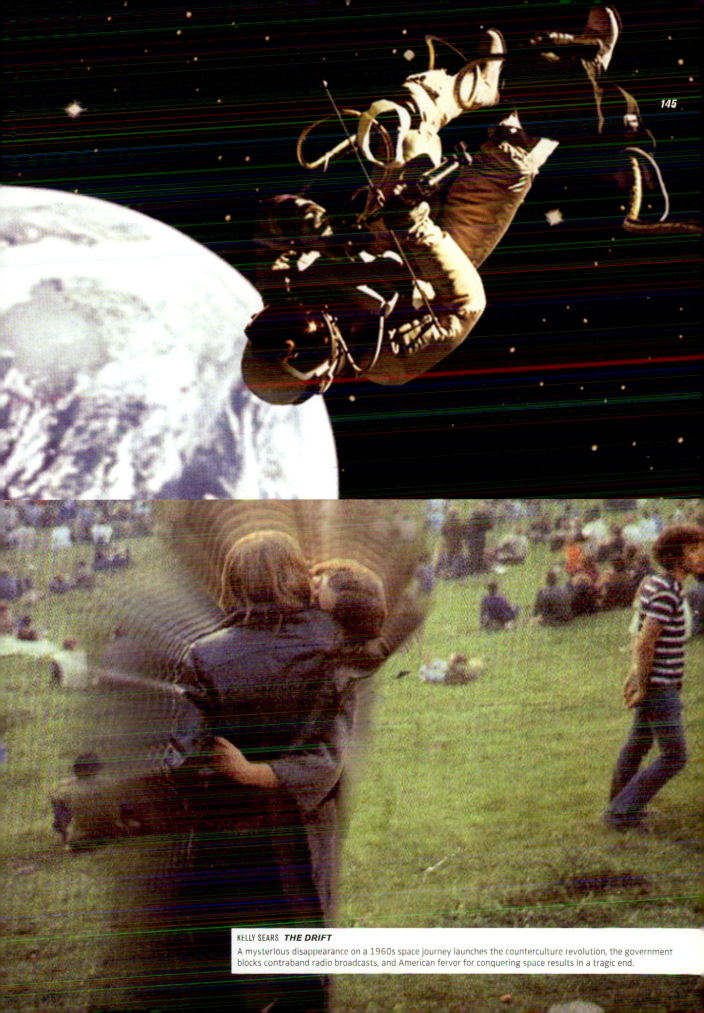

KELLY SEARS *THE DRIFT*

A mysterious disappearance on a 1960s space journey launches the counterculture revolution, the government blocks contraband radio broadcasts, and American fervor for conquering space results in a tragic end.

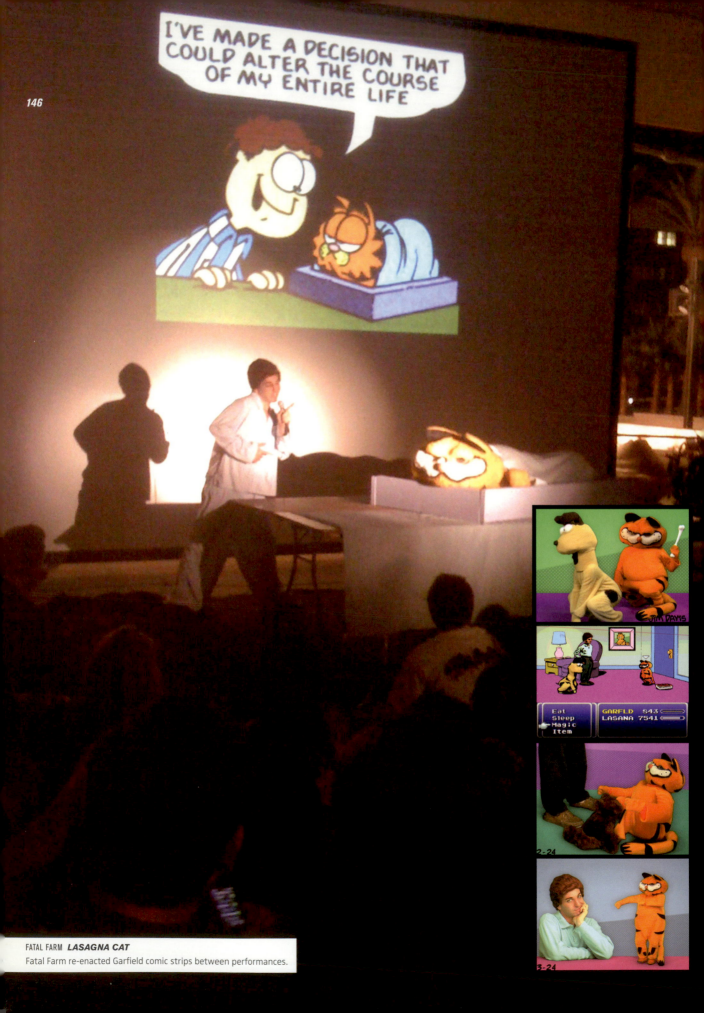

146

FATAL FARM *LASAGNA CAT*
Fatal Farm re-enacted Garfield comic strips between performances.

FATAL FARM

CHRISTY McCAFFREY AND ALLISON MILLER

Christy McCaffrey and Allison Miller Lasagna Cat, there was a lot going on at *Machine Project Field Guide to LACMA* and we were kind of drunk, so can you remind us what you did that night?

Fatal Farm Well, as you probably know, I've been the star of a massively popular syndicated comic strip for over thirty years now. What I did for Machine Project's event was to recreate a handful of those classic strips live.

Christy and Allison Oh, that's right, Lasagna Cat. Usually you produce videos for your website (lasagnacat.com); what led you to start doing this?

Fatal Farm After my unparalleled success in print and on the silver screen, I wanted to reinterpret myself for the internet. But actually, I only passively assisted in the production of the videos for Lasagnacat.com. I've been told it was the actors' goal to recreate a hundred days of my life. But that halfway through that endeavor they got bored with the project and somewhat arbitrarily decided to take it in a schlocky music video direction.

Christy and Allison Can you, Lasagna Cat, tell us about your relationship to the Emmy-award winning Jim Davis (creator of Garfield)?

Fatal Farm Jim Davis is a nonfiction writer and documentarian who has dedicated his life to capturing my own in print and film for over thirty years. I appreciate his endurance and commitment to me, but as a man, he's kind of banal.

Christy and Allison Can you tell us about your relationship to Garfield?

Fatal Farm Garfield is the name I go by in traditional media. It was given to me by my slave-human, Jon Arbuckle. Lasagna Cat is a persona I have adopted for experimentation. Similar to Ziggy Stardust or Chris Gaines.

Christy and Allison Can you tell us about your relationship to Odie?

Fatal Farm Odie is a severely handicapped animal. I've carried out two-way conversations with inanimate objects and have a bathroom scale that could pass the Turing test, and yet Odie just barks and drools. Given this, it seems unconscionable that Odie's disability should so often be the subject of humor, but I guess it's a psychosis of humanity that my audience would want to belittle the weak so that they may feel strong.

Christy and Allison Lasagna Cat, what did you learn about yourself by going through the process of recreating some of these comic strips live? Did you have any anxiety associated with that experiment?

Fatal Farm I learned that funny is funny no matter what the medium. And that a cat exhibiting predictably sarcastic behaviors in contrived exchanges with its self-effacing owner is a prescription for laughter. Yes, I was anxious. But I was so doped up on Klonopin, Xanax, and Ativan that I made it through all right.

Christy and Allison Lasagna Cat, what do you think is the basis for the public's interest in you? Why do we care?

Fatal Farm My only interest in the public's interest is whether or not it will result in my acquisition of more food. I guess you could call me a diva, but I don't care if you care as long as I have pizza.

Christy and Allison And finally, Lasagna Cat, where do you see yourself in five years? Ten years?

Fatal Farm Merchandising deals aside (I have expensive habits), I hope to be mercifully put out of my misery by then. If my comic strip is still running in ten years, God help us all.

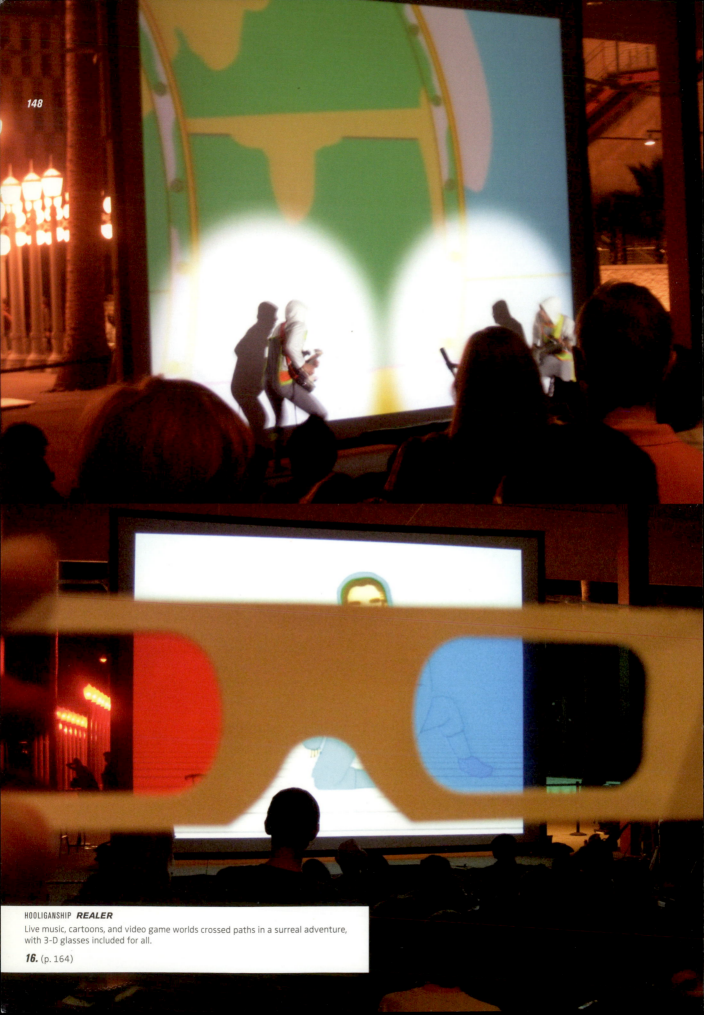

HOOLIGANSHIP *REALER*
Live music, cartoons, and video game worlds crossed paths in a surreal adventure, with 3-D glasses included for all.

16. (p. 164)

7.

Props for Performance:
Some Notes on Methodology

Field

Cheer Up the Loneliest Gallery

Ambient Haircut

PROPS FOR PERFORMANCE
Some Notes on Methodology
LIZ GLYNN

I like museums. I spend quite a lot of time in them, whether doing research, coordinating exhibitions, or hoping sincerely for new ideas born out of Cycladic figures. But as a child of institutional critique, I have typically entered relationships with museums with trepidation. I had a romantic impression prior to the _Field Guide_ of the museum as a battleground, where artists would defend their most radical expressions against all curatorial objections and attempts to rein in the work. Like many of the other artists in the _Field Guide_, my work also presents some practical challenges for tightly regulated institutional spaces. I'm deeply invested in process, and my projects frequently involve power tools, food, liquids, flammables, and tend not to be static. The idea of "museum as mausoleum," the place where artwork goes to die and live forever immortal, seems difficult to reconcile the experience of work that unfolds unpredictably, in real time. The first time I visited LACMA to consider this project, my first thoughts were of debaucherous banquets and horses in the gallery, immediately followed by the realization that neither would pass curatorial muster.

One of the first questions I had for Mark Allen was whether we would share all of our concerns with the curatorial staff at LACMA. We decided not to hide anything, and we worked closely with Charlotte Cotton and Eve Schillo in the photography department. They helped us understand that navigating a vast encyclopedic museum involves not only plowing through bureaucratic procedural channels, but maintaining a keen awareness of the collective social organism composed of many individual affinities. A master list of prohibitions simply did not exist; tracing LACMA's boundaries was more like a game of Battleship, where the flash points only became visible over time, through trial and error. Squeamishness with some of the projects—were they not serious Art?—is typically hidden under the passive negation of standard institutional language. After all, it's simply more polite to evoke concern about possible effects on the collection than to suggest a piece is stupid. Over a period of several months, Charlotte sought to engage her fellow curators, debunk any myths about the presumed dangers of everything from large crowds to live botanical matter, and convince them that it was all going to be okay. This allowed us to push boundaries that we couldn't have permeated by sneaking around. Over the course of the _Field Guide_, I came to understand a new paradigm beyond the binary of artist against curator: developing working relationships over time and continually challenging each other allows the two parties to come to an expanded notion of what is possible. When I began working on the _Field Guide_, I could predict potential objections almost instinctually, because I felt them myself after spending years tiptoeing respectfully through museums. I had to actively separate this paranoia from the reality that a much larger set of actions can exist inside a museum without damaging the other artwork. I hope the fact that the museum was still standing on November 16 gave LACMA a newfound confidence as well: a project like this can happen without the museum imploding.

In order to make some of the projects happen, we approached the most quixotic fantasies at the most practical level of nuts, bolts, and debugged flowers. We asked a lot of questions that had never been asked—like, can we use that leftover carpet, and how do we turn off that bird alarm call speaker, a device used to prevent pigeons from nesting in the rafters? We still don't know who controls the speaker; on the day of the *Field Guide*, one of the guards had to scale a fifteen-foot balcony to unplug it manually. In the case of Holly Vesecky's *Sam Frantasy*, the curators initially said no to live flowers because of the potential for unknown bugs to devour the paintings, but with a little research, we discovered a number of instances of temporary floral displays in museums, and were able to obtain debugged live flowers from a florist. We took advantage of in-between spaces which were not controlled by curatorial oversight, including a balcony on the Art of the Americas Building that wound up housing *Gothic Arch Speed Metal* and an outdoor amphitheater where Michael O'Malley assembled a temporary brick oven and cooked pizza. In the case of *Replica, Replica, for W.R.H.*, a workshop I organized for the *Field Guide*, the curator in control of the Pauley Gallery had negged the idea of temporarily installing a second set of pedestals to allow the replicas to rest side-by-side with the permanent collection. On November 15, one of the workshop participants asked if he should deposit his replica up in the Greek and Roman gallery near the piece on which it was based. We began "reverse looting," or simply leaving the replicas behind on the floor of the gallery. After all, it wasn't going to hurt anything.

Many of the works in the *Field Guide* existed in a mutualistic relationship with LACMA as a site of cultural production, and yet there was literally nowhere to put our stuff. The museum contains numerous strange alcoves that lead to nowhere, and spaces for art storage, but there was nowhere to change costumes or lay out tools. On the day of the event, we deposited all of our supplies in small garage normally used by the caterers. We were always leaving our bags on the floor during site visits, and trying to ignore the half-finished aspects of unrehearsed performances in the weeks leading up to the show. During the early rehearsals, I remember Corey Fogel arriving with his pepper-can suit loosely wrapped in a green sack, which he kept leaving behind as we moved through the museum. When the time came for him to put the suit on for a photo shoot, he replied that it couldn't be put on: the suit was still, literally, in pieces.

None of the objects we brought in fell under the institutional guidelines confirming their status as art. "Art" involves loan forms *and* insurance, not to mention a staff of trained preparators. Everything we brought in fell under the auspices of "props for performance."[1] By definition, props are meant to be handled. They are a pretext for something bigger to happen, but on their own, they are dormant. Some artists brought props in the traditional sense—Stephanie Hutin and Florencio Zavala's collection of vacuum cleaners come to mind. Others used the museum's collection as an animating mechanism: Ken Ehrlich's *Kinetic Companions* are only understood when viewed in front of the paintings on which they are based. In the case of Kamau Patton's *Proliferation of Concept/Accident Tolerant: A Series of Feedback Loops*, the notion of a prop served as a Trojan horse to place an installation in close proximity to a Morris Louis painting that became raw material to be reprocessed through a video feedback loop.

Over the evolution of the *Field Guide*, the artists in the show were not only bound to the museum, but tied more tightly to each other. Machine isn't an array of well-oiled

parts connected synchronously. In reality, it looks more like what happens when you accidentally knock a toolbox off the table: some cluster magnetically, while others scatter farther afield. These days, we are increasingly asking each other to be involved in new projects, whether for several months, or just for a night. This model is intuitive for musicians, but to visual artists like me, it can be somewhat disarming. Even as art discourse has embraced collaborative practice, it often privileges a model based on long-term, fixed groups with visually codified practices and proper names. Such sustained relationships have proven to be one generative methodology, and yet there are other more casual, fleeting modes of engagement which we are only just beginning to explore.

At Machine the sheer volume of output prevents a certain kind of preciousness; wild experimentation is valued over practiced mastery. We try our best, we fail, and we try again, and as Samuel Beckett writes, "Fail again. Fail better." What matters is the gesture, and the sustained commitment to never knowing exactly what will happen next.

1. When Charlotte Cotton made the final walkthrough for the *Field Guide* with the chief preparator, she was asked with a knowing glance if anything we were bringing in was "art." "No, just props for performance," she replied.

Planning meeting, November 14, on the BP Grand Entrance.

SHEILA GOVINDARAJAN / WALTER KITUNDU / ROBIN SUKHADIA *FIELD*
Sheila Govindarajan (vocals), Walter Kitundu (invented kora harp), and Robin Sukhadia (tabla and hand chimes) performed on the ground floor of BCAM inside Richard Serra's *Band*.

NOTES ON FIELD *ROBIN SUKHADIA*

The pieces are based very loosely on structures of time called *talas* in north Indian music, and we improvise heavily within those structures. We improvise around these classical compositions, adding our own ideas and extrapolating from existing ones. Dynamics and silence play a large role in our approach to making music, and we try to open up spatially within the cycles of time to create a sense of movement for the audience. It worked beautifully within the Serra sculpture.

The experience of playing within the slanted and curved walls of the Serra sculpture was absolutely amazing. We were also very much listening to sound reflecting back from the high ceiling and the depth of the entire building. The reflected sound would swirl around within the sculpture and at times compete with us. We surrendered to these waves of delay, and that is when the music really became something more poetic. As more people flowed into the sculpture to take their seats, that too affected the absorption of sound. It felt very fluid in there, at times we would play loud and could hear nothing, and then play quietly and it would feel more epic. I felt like we were humanizing the sculpture in some ways, giving it a pulse.

CHEER UP THE LONELIEST GALLERY

STEPHANIE HUTIN AND FLORENCIO ZAVALA

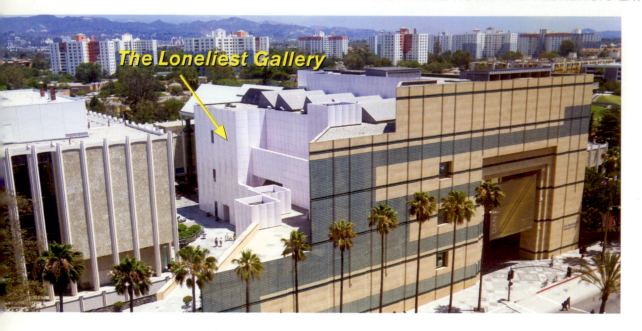

The Loneliest Gallery

Cheer up the Loneliest Gallery. It needs you. It needs all of us. Nobody wants to be lonely.

Deep inside the museum's nineteenth-century French painting hall, the Loneliest Gallery, otherwise known as the Photography Foyer,[1] will be experiencing a day of reckless pampering, unadulterated encouragement, and general acknowledgment. Sculptural elements and performances will collide in a community-driven campaign of cheer, all within the confines of the four smallest walls in the institution. On this day, the Loneliest Gallery will no longer be out of place; the nearly closet-sized eyesore will finally get the treatment it deserves, but it needs your help!

Join the Loneliest Gallery Cheer Committee! Write a song! Choreograph a dance! Donate to the flower fund! Bring a friend! Grab a vacuum!

Help us hang a show. Wear a blindfold. Get disoriented. See what happens!

"In general, artwork should be hung so that the center point of the picture or grouping is at about eye level for the average person. While this won't be possible in every situation, it's a good guideline to keep in mind."

—Excerpt from *28 Tips for Hanging Art*

1. The permanent collection of photography at LACMA is allotted only a single alcove, outside of the curatorial offices and photography reading room on the third floor of the Hammer Building. Planned renovations of the former May Company building known as LACMA West, as well as the construction of the new Lynda and Stewart Resnick Exhibition Pavilion, will give photography a new home. Until then, honestly, the photography department seemed a little sad. Machine decided it was time to brighten up the Loneliest Gallery, and enlisted the help of Stephanie Hutin and Florencio Zavala.

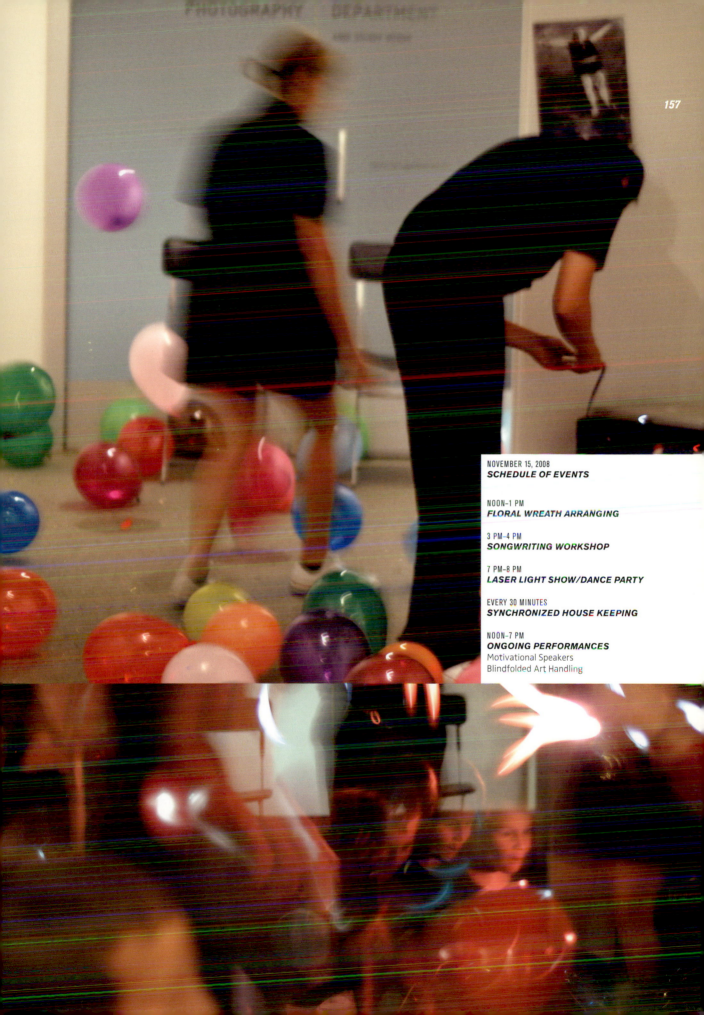

NOVEMBER 15, 2008
SCHEDULE OF EVENTS

NOON–1 PM
FLORAL WREATH ARRANGING

3 PM–4 PM
SONGWRITING WORKSHOP

7 PM–8 PM
LASER LIGHT SHOW/DANCE PARTY

EVERY 30 MINUTES
SYNCHRONIZED HOUSE KEEPING

NOON–7 PM
ONGOING PERFORMANCES
Motivational Speakers
Blindfolded Art Handling

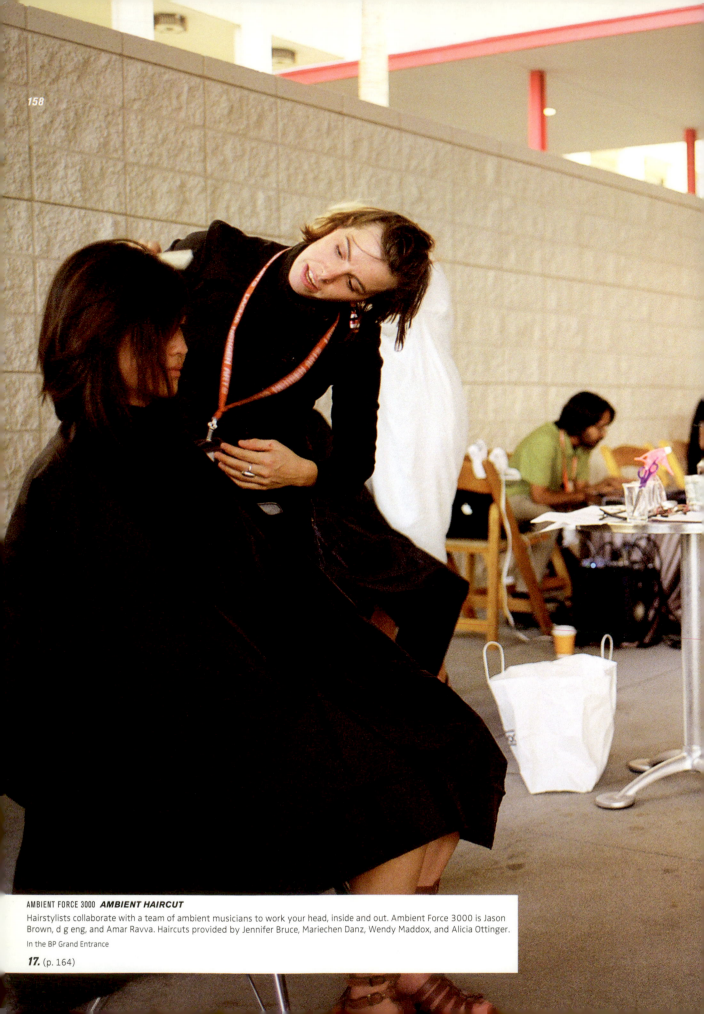

AMBIENT FORCE 3000 *AMBIENT HAIRCUT*
Hairstylists collaborate with a team of ambient musicians to work your head, inside and out. Ambient Force 3000 is Jason Brown, d g eng, and Amar Ravva. Haircuts provided by Jennifer Bruce, Mariechen Danz, Wendy Maddox, and Alicia Ottinger.

In the BP Grand Entrance

17. (p. 164)

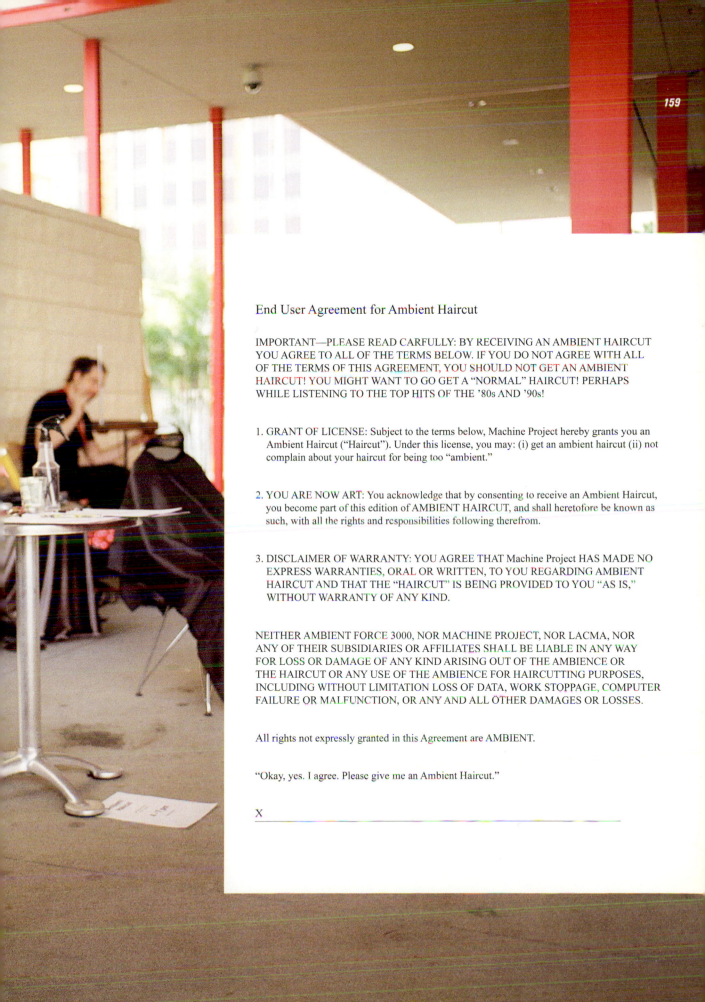

End User Agreement for Ambient Haircut

IMPORTANT—PLEASE READ CARFULLY: BY RECEIVING AN AMBIENT HAIRCUT YOU AGREE TO ALL OF THE TERMS BELOW. IF YOU DO NOT AGREE WITH ALL OF THE TERMS OF THIS AGREEMENT, YOU SHOULD NOT GET AN AMBIENT HAIRCUT! YOU MIGHT WANT TO GO GET A "NORMAL" HAIRCUT! PERHAPS WHILE LISTENING TO THE TOP HITS OF THE '80s AND '90s!

1. GRANT OF LICENSE: Subject to the terms below, Machine Project hereby grants you an Ambient Haircut ("Haircut"). Under this license, you may: (i) get an ambient haircut (ii) not complain about your haircut for being too "ambient."

2. YOU ARE NOW ART: You acknowledge that by consenting to receive an Ambient Haircut, you become part of this edition of AMBIENT HAIRCUT, and shall heretofore be known as such, with all the rights and responsibilities following therefrom.

3. DISCLAIMER OF WARRANTY: YOU AGREE THAT Machine Project HAS MADE NO EXPRESS WARRANTIES, ORAL OR WRITTEN, TO YOU REGARDING AMBIENT HAIRCUT AND THAT THE "HAIRCUT" IS BEING PROVIDED TO YOU "AS IS," WITHOUT WARRANTY OF ANY KIND.

NEITHER AMBIENT FORCE 3000, NOR MACHINE PROJECT, NOR LACMA, NOR ANY OF THEIR SUBSIDIARIES OR AFFILIATES SHALL BE LIABLE IN ANY WAY FOR LOSS OR DAMAGE OF ANY KIND ARISING OUT OF THE AMBIENCE OR THE HAIRCUT OR ANY USE OF THE AMBIENCE FOR HAIRCUTTING PURPOSES, INCLUDING WITHOUT LIMITATION LOSS OF DATA, WORK STOPPAGE, COMPUTER FAILURE OR MALFUNCTION, OR ANY AND ALL OTHER DAMAGES OR LOSSES.

All rights not expressly granted in this Agreement are AMBIENT.

"Okay, yes. I agree. Please give me an Ambient Haircut."

X _____

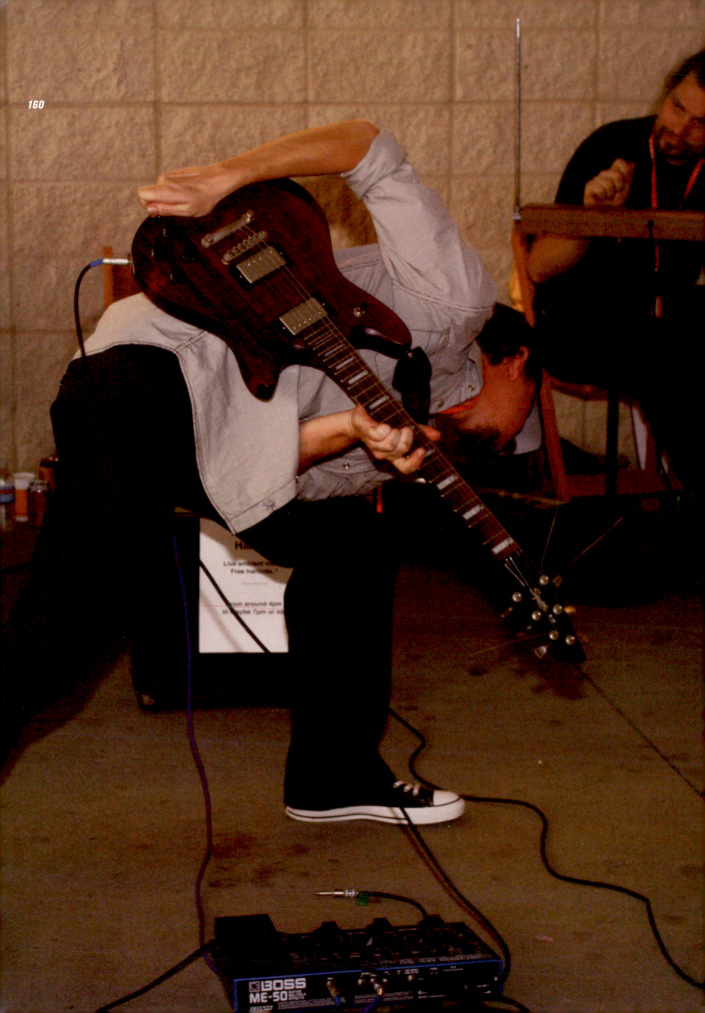

8. End Notes

END NOTES JOSHUA BECKMAN

1. "Last night, in sweeping over a part of the heavens with my 5-feet reflector, I met with a telescopic comet." Caroline Herschel, *Account of the Discovery of a New Comet*, 1795

2. As related in Richard Foster Jones' book *Ancients and Moderns*, at the time when the Royal Society was founded, Glanvill expressed (in his *Vanity of Dogmatizing*, 1661) the opinion that such men as Descartes, Galileo, Harvey, and the members of the Royal Society would "strike dead the opinion of the world's decay, and conclude it, in its Prime."

3. "In that season of the year when the serenity of the sky, the various fruits which cover the ground, the discoloured foliage of the trees, and all the sweet but fading graces of inspiring autumn open the mind to benevolence, and dispose it for contemplation; I was wandering in a beautiful and romantic country, till curiosity began to give way to weariness; and I sat me down on the fragment of a rock overgrown with moss, where the rustling of the falling leaves, the dashing of waters, and the hum of the distant city, soothed my mind into the most perfect tranquility; and sleep insensibly stole upon me, as I was indulging the agreeable reveries which the objects around me naturally inspired." Anna Laetitia Barbauld, *The Hill of Science*, 1825

4. "It is a great thing to add to the countless multitude of fixed stars visible hitherto by natural means and expose to our eyes innumerable others never seen before." Galileo Galilei, *Sidereus Nuncius*, 1610

5. "But other questions come upon us. What is a man's eye but a machine for the little creature that sits behind in his brain to look through? A dead eye is nearly as good as a living one for some time after the man is dead. It is not the eye that cannot see, but the restless one that cannot see through it. Is it man's eyes, or is it the big seeing-engine which has revealed to us the existence of worlds beyond worlds into infinity? What has made man familiar with the scenery of the moon, the spots on the sun, or the geography of the planets? He is at the mercy of the seeing-engine for these things, and is powerless unless he tack it on to his own identity, and make it part and parcel of himself." Samuel Butler, *Erewhon*, 1872

6. "As in *Geometry*, the most natural way of beginning is from a Mathematical *point*; so is the same method in Observations and *Natural history* the most genuine, simple, and instructive. We must first endeavor to make *letters*, and draw single strokes true, before we venture to write whole *Sentences*, or to draw large *Pictures*. And in *Physical* Enquiries, we must endeavour to follow Nature in the more *plain* and *easie* ways she treads in the most *simple* and *uncompounded* bodies, to trace her steps, and be acquainted with her manner of walking there, before we venture our selves into the multitude of *meanders* she has in *bodies of a more complicated* nature; left, being unable to distinguish and judge of our way, we quickly lose both *Nature* our Guide, and *our selves* too and are left to wander in the *labyrinth* of groundless opinions; wanting both *judgment*, that *light*, and *experience*, that clew, which should direct our proceedings." Robert Hooke, *Micrographia*, 1665

7. "Nov. I. An imperfect rainbow on the fog; a more vivid one on the dewy grass." Gilbert White, *Journals*, 1771

8. "But I have one want which I have never yet been able to satisfy; and the absence of the object of which I now feel as a most severe evil. I have no friend, Margaret: when I am glowing with the enthusiasm of success, there will be none to participate my joy; if I am assailed by disappointment, no one will endeavor to sustain me in dejection." Mary Shelley, *Frankenstein*, 1818

9. "Through a Telescope we could show the moon at night along with other heavenly

bodies. We could send for the water drinker. We could test machines which would throw things exactly at a given point. Exhibits of the muscles, nerves, bones: *item*, machine representing the human body. Insects of Mons. Swammerdam... Amusing and colloquial disputes. Exhibit of *camera obscura*. Paintings which can only be seen with (an instrument) from one angle presenting one picture, from another, quite a different one, like that of a certain Mons. a l'isle, v.d.—farms as at Versailles on the edge of a Canal. Public diversions (such as) pictures on oiled paper and burning lamps or lanterns. There could be figures who could walk, with a little illumination inside them, so as to show whatever might be printed on the paper. For magic lanterns, there would be not only simple objects painted on something transparent, but also detachable moving pictures of very unusual and grotesque objects, which it would be possible to make." Gottfried Leibniz, *An Odd Thought Concerning a New Sort of Exhibition*, 1675

10. As related by William Powell Jones in *The Rhetoric of Science*, Dr. Samuel Bowden's 1737 "A Poem Sacred to the Memory of Sir Isaac Newton," listed among Newton's great accomplishments, learning to view a comet without surprise.

11. "*Hearing*, a most excellent outward sense, *by which we learn and get knowledge*. His object is sound, or that which is heard; the *medium*, air; the *organ* the ear. To the sound, which is a collision of the air, three things are required: a body to strike, as the hand of a musician; the body strucken, which must be solid and able to resist, as a bell, lute-string, not wool, or sponge; the *medium*, the air, which is *inward*, or *outward*; the outward, being struck or collided by a solid body, still strikes the next air; until it come to that inward natural air, which, as an exquisite organ, is contained in a little skin formed like a drum-head, and struck upon by certain small instruments like drum-sticks, conveys the sound, by a pair of nerves appropriated to that use." Robert Burton, *The Anatomy of Melancholy*, 1621

12. from Mary Wollstonecraft's *Lessons*, 1795

LESSON I

Cat. Dog. Cow. Horse. Sheep. Pig. Bird. Fly.
Man. Boy. Girl. Child.
Head. Hair. Face. Nose. Mouth. Chin.
Neck. Arms. Hand. Leg. Foot. Back. Breast.
House. Wall. Field. Street. Stone. Grass.

LESSON II

Come. Walk. Run. Go. Jump. Dance.
Ride. Sit. Stand. Play. Hold. Shake.
Speak. Sing. Cry. Laugh. Call. Fall.
Day. Night. Sun. Moon. Light. Dark.
Sleep. Wake.

Wash. Dress. Kiss. Comb.
Fire. Hot. Burn. Wind. Rain. Cold.
Hurt. Tear. Break. Spill.
Book. See. Look.
Sweet. Good. Clean.
Gone. Lost. Hide. Keep. Give. Take.
One. Two. Three. Four. Five. Six.
Seven. Eight. Nine. Ten.
White. Black. Red. Blue. Green. Brown.

Stroke the cat. Play with the dog. Eat the bread. Drink the milk. Hold the cup.
Lay down the knife.

Look at the fly. See the horse. Shut the door. Bring the chair. Ring the bell.
Get your book.

Hide your face. Wipe your nose. Wash your hands. Dirty hands. Why do you cry?
A clean mouth. Shake hands. I love you. Kiss me now. Good girl.

The bird sings. The fire burns. The cat jumps. The dog runs. The bird flies.
The cow lies down. The man laughs. The child cries.

13. "The shock of every single ray may generate many thousand vibrations and, by sending them all over the body, move all the parts, and that perhaps with more motion than it could move one single part by an immediate stroke; for the vibrations, by shaking each particle backward and forward, may every time increase its motion, as a ringer does a bell by often pulling it, and so at length move the particles to a very great degree of agitation, which neither the simple shock of a ray nor any other motion in the ether besides a vibrating one could do." Sir Isaac Newton, *Hypothesis Touching on the Theory of Light and Colors*, 1675

14. "We are born capable of sensation and from the first are affected in different ways by the objects around us. When we become conscious of our sensations we naturally tend to seek or to avoid the objects which produce them: at first, because they are agreeable or disagreeable to us… at last, because of the judgment we pass on them by reference to the idea of happiness or perfection we get from reason. These tendencies extend and strengthen with the growth of sensibility and intelligence, but under the pressure of habit they are changed to some extent by our opinions. The tendencies before this change are what I call our nature. In my view everything ought to be in conformity with these original inclinations." Jean-Jacques Rousseau, *Emile*, 1762

15. "The use of the *Microscope* will naturally lead a thinking Mind to a Consideration of *Matter*, as fashion'd into different Figures and Sizes, whether Animate or Inanimate: It will raise our Reflections from a Mite to a Whale, from a Grain of Sand to the Globe whereon we live, thence to the Sun and Planets; and, perhaps, onwards still to the fixt Stars and the revolving Orbs they enlighten, where we shall be lost amongst Suns and Worlds in the Immensity and Magnificence of Nature." Henry Baker, *The Microscope Made Easy*, 1743

16. "We procure means of seeing objects afar off, as in the heaven and remote places; and represent things near as afar off, and things afar off as near; making feigned distances. We have also helps for the sight, far above spectacles and glasses in use. We have also glasses and means to see small and minute bodies perfectly and distinctly; as the shapes and colors of small flies and worms, grains, and flaws in gems which cannot otherwise be seen, observations in urine and blood not otherwise to be seen. We make artificial rainbows, halos, and circles about light. We represent also all manner of reflections, refractions, and multiplications of visual beams of objects." Francis Bacon, *The New Atlantis*, 1627

17. "Some there are who desire but to Please themselves by the Discovery of the Causes of the known Phænomena, and others would be able to produce new ones, and bring Nature to be serviceable to their particular Ends, whether of Health, or Riches, or sensual Delight. Now as I shall not deny but that the Atomical, or some such Principles, are likely to afford the most of satisfaction to those speculative Wits that aim but at the knowledge of Causes; so I think that the other sort of men may very delightfully and successfully prosecute their ends, by collecting and making Variety of Experiments and Observations, since thereby learning the Qualities and Properties of those particular Bodies they desire to make use of, and observing the Power that divers Chymical Operations, and other wayes of handling Matter, have of altering such Bodies, and varying their Effects upon one another, they may by the help of

Attention and Industry be able to do many Things, some of them Strange, and more of them very useful in Humane Life." Robert Boyle, *Certain Physiological Essays*, 1661

18. "There is a bright spot seen in the corner of the eye, when we face a window, which is much attended to by portrait painters; this is the light reflected from the spherical surface of the polished corner, and brought to a focus; if the observer is placed in this focus, he sees the image of the window; if he is placed before or behind the focus, he only sees a luminous spot, which is more luminous and of less extent, the nearer he approaches to the focus. The luminous appearance of the eyes of animals in the dusky corners of a room, or in holes in the earth, may arise in some instances from the same principle; viz. the reflection of the light from the spherical cornea; which will be coloured red or blue in some degree by the morning, evening, or meridian light; or by the objects from which the light is previously reflected." Erasmus Darwin, *The Loves of the Plants*, 1791

INDEX

ACKNOWLEDGMENTS

Machine Project would like to acknowledge the support and efforts of the following heroic humans:

Machine Curatorial Team
Mark Allen, Matthew Au, Joshua Beckman, Jason Brown, Ken Ehrlich, Kelli Cain, Chris Colthart, Brian Crabtree, Jim Fetterley, Corey Fogel, Aaron Gach, Jordan Gimbel, Liz Glynn, Fritz Haeg, Jessica Hutchins, Emily Joyce, Dawn Kasper, Lewis Keller, Walter Kitundu, Emily Lacy, Anthony McCann, Annie O'Malley, Kamau Patton, Casey Rentz, Mathew Timmons, Sara Roberts, Phil Ross, Kelly Sears, Laura Steenberge, Robin Sukhadia, Ryan Taber, Jason Torchinsky, Caleb Waldorf, Kimberly Varella, Holly Vesecky, and Michele Yu.

Video Documentation
Coordinated by Jim Fetterley.

Videography and audio recording by Justin Allen, Nick Amato, Bryan Brown, Lindsay Byrne, Donavan Crony, Julia Dzwonkowski, Anne Hadlock, Jason Harris, David Harrow, Cyril Kuhn, Kelley Parker, Kye Potter, Scott Shackleford, and Seung Heun Yoo.

Machine Project Volunteer Army
Yuki Ando, Ashley Atkinson, Karen Atkinson, Nicole Bestard, Summer Block Kumar, Barbara Bogaev, India Brookover, Bernard Brunon, Maximilian BuschmanChad Clark, Alice Clements, Megan Daadler, Maray Dang, Astrid Diehl, Mindy Farabee, Enrique Farfan, Bruce Fox, Field Garthwaite, Karen Gomez, Gabriela Gonzalez, Katherine Guillen, Ann Hadlock, Dorka Hegedus, Tatiana Hernandez, Adnan Khan, Stephanie Libanati, Karen Linderman, Fei Liu, Lindsay Ljungkull, Ellen Lutwak, David Magid , Miles Martinez, Sofia Mas, Kirstin McLatchie, Sam Meister, Vanessa Mesner, Leah Morelli, Erwin Ong, Tim Ottman, Nathaniel Osollo, Grigor Pankov, Billie Pate, Dharmesh Patel, Sonia Paulino, Roberto Paz, Eugenio Perez, Christophe Pettus, Viridiana Ravalcaba, Paul Redmond, Jeni Rohlin, Autumn Rooney, Brian Schirk, Heather Schlegel, Aili Schmeltz, Jan Silverstrom-Elfman, Henry Solis, Stephanie Stein, Michael Sy, Cameron Taylor-Brown, Erik Tillmans, Evans Vestal Ward, Alyssa Wang, Teresa Williams, Nico Wyland, Kim Ye, and many more.

Many thanks to the Los Angeles County Museum of Art, including
Allison Agsten, Austen Bailly, Chris Bedford, Terence Blanton, Terri Bradshaw, Jane Burrell, Sara Cody, Tom Drury, Aileen Fraser, Tom Frick, Brooke Fruchtman, Paul Gardener, Mark Gilberg, Fredric Goldstein, Rita Gonzalez, Bindu Gude, Jeff Haskin, Alexandra Klein, Dion Lewis, Leo Lopez, Andrew Martinez, Rachel Mullennix, Randy Murphy, Carol Norcross, Ernesto Portillo, Cheryle Robertson, Susan Schmalz, Janice Schopfer, Piper Severance, Nancy Thomas, Glenn Thompson, Elvin Whitesides, Sarah Bay Williams, Erin Wright, the LACMA security staff, and the murder mystery test players.

Thanks also to
Katie Bachler, Scott Mayoral, Daniella Meeker, Christopher Murphy, and Sidonie Loiseleux.

Special thanks to
Charlotte Cotton, former department head and curator of LACMA's Wallis Annenberg Photography Department, and senior collections administrator Eve Schillo for their guidance and patience in making the whole project happen.

Machine loves you.

IMAGE CREDITS

Works in the catalogue are licensed and copyright-protected by the artist listed. Most photographs are reproduced courtesy of the creators and lenders of the material depicted. For certain artwork and documentary photographs we have been unable to trace copyright holders. The publishers would appreciate notification of additional credits for acknowledgment in future editions.

Front cover. photo by Katherine Guillen

1. photo by Michele Yu

2. photo by Emily Joyce

3. photo by Roberto Paz

4. (TOP) photo by Autumn Rooney; (BOTTOM) photos by Sidonie Loiseleux

11. (TOP) photo by Gene Ogami; (MIDDLE & BOTTOM) photos courtesy Machine Project

12. photo by Sidonie Loiseleux

14. photo by Sam Meister

15. (TOP) © 2009 Google Map, data © 2009 Tele Atlas; (BOTTOM RIGHT) courtesy of Matthew Au; (BOTTOM LEFT) photo by Scott Mayoral

16. photo by Scott Mayoral

17. courtesy of Matthew Au

18. photo by Sidonie Loiseleux

19. (TOP) photo by Nate Page; (MIDDLE & BOTTOM) photos by Sidonie Loiseleux

20-21. photo by Sidonie Loiseleux

21. courtesy of Lewis Keller

22. photo by Scott Mayoral

25. (TOP) courtesy of Franz Kunst. Licensed with Creative Commons; (MIDDLE) courtesy of candid, flickr.com. Licensed with Creative Commons; (BOTTOM) courtesy of Brian Flores

26. (TOP) courtesy of Eric Chang, maveric2003, flickr.com; (MIDDLE) photo by Karin Dalziel Licensed with Creative Commons; (BOTTOM) photo by Kim Scarborough, CC/SA licensed.

29. photo by Michele Yu

30-31. photo by Sidonie Loiseleux

32. photo by Dorka Hegedus

34. courtesy of Walter Kitundu

35. photo by Scott Mayoral

37. photo by Scott Mayoral

38-39. photo by Scott Mayoral

40. photo by Sidonie Loiseleux, (BACKGROUND) artwork © The Estate of Morris Louis

41. From *Mutatis Mutandis* by Herbert Brün, © Smith Productions, 2617 Gwynndale Ave., Baltimore, MD 21207. Used by permission.

43. courtesy of Fol Chen

45. photo by Melissa Thorne

46. photo by Scott Mayoral, (BACKGROUND) artwork © Mondrian/Holtzman Trust, © Gerrit Rietveld Estate/Artists Rights Society (ARS), NY/Beeldrecht, Amsterdam

47. photo by Sidonie Loiseleux, (BACKGROUND) artwork © El Lissitzky Estate/Artists Rights Society (ARS), NY/VG Bild-Kunst, Bonn

48. photo by Scott Mayoral

49. courtesy Jason Torchinsky

50-51. photo by Sidonie Loiseleux, (BACKGROUND) artwork © Max Beckmann Estate/Artists Rights Society (ARS), NY/VG Bild-Kunst, Bonn

52. photo by Justin Allen

61. photo by Scott Mayoral

62. (TOP) photo by Katherine Guillen; (BOTTOM) photo by Dao Nguyen

63. photo by Katherine Guillen

64-65. photo by Sidonie Loiseleux

66-67. courtesy of the Center for Tactical Magic

69. photo by Scott Mayoral

70. courtesy of Kelli Cain

71. (TOP) courtesy of Kelli Cain; (BOTTOM) photo by Dorka Hegedus

72. photo by Katherine Guillen

73. photo by Scott Mayoral

75. photo by Sidonie Loiseleux

76. photo by Sidonie Loiseleux

81. from the California Historical Society Digital Archive, digitally reproduced by the University of Southern California Digital Archive. Available: http://digarc.usc.edu

82. (TOP) from the Dick Whittington Studio Collection, digitally reproduced by the USC Digital Archive. Available: http://digarc .usc.edu (WHIT-M1440); (MIDDLE) photo by Peter Sheik; (BOTTOM) Creative Commons License/Wikipedia. Attribution: Cb162

83. (TOP) © 1969 Q Productions; (MIDDLE & BOTTOM) courtesy of the United States Atomic Energy Commission

84. (TOP) courtesy of the United States Department of Energy; (BOTTOM) From the *Los Angeles Examiner* Negatives Collection, 1950–61. Photo by Olmo. Digitally reproduced by the USC Digital Archive. Available: http://digarc.usc.edu (EXAMINER-M17307)

85. (TOP) From the California Historical Society Digital Archive, Los Angeles Chamber of Commerce Collection, 1888–1960. Digitally reproduced by the USC Digital Archive. Available: http://digarc.usc.edu (CHS-M2646); (MIDDLE) From the California Historical Society Digital Archive, digitally reproduced by the USC Digital Archive. Available: http://digarc.usc.edu (CHS-M20564); (BOTTOM) Creative Commons License/Image courtesy Biodiversity Heritage Library. http://www.biodiversity library.org

86. (TOP) photo by Aaron McBride; (MIDDLE) photo by Eugene Zelenko; (BOTTOM) photo by Tony Maroni

87. courtesy of the National Nuclear Security Administration, Nevada Site Office

88. © William Crutchfield, photo courtesy of Museum Associates/LACMA

92. photos by Caleb Waldorf

97. photo by Dorka Hegedus

98. crochet pattern © Cheryl Cambras. This pattern is for personal use only. Commercial use of this pattern, duplication or internet posting of pattern, and retail of resulting piece are prohibited.

99. (TOP) photos by Kelli Cain; (BOTTOM) photo by Katherine Guillen

100. photo by Michele Yu

101. courtesy of Ryan Taber

103. courtesy of Ryan Taber

105. photos by Kelli Cain

106. photo by Sidonie Loiseleux

109. photo by Tessa Young

110. (TOP) photo by Tessa Young; (BOTTOM) photo by Sidonie Loiseleux

111. courtesy of Douglas Irving Repetto

112. photo by Al Hermann

114. photo by Dorka Hegedus

115. (TOP & MIDDLE) photos by Sidonie Loiseleux; (BOTTOM) photo by Bernard Brunon

116. (TOP & MIDDLE) photos by India Brookover; (BOTTOM) photo by Andrea Kim

117. photo by Tessa Young

118–119. photo by Al Hermann, (BACKGROUND) artwork © Sam Francis Estate, Venice, CA

121. photo by Roberto Paz

122. (TOP RIGHT) photo by Beth Wood, (BACKGROUND) artwork © Enrique Chagoya; (TOP LEFT) photo by Scott Mayoral; (MIDDLE LEFT) photo by India Brookover; (BOTTOM) photo by Sidonie Loiseleux, (BACKGROUND) artwork © John Chamberlain/Artists Rights Society (ARS), NY; Art © 2009 The Dedalus Foundation, Inc./Licensed by VAGA, NY

123. photo by Sidonie Loiseleux

124. photo by Autumn Rooney

125. courtesy of Jacinto Astiazarán

126. photo by Dorka Hegedus

127. (TOP RIGHT) photo by Katherine Guillen; (TOP LEFT) photo by Dorka Hegedus; (MIDDLE LEFT) photo by Justin Allen and Seunghyun Yoo; (BOTTOM RIGHT) photo by Sidonie Loiseleux; (BOTTOM LEFT) photo by Roberto Paz

128. photo by Katherine Guillen

130. photo by Michele Yu

132. photo © 2009 Museum Associates/LACMA

137. photo by Cyril Kuhn and Scott Shackleford

138. photo by Katherine Guillen

140. courtesy of Philip Ross

141. courtesy of Philip Ross

142. courtesy of Kristina Yu, © Exploratorium, www.exploritorium.com

143. (TOP & MIDDLE) photos by Aimee Lind; (BOTTOM) photo by Takeshi Murata

145. courtesy of Kelly Sears

146. photo by Chris Spurgeon; (INSETS) courtesy of Fatal Farm

148. (TOP) photo by Michele Yu; (BOTTOM) photo by Aimee Lind

152. photo by Michele Yu

154-155. photo by Sidonie Loiseleux

156. photo © 2009 Museum Associates/LACMA

157. photo by Roberto Paz

158–159. photo by Field Garthwaite

160. photo by Tessa Young

170. photo by Scott Mayoral

172. photo by Autumn Rooney

Back cover. photo by Jared Eberhardt

MACHINE PROJECT:
A FIELD GUIDE
to the Los Angeles County Museum of Art

Published by Machine Project and the Wallis Annenberg Photography Department at the Los Angeles County Museum of Art, with support from the Ralph M. Parsons Fund. This project was funded in part by generous support from Pomona College (Mark Allen).

Machine Project
1200-D North Alvarado Street
Los Angeles, California 90026
machineproject.com

Los Angeles County Museum of Art
5905 Wilshire Boulevard
Los Angeles, California 90036
lacma.org

Distributed by
D.A.P./Distributed Art Publishers, Inc.
155 Sixth Avenue
New York, New York 10013
artbook.com

Edited by Mark Allen, Jason Brown, and Liz Glynn

The event was initiated by Charlotte Cotton and produced by Mark Allen, Liz Glynn, Eve Schillo, and Michele Yu.

Photographic documentation / Rights and reproductions managed by Sarah Bay Williams.

Editorial assistance for essays provided by Carlin Wing, Charlotte Cotton, Sean Dockray, Liz Glynn, Emily Joyce, Anthony McCann, Jason Torchinsky, Caleb Waldorf, Michele Yu.

Design by Department of Graphic Sciences, Los Angeles, CA. www.deptofgraphicsciences.com. Art direction by Kimberly Varella, production by Steven L. Anderson.

Printed and bound in the United States by PrintUp Graphics, Santa Monica, CA.

ISBN: 0-9753140-4-1

Visit machineproject.com/lacma for videos, audio, images, and more from the *Machine Project Field Guide to LACMA*.

(ON THE COVER)
COREY FOGEL *COUNTERCUMULATIVE MARCOTTING*
Pictured in the Ernestine and Stanton Avery Gallery
(BACK COVER)
MACHINE PROJECT ELEVATOR PLAYERS *MACHINE MUSICAL ELEVATOR*
Luke Storm playing the tuba inside the *Machine Musical Elevator*.
In the Ahmanson Building

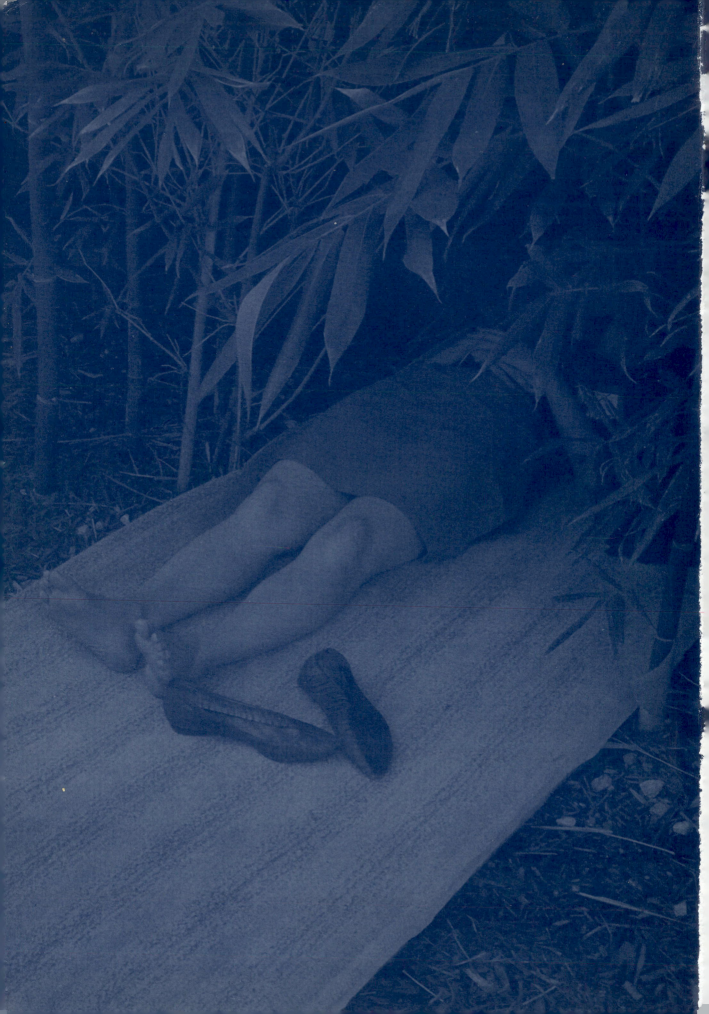